— THE —

LOG
CABIN

THE LOG CABIN

AN ILLUSTRATED HISTORY

Andrew Belonsky

THE COUNTRYMAN PRESS

A division of W. W. Norton & Company

Independent Publishers Since 1923

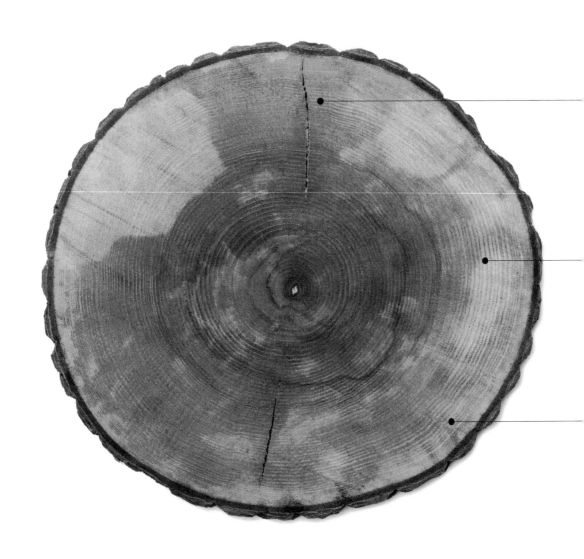

CONTENTS

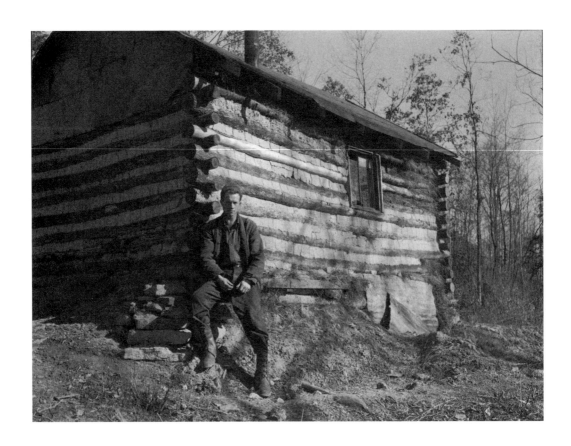

IMAGE I.1 This man is rightly proud of his log cabin, but one wonders if he knows the structure's true story. *(Library of Congress)*

INTRODUCTION:
IT'S BIGGER
THAN IT LOOKS

WHY IS THE log cabin such a B.F.D. in the USA? This may not seem like a question that needs to be asked, but if you stop to think about it, the log cabin is everywhere in American culture today. And I mean *everywhere*. It's all over basic cable in the form of reality shows about Alaskans who allegedly live in log cabins (the Discovery Channel's *Alaskan Bush People* and *Alaska: The Last Frontier*), programs about harried urbanites seeking woodland escape (HGTV's *Log Cabin Living*), and chronicles of log cabin reconstructions (DIY's *Barnyard Builders*).

Urban sidewalks remain crowded with lumbersexuals, men whose thoughtful style rests on buffalo plaid, roughed-up boots, and fulsome, well-maintained beards. Perhaps they're carrying a few of the many cabin-centric books that have hit the shelves as of late—*Cabin Porn*; *Rock the Shack*—as his gal pals pick up *The Pioneer Woman*, the Hearst magazine based on the rural lifestyle blog and TV show of the same name. There's even a *Walden* videogame in which players build a cabin and get back to nature, striking a balance between survival and quietude—all from the comfort of your own home.

A Gettysburg hotelier
was one of many post-
WWII Americans
to embrace the log
cabin anew. *(Library of
Congress)*

Contemporary Americans' fixation on the log cabin isn't random. Looking back at pop culture moments past, we see the log cabin's stock always rises in times of turmoil, trauma, and sometimes even triumph—and I think we can all agree we've had plenty of each in the past decade or so. Log cabin idolization was in full swing after World War I, and ditto following World War II's nuclear conclusion, when the cabin was turned into a candy-colored plaything. Even further back, as the nation crawled from the wreckage of the Civil War, there was the log cabin, elevated in luminous paintings, self-aggrandizing myths, and marketing gimmicks. The log cabin is like a teddy bear made of wood, an architectural security blanket to which Americans flee when times gets tough. But these log cabin flare-ups are more than just a reaction to upheaval, a Pavlovian cultural response. That's too

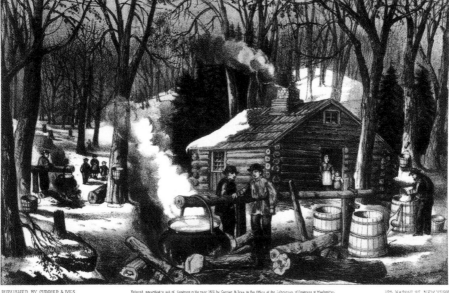

MAPLE SUGARING,
EARLY SPRING IN THE NORTHERN WOODS

IMAGES I.3–I.4

Wholesome log cabin scenes like this are standard American issue, but they're also romanticized, anachronistic, and just plain wrong. *(JT Vintage / Art Resource, NY and New York Public Library)*

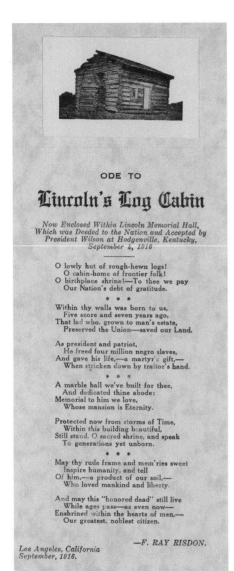

IMAGE I.5 Changing times always inspire log cabin love, as in this ode to Lincoln's sylvan hut, penned in 1916, with a great war looming. *(Library of Congress)*

cut and dry for something as surprisingly intricate as the log cabin.

Today's (and tomorrow's, and the next day's) log cabin trends aren't simple style cycles, like when disco comes back every twenty years, or when it's suddenly hip to be fifties-square. The log cabin is more permanent than any fad or craze. It's far more ingrained in our national psyche and identity than bell bottoms or sock hops. You don't see powdered wigs making a comeback, do you? The log cabin is something special. It exists in other places in the world, but nowhere else but America is it as elemental, as much of a cultural force.

As such, the log cabin crops up in every corner of American culture in almost every era. It appears in some of our nation's most celebrated works of art and literature, from Thomas Cole's 1845 painting *The Hunter's Return* to J. D. Salinger's *The Catcher in the Rye* (1951), in which whiny Holden Caulfield longs for a cabin retreat. Country singer Porter Wagoner crooned about log cabins in his 1960 cover of "An Old Log Cabin for Sale," and Lil Wayne and T-Pain rapped about one in their 2008 hit "Can't Believe It." Americans of all walks of life and musical tastes worship the log cabin equally. It is our logo, our emblem.

Etched on money, imprinted on stamps, and enshrined on state seals, the log cabin is an indelible, unflappable American icon, one upheld alongside the bald eagle and apple pie in America's pantheon of sacred symbols. More than wood and mud, it's a metaphor—a tenacious and timeless one that was essential to the nation's economic, geographic, and psychic development, but not in the ways you may think or have been taught.

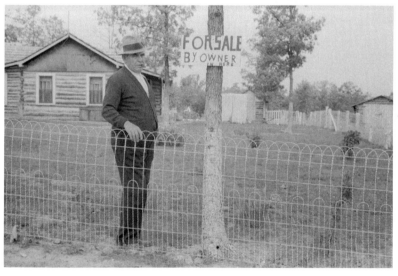

IMAGES I.6–I.7 The log cabin is always in the background of American history, but, like, *why*? *(Library of Congress)*

Most Americans have a fondness for the log cabin, but not many understand why. We worship it ritualistically, lusting after "cabin porn" and teeny, tiny little spaces, but few fully comprehend the forces behind the log cabin's enduring allure. Though the primary image of the log cabin is as the acorn of a mighty empire, as the first home of Pilgrims and pioneers, it's more than all that. It's ubiquitous but invisible. It's a prefabricated icon standing for nothing in particular but everything all at once. It's a symbol on autopilot. It's always there, but, like, what is it doing?

But it wasn't always this way. The Founding Fathers turned their noses up at the log cabin and its inhabitants. Benjamin Franklin derided the structure as "rude" and "miserable," while those within were "dirty, . . . ragged and ignorant, and vicious."[1] To him and his fellow elites, log cabins were rubbish homes for rubbish people. Yet, fifty years later, in 1840, there is wealthy, mansion-dwelling presidential candidate William Henry Harrison claiming to live in one, a lie that helped him win the election. Soon we hear his successor, John Tyler, heralding the log cabin as the cornerstone of our very nation, projecting it onto our earliest days. The log cabin was now something to be proud of, something to cheer and adore. How did this happen? What forces transformed a stack of sticks into a badge of honor? What cemented its status as a symbol, and why does it persist today? The short answer is: heaps of historic revisionism, a whole lot of wishful thinking, and more than a few good ol' fashioned lies, all adding to a cauldron of national self-mythologizing. The longer answer to the persistence of the log cabin, however, is a bit knottier. Hence this book.

Before going on, I have to define "log cabin." This sounds silly, yes, but it is more complex than just a few sticks. On a structural level, the earliest American log cabin is characterized by horizontal logs interlocked at the corners and with gaps plugged up with mud and muck. If it has windows they're typically made of greased paper;

glass doesn't travel so well in the woods, but it's not unheard of in later years. In fact, a single pane of glass could increase a cabin's value from one dollar to five, according to 1798 tax records. Some of these cabins have rounded, bark-covered logs, others are squared. The nation's earliest log cabins, thrown up in a race against the elements, were typically one-room affairs, mostly with earthen floors, and perhaps with a partition dividing them in two or with a loft for sleeping quarters. More carefully crafted cabins could be two rooms, or even two stories, a detail more architecture-focused authors define as a "log house," but here—and in the majority of primary sources cited—they're "log cabins." The terms are interchangeable because the log cabin in America is more than an edifice. It's a concept, one whose purpose and meaning change with context.

As you might have guessed, this is not just an architectural history

IMAGES I.9–I.10 The log cabin is more than a just structure in America, it's a concept, which explains why both this settler's structure and this mansion, built in 1793 for refugees of the French Revolution, are referred to as a "log cabin." *(Kansas State Historical Society and Bradford County Historical Society)*

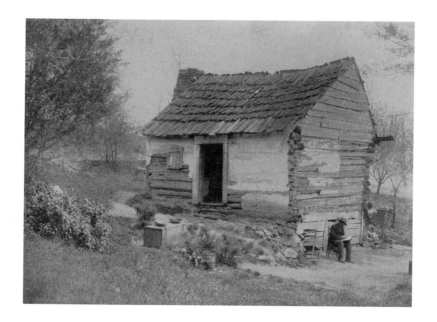

of the log cabin. Or even just a cultural history of the cabin. Histories are rarely only about the past. This narrative is about myths and how they're contrived. It's the story of how the equally contradictory United States defined itself by its tall, inaccurate tales, and how those fictions are deployed today, often at the sake of actual history. Americans jump at the opportunity to portray the log cabin as a springboard for great men like Abraham Lincoln, but few people mention that Lincoln's killer, John Wilkes Booth, was also born in a log cabin. We'll see that a lot in these pages: Americans overlooking nastier bits of our past for the sake of a broader myth.

In dispelling some of America's foundational myths, I hope to show what makes us tick, because as much as this is a book about log cabins, it's also a dissection of the American character. Examining the log cabin's role and America's relationship to this structure gives us a clearer understanding of what made this great nation what it is today, both physically and psychically. Or, rather, how the nation made itself.

IMAGE I.11 Despite prevailing myths, the log cabin's history isn't all sunshine and delight. There's also vast inequality, racism, and terrible destruction. *(Library of Congress)*

In doing so, I will show how a seemingly unassuming structure played an over-sized role in shaping our collective identity, how it propelled and steered our history every step of the way, evolving in lock step with the nation itself—from a scraggly, scrappy hut sheltering struggling colonists to an international powerhouse's beloved icon—and with both experiencing plenty of growing pains along the way.

In the log cabin's story, we encounter some of the best and worst of America's traits: determination and grit, and avarice and ignorance, too. We see its highest promise and its darkest shames. We meet well-intentioned heroes and vile villains. We see hope and despair, expansive imagination and stunning shortsightedness that still haunt us today.

In one circumstance, it's a simple protector from elements, in another it's a harbinger of destruction. In one situation, the log cabin helps break institutions, in another it's an institution all its own. To some the log cabin was the stake to a new beginning, to others it was something that needed to be escaped ASAP.

Therefore, the log cabin's something of a blueprint for the American experience. In exploring the log cabin's true history, I hope to provide a more nuanced, fuller, and unflinching history of the nation itself. As Daniel Drake said in an 1834 speech singing the log cabin's praises, "Self-knowledge of nations is especially necessary for one of recent origin, where everything is still green."[2] Drake's words are more than 180 years old but remain just as true today. The United States are still young compared to many other countries, and we still have a lot of growing up to do. Looking at the good, bad, and ugly of the log cabin helps to reinvigorate pride in the nation's against-the-odds success, yes, but it also reminds us that age-old blemishes are still rearing their ugly heads.

There's a lot of light here: stories of tenacious immigrants seizing their destiny, bravely venturing out for a brighter future. But there's just as much darkness: millions of slaves living and dying in cabins, ramshackle edifices that made forced labor all the more lucrative for their overlords—you're not going to see that on syrup bottles, that's

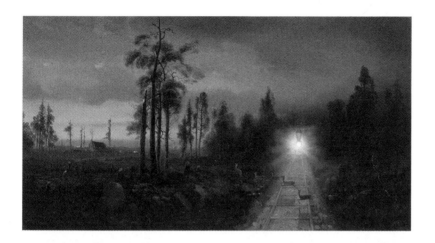

IMAGE I.12–I.13 The log cabin sits by as the railroad industry pummels our natural resources in Andrew Melrose's 1867 painting, *Westward the Star of Empire Takes its Way*, a realistic takeoff of Frances Flora Bond Palmer's more rose-tinted, *Across the Continent: Westward the Course of Empire Takes its Way*. (*Autry Museum, Los Angeles and Mireille Vautier / Art Resource, NY*)

for damn sure. Savory or not, these truths all help explain the American character. It turns out the log cabin is more than a simple stack of sticks. It's like a transformer: There's more than meets the eye. In other words, it's complicated—kind of like America itself.

Spanning from 1638 to today, this narrative is broken up into three parts. The first part is the historical nitty-gritty: the overlooked truth

about the log cabin's origins in this country. Despite what countless "First Thanksgiving" postcards exhibit, it wasn't brought here by the Pilgrims. Nor was the log cabin a welcome sight. It was "bleak" and "miserable," and its inhabitants were most often dismissed by their more well-heeled peers as tramps, interlopers, weirdos, and generally lame. Using colonial diaries and official records, this section explores the ways in which the log cabin, disparaged as it and its tenants were, helped sow the seeds for the American Revolution.

The second section delves into the first heady days of America's love affair with the log cabin. Here we'll feast our eyes on Romantic paintings and patriotic poems and encounter the first beloved pioneers, the Daniel Boones and such, while also getting a healthy dose of political and social history that explains a lot about today's political climate. This is where we find the first seeds of a myth that grows in the following decades, perpetuated by politicians, marketing gurus, the publishing industry, and, yes, even schoolteachers.

And that brings us to the third and final part: the twentieth and twenty-first centuries, familiar territory where the log cabin has blossomed into a full-blown yarn. Here we see the ways in which log cabin lore was given new, technicolor form, perpetuating misconceptions about history, and about reality, too. Interspersed throughout this journey are tidbits and fun facts about log cabins, as well as slightly longer interludes exploring the cabin's aforementioned underbelly: its use as a slave prison; its function in Indian assimilation and later removal; its role in deforestation and, yes, how this seemingly democratic structure came to exemplify inequality. (Also, be sure to check out the endnotes, where I've slipped in some asides, anecdotes, and a potpourri of factoids among my sources.) Taken as a whole, this book demonstrates how selective memory edits out the bad and elevates the good for the sake of national fables. But every myth has a kernel of truth, and I'll get to that here, as well, showing how the log cabin can help our fractured nation navigate troubling times.

And just in case you're still not convinced to read on, this whirlwind, century-straddling tour includes an absolute constellation of stars, including but not limited to (in the lilting voice of an awards show announcer): Thomas Jefferson, Loretta Lynn, Mark Twain, Dolly Parton, Davy Crockett, Booker T. Washington, "Honest Abe" Lincoln, Asher Durand, Angela Chase and Jordan Catalano, Walt Disney, Tecumseh, Kurt Cobain, Ralph Lauren, the demons from *The Evil Dead*, and Donald Trump! Yes, it's a star-studded affair indeed. Oh, and there are a *ton of pictures*! So sit back, relax, and get ready to have your mind blown by a history of hardwood you never knew you needed.

IMAGE I.14 A park ranger and guard hike past a log cabin in New Hampshire's White Mountain National Forest, 1926. *(Forest History Society, Durham, NC)*

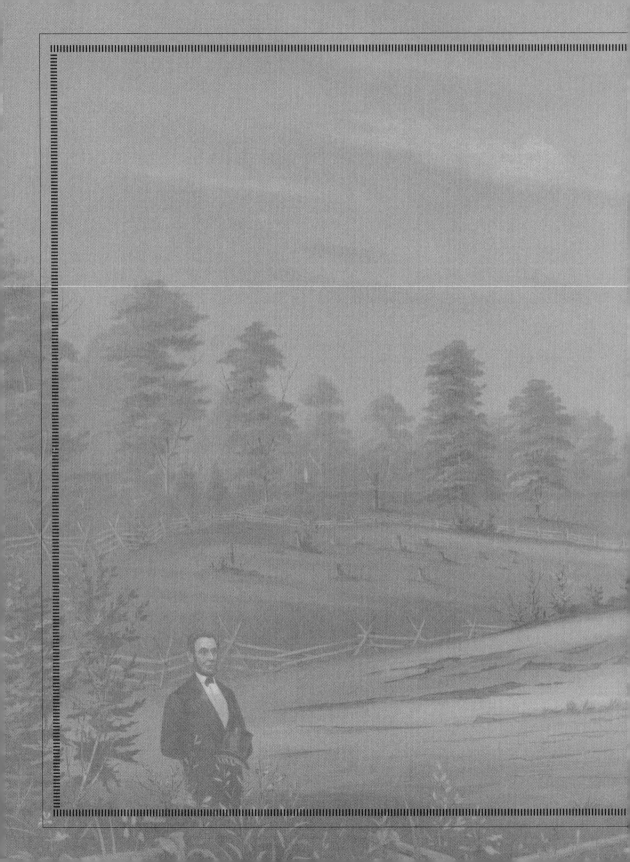

Part I

HISTORY, STRAIGHT-UP

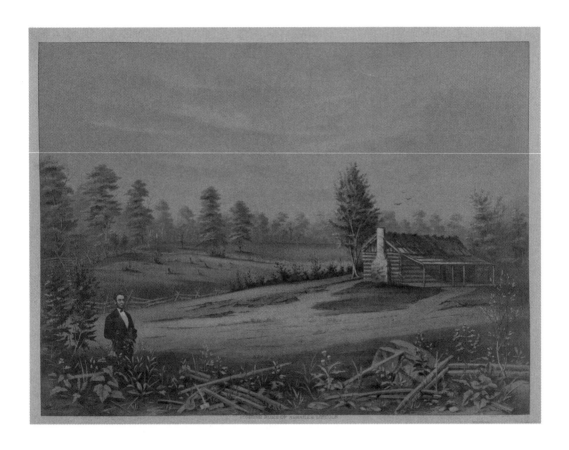

IMAGE 1.1 Americans make a lot of hay about Abraham Lincoln's log cabin roots, but such idolization is about more than the Great Emancipator's legacy. It's part of a larger myth. *(Library of Congress)*

· 1 ·

HARD TRUTHS

IT WAS RAINING like holy hell in Hodgenville on February 12, 1909, but that didn't prevent an estimated 15,000 "reverent and curious Americans"[1] from turning out to Sinking Spring, the Kentucky farm where Abraham Lincoln had been born a century earlier. President Teddy Roosevelt and the First Family themselves traveled from Washington to lay the cornerstone for the memorial, the first of many to the slain president. This particular remembrance, crowdfunded by more than one hundred thousand Lincoln lovers, would be a marble and granite masterpiece designed by star architect John Russell Pope to enshrine the site's crown jewel: the very log cabin in which Lincoln had been born, made with logs cut by the Great Emancipator's own father.

Roosevelt declared the site "a national temple of patriotic righteousness."[2] New Hampshire Senator Jacob Gallinger called it an "altar of patriotism," one that would go far in "inculcating" a new generation with "the principles of patriotism."[3] Oshkosh, Wisconsin's *Daily Northwestern* pronounced the cabin "a mecca for all Americans,"[4] and *The Cincinnati Enquirer* also used the m-word, calling the hillside "a mecca

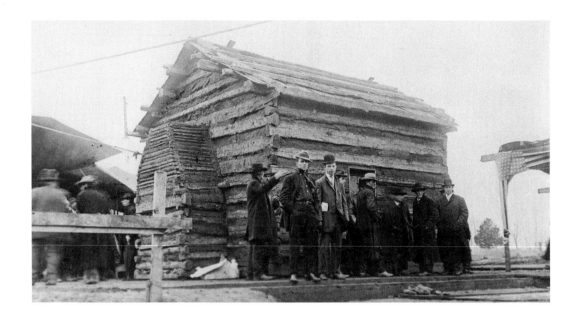

IMAGE 1.2 These charming men donned their best duds to visit the beloved late president's alleged birthplace. *(Library of Congress)*

for all patriotic men and women." Though that paper conceded that "the stark landscape is not inviting," there was no debating "the fact that the bare feet of Abraham Lincoln touched the earth here will make it hallowed ground."[5] Few of the dignitaries, admirers, or reporters mentioned that Lincoln had only lived on the farm for two years, until 1811, and absolutely none of the awestruck fanboys acknowledged what many of them surely suspected: The Lincoln log cabin was a ruse.

The idolized logs hadn't been subjected to any rigorous fact-checking. The Lincoln Farm Association, the memorial steering committee which included luminaries like editor Robert Collier, future-president William Howard Taft, and humorist Mark Twain, acquired them in 1906 under less-than-luminous conditions: out of a basement in Queens, New York, from a man named David Crear, who had taken control of them after their previous owner, a bankrupt

restaurateur named Alfred Dennett, went insane.[6] So, yeah, things were shady from the get-go.

Some within the Lincoln Farm Association's inner circle knew and willfully overlooked the truth: Dennett bought the wood off some random guy back in 1895, when the future-convalescent hatched a plan to turn the Lincolns' former Hodgenville farm into a roadside attraction. The only problem was that there was nothing there. Just wide open earth and a whole lotta soil. Local lore had it that the real Lincoln cabin was dismantled in 1840 and burned for fuel shortly thereafter, leaving a pile of ashes where a pot of gold could have been. This rumor was confirmed in an 1865 letter in which William H. Herndon described the land in great detail—here a "little knoll," there a "barley field," everywhere "rocks indicating the site of the chimney"[7]—but that made no mention of a cabin. And a Lincoln supporter who visited the site in 1860 remarked categorically, "The house has been removed."[8] But Dennett and his business partner, Reverend James W. Bigham, weren't about to let something like the truth uproot their plans: They simply procured a dilapidated cabin from a local man who would claim, should anyone ask, that it was the original Lincoln abode.[9] Dennett and the not-so-righteous reverend were clearly more than willing to bend the truth for a buck. But the bucks never came. Most locals didn't give a hoot about some crummy old cabin they knew to be a fake, nor were most Americans yet mobile enough to pop into a farm in the middle of rural Kentucky. The "Lincoln birthplace" was a ghost town.

Undeterred, Dennett decided that if the action wouldn't come to them, they would go to the action, so he shipped the cabin off to the 1897 Tennessee Centennial Exposition in Nashville, where it was erected alongside another structure of dubious origin: the alleged home of Lincoln's Confederate counterpart, Jefferson Davis. Like the Lincoln logs, Davis's "home" was an arbitrary structure Den-

nett Frankensteined in the preceding months, but razzle-dazzle goes a long way in obscuring the truth. Patriotic gawkers from North and South flocked to gaze upon the cabins. Later, once the exposition had wrapped, the logs were tossed in a jumble and transported to New York's Bowery, where they sat in storage for years, trotted out only for special occasions.

With each fresh excursion, the "Lincoln" and "Davis" logs were mixed and mingled, shaken and stirred; dozens of pieces were lost along the way, sometimes replaced, sometimes not. At least once the logs were fused into a single structure, "The Lincoln and Davis Cabin," a showman's desperate attempt to improve on the so-called originals.[10] Dennett was sent to a padded room, not long after in 1904, leaving the logs to be sold to the Lincoln Farm Association for $1,000.[11] And with that simple transaction the humdrum logs were imbued with tremendous symbolic power. Suddenly invaluable, they were paraded back to Kentucky, accompanied by hordes of admirers and armed guards along the way.

Sure, there were some who spoke against the structure's authenticity: Judge John C. Creal, a man who lived on the Lincoln farm after the famous family left, swore that the cabin in question was a fraud, telling Lincoln Farm Association lawyers during their perfunctory investigation, "These logs, afterwards removed from the place, had no connection whatever with the logs in the original cabin."[12] But the Lincoln Farm Association simply stonewalled him and other would-be dissenters, presenting more affirmatory affidavits and declaring: "[We believe] that the American people will not be so unreasonable or critical as to demand more conclusive evidence of the birthplace of this great American."[13] They buried the truth. And so strong and widespread was their devotion to this illusion that misgivings were suppressed even *after* the "birth cabin" was trimmed from 16 x 18 feet to 12 x 17 feet to fit into the memorial, which cost $200,000, or about $5.5 million in today's market. Pomp, circumstance, and sophistry

overshadowed actual fact. And, you know, they had spent *all that money . . .*

Any and all back talk against the so-called birth cabin was slapped down in those years, including an almost immediate rebuke from a former local, Admiral Lucien Young, who declared the "hut" a hoax that "emanated from the fruitful brain of some imaginative and enthusiastic showman." Young asserted, "I attended school at Hodgenville and used to romp and play over at the Lincoln farm and I never saw any such cabin on the place then."[14]

And so the "Lincoln cabin" yarn remained tight for decades until 1948, when amateur historian Roy Hays released a report that both recounted Dennett's ruse and, more damning, unearthed a 1919 denouncement from Robert Todd Lincoln, the president's last living child. The revered structure was a "pretended cabin," young Lincoln wrote in a letter to antique collector Otto Wiecker.[15] "The actual cabin

IMAGE 1.3 There was much pomp and even more circumstance surrounding the shady logs that made up Lincoln's supposed birth site. Here, the Clydesdales that transported the cabins from Long Island to Kentucky pose for posterity. Not pictured: armed guards. *(Library of Congress)*

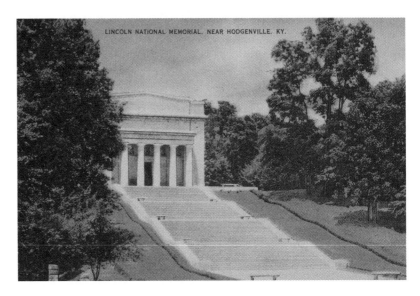

LINCOLN NATIONAL MEMORIAL, NEAR HODGENVILLE, KY.

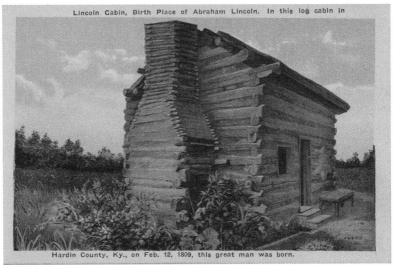

Lincoln Cabin, Birth Place of Abraham Lincoln. In this log cabin in

Hardin County, Ky., on Feb. 12, 1809, this great man was born.

IMAGES 1.4–1.5 This $200,000 beauty was crowdfunded to house *that* old thing. Only in America, folks. *(Library of Congress)*

was a decayed ruin long before my father's election. . . . The structure now enshrined in a great marble building in Kentucky is a fraud when represented as the actual home." The press went wild with the news, running headlines declaring the cabin a flimflam and ultimately forcing the government to concede that, yes, *some* of the logs were shams invented by shysters.

Married to the myth as it was, though, the government couldn't bring itself to abandon the imposter cabin altogether, so it put up a disclaimer: "The log cabin in the Memorial Building is the traditional birthplace cabin. It is impossible to say with certainty that it is the original cabin." Again, this quite intentionally let the imagination run wild with visions of Lincoln crawling across a dirt floor to his great American destiny. And, again, decades passed, leaving thousands of visitors, maybe even millions, with the impression that they had seen Lincoln's actual birthplace.

It wasn't until the twenty-first century, in 2004, that a tree ring analysis proved that the "Lincoln logs" on display were in fact felled around 1848, well after their namesake's 1809 birth, finally convincing the government to change its stance. Instead of being called "traditional," the Lincoln birth site is now the president's "symbolic" birthplace. As Hunter S. Thompson wrote, "Myths and legends die hard in America. . . . We love them for the extra dimension they provide, the illusion of near-infinite possibility to erase the narrow confines of most men's reality."[16]

The story of the Lincoln "birth cabin" from the fortune hunting to the ceremonial celebration of the humble to the relentless swirl of historic revisionism and misinformation, speaks volumes about our nation's attachment to the log cabin in general. The Lincoln birth site would be meaningful if it were a frame house or a stone house or, populism forbid, a mansion like Monticello, but the structure's loginess gives it extra symbolism. The log cabin was already an icon when the "birth cabin" found its way home. The late president's memorial foundation was laid atop

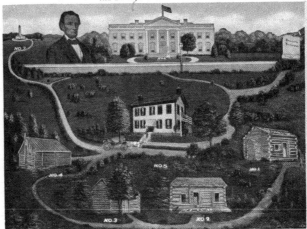

THE EARTHLY PILGRIMAGE OF ABRAHAM LINCOLN

1. Birthplace of Abraham Lincoln, Hodgenville, Ky. Born Feb. 12, 1809.
2. Home of Lincoln at Lincoln City, Indiana, 1817 to 1830.
3. Home of Lincoln near Decatur, Illinois. From 1830 to 1831. Drove ox team to this city in 1830.
4. One of the homes of Lincoln while at New Salem, near Petersburg, Illinois, 1831-1837.
5. Lincoln leaving Home at Springfield, Ill. for Washington, as President, 1861.
6. The White House, Washington, D. C., 1861.
7. Lincoln's Monument, Oak Ridge Cemetery, Springfield, Ill.

COPR. 1921-1923 BY JESSE C. SHULL

FROM LOG CABIN TO THE WHITE HOUSE—K52

IMAGES 1.6–1.7 Two of the dozens and dozens of postcards glorifying Lincoln's log cabin background. *(University of Kentucky and Archive.org)*

a preexisting culture of log cabin worship, a collective predilection in which the log cabin dweller is inherently admirable and the cabin itself is an insignia representing our singular nation's allegedly singular opportunities. Part of a larger rags-to-riches (or, rather, logs-to-luxury) fable, the log cabin is held up as an example of distinctly American mobility, and the Lincoln cabin was the greatest of them all. "Lincoln was born in poverty and rose to glory," Kentucky Governor Augustus E. Willson said in 1911, upon the "birth cabin" memorial's completion. "[And] his little home . . . impresses upon our hearts the lesson that one does not have to be born with wealth in order to attain the highest rung of success. All that is necessary for the success of the American youth of today is courage, good sense, integrity of purpose and honesty."[17] The log cabin in this situation is an opiate of sorts, a way of keeping people in their place with a promise of progress. It perpetuates the idea that *all Americans* can achieve great heights while ignoring the systems that work against such movement.

To that point, though the phrase "from log cabin to the White House" is most often associated with Lincoln, it was first applied to a different assassinated president, James Garfield, in historian William M. Thayer's 1880 book, *From Log-Cabin to the White House*.[18] But Thayer's decision to use "log cabin to the White House" to sell Garfield's life was hardly haphazard. Thayer's logs-to-riches work debuted amidst decades' worth of spurious histories that projected the log cabin far into the past, sticking it where it didn't belong: bogus pronouncements like Reverend Alexander Young's 1841 claim that Plymouth's first homes were "probably log-huts," and historian John G. Palfrey's well-regarded 1860 assertion that New England's colonists "made themselves comfortable in log-houses, of construction similar to those which are still scen [sic] in new settlements."[19] Thayer was undoubtedly familiar with these works, and he had probably even seen David E. Field's 1853 imaginative picture of a colonial-era log cabin meetinghouse, one of the first such anachronisms and seen in

chapter six. But these and similar tales were apocryphal lore dreamt up by Anglocentric historians in the mid-nineteenth century, back when the nation first fought over and then came together around an origin story. In this version of our nation's founding, Pilgrims and Puritans, those "first Americans," are architectural geniuses whose innovation was the catalyst for democracy. In this retelling, these stout colonists' stout log cabins birthed a new world superpower. That couldn't be further from the truth.

UPRIGHT BRITISH, UNDERGROUND

Real talk: There were no log cabins in early English colonies. Yes, I know we've all been conditioned to think otherwise, but the cold, hard truth is that the Pilgrims of Plymouth didn't live in log cabins, and neither did Captain John Smith and his cohorts down in Jamestown. Yes, the English *should* have lived in log cabins. Forest was literally everywhere—about 950 million acres of it[20]—and it took only about a day, zero money, and very little imagination to put tree and tree together. But, alas, architectural ignorance kept them out in the cold. More familiar with the trim frame houses of the Kingdom proper, most had never even *seen* a log cabin, never mind the forest from which they sprang. These precious colonists arrived as complete babes in America's fearsome woods.[21] Absolutely confounded by the sylvan chaos and utterly incapable of building log cabins, they had no other option but to pop squats in dugouts: crude, subterranean holes gouged "cellar fashion"[22] into the ground or a hillside, earthen burrows far closer to hell than the heaven they so fiercely sought.

"Many famished in holes and other poore [sic][23] cabbins in the grounde, not respected because sicknes had disabled them for labour," British businessman Sir Thomas Dale wrote of Virginians' "wante of

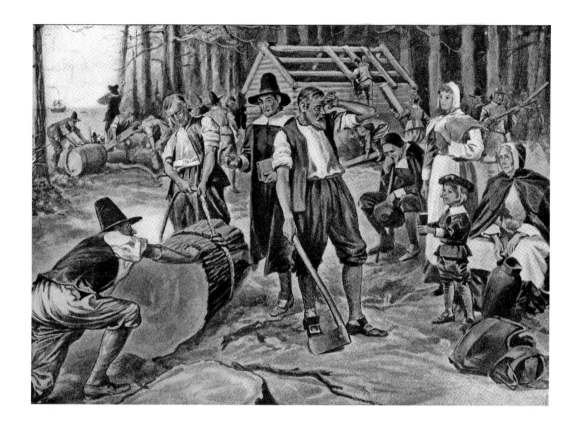

houses" in winter 1611.[24] (Although he writes "cabbin," he's talking about something else entirely, as we'll see in a bit.) Ten years later, Virginia colonial authorities still described Jamestown's real estate scene as mostly "holes within the grounde."[25] Edward Johnson saw a similar scene in Massachusetts, writing in his 1654 diary, "[New Englanders] burrow themselves in the Earth for their first shelter, under some hillside, casting the Earth aloft upon timber;"[26] and Philadelphians of 1682 suffered in skimpy homes "formed by digging into the ground . . . about three feet in depth; thus, making half their chamber under ground, and the remaining half above ground was formed of sods of earth."[27] This dirt-laden toil was nothing new for the poorest

IMAGE 1.8 A stock image perpetuates the foundation myth many of us know and love, but it's a lie, one built over centuries by people high and low. *(North Wind Picture Archives / Alamy Stock Photo)*

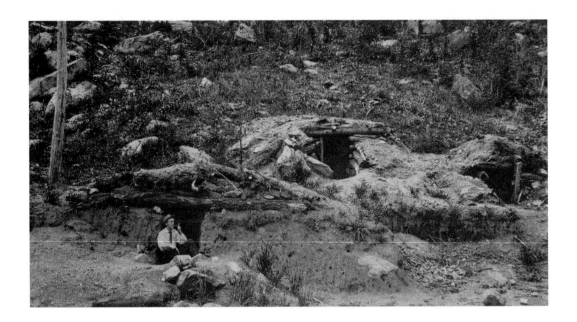

of the colonists, for whom "the rude shelters meant no more than a perpetuation of conditions back home," but it was more than a shock to the elite's collective system: "To the gentlemen who were leaders and chroniclers, their first abodes in the new world were mean enough compared with those to which they were accustomed."[28] Poor, unfortunate souls indeed, dugout-dwelling colonists graduated from their subterranean lairs only after they had cleared land, planted crops,[29] and the mills and kilns were up and running, churning out timber and brick for more substantial abodes.

So, yeah, life in the early colonies wasn't as warm and snug as legend would have it. On the contrary, it was the pits: a frigid, mud-smeared reality that doesn't lend itself to a very attractive origin story. It's little wonder that Anglo-obsessed historians later whitewashed the truth, editing out dugouts to create a more impressive national origin story in which the Pilgrims and Puritans' on-the-fly innovation powered the future nation's creation. It just sounds better. But for the sake

of driving this point home, let's take a quick dip into the log cabin's ancient history. It will be painless, I promise.

OLD WORLD, NO CHARM: THE CABIN'S ORIGINS

The log cabin that we regularly celebrate as all-American actually traces its roots to a long time ago, in a land far far away, Northern Europe, in what is today Denmark, southern Sweden, and northern Germany, among the Maglemosian people who lived there hella long ago, i.e., around 9000 to 6000 BC. There was no Instagram back then, if you can imagine, so we have no way of knowing exactly how the log cabin first arose there, but a condensed, based-on-a-true-story version goes something like this: For centuries, Maglemosian folk made their homes by hammering log posts vertically into the ground, creating a yawning circle of protection that kept animals out, but not the weather. Laying awake in such a structure one night, and absolutely sick to death of the inclement intrusion, a random person—let's call them Frig—had a brainstorm: "What if Frig turn logs other way, against the earth? Would that keep Frig more snug?"

Eager to find out, Frig spent the whole next day yanking his logs out of the icy earth, hacking out notches at the end and then stacking them together, like a box. There were gaps, of course, but Frig just filled these in with mud, muck, moss, and poop. This was of course all very unusual, not to mention smelly, and Frig's neighbors assumed the burgeoning architect had lost his mind. But Frig turned a blind eye to this side eye and kept right at it until it was time to turn in for the night. Frig slept like a baby that evening and bragged all the next day about his domestic invention, inspiring erstwhile naysayers to start crude imitations of their own—and, surprise, surprise, they too found the results magnificent.

The instructions for Frig's cabin were thus passed on to the next generation, and then to the next, and so on, so by the Bronze Age the cabin spread far beyond his neighborhood and could be found all across the continent, from Russia to France.[30] But poor island England, separated from Europe by the blasted Channel, never got the log cabin memo, and their architectural evolution took a different form, evolving from mud huts and branch cottages into timber frame homes and, for the wealthiest, brick manses. There's therefore no way the Englishmen brought the log cabin to American shores.

So if the pious English colonists didn't erect the first log cabins in America, who did? Who introduced this titan of American iconography to our shores? Not the Dutch over in New Netherland. They lived in wooden, stone, or sometimes brick homes, but never in log cabins. The French in Florida and Louisiana were partial to the *poteaux en terre*-style, i.e., post-in-the-ground structures like Frig used back in Europe. And the Spanish in Florida and the Southwest lived in either adobe abodes or "tabby" houses built of pulverized shells, lime, and sand. So who does that leave? An obscure, short-lived colony of an oft-forgotten group: the Swedes and the Finns of New Sweden.

FIRST CONTACT

The year was 1638, twenty years into the Thirty Year War, and military powerhouse Sweden was at the top of its game. Keen to keep the momentum going and build the nation into an international titan like Britain, Queen Christina and the New Sweden Company dispatched Governor Peter Minuit and about four dozen colonists to the Delaware Valley, which included today's New Jersey and eastern Pennsylvania, to establish a colony they hoped would grow their global prestige and maybe, just maybe, rival their rivals' tobacco and fur trades. But before taking on their economic nemeses, the Swedes and

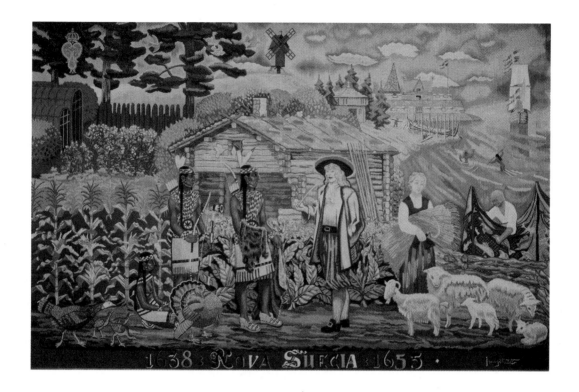

IMAGE 1.10 Log cabins stood tall in the short-lived New Sweden colony. (*American Swedish Historical Museum*)

Finns needed houses. Being descendants of Frig, and with many having lived in log cabins back home, these colonists did what came naturally: cutting down spruce, pine, and oak to create little homes in a matter of hours, leaving plenty of time to clear land and till soil. So efficient were these new arrivals that Englishman Thomas Paschall marveled in 1683, "[The Swedes] will cut down a tree . . . sooner then two [English] men can saw him."[31] That's pretty darn fast.

No, these cabins weren't always the most attractive of abodes. Historian C. A. Weslager describes them as "hastily built of round, undressed logs by peasant farmers."[32] Yet they were leaps and bounds better than the dugouts and hovels the English reluctantly called home. Dutchman Jasper Danckaerts wrote in 1679 that English homes in Maryland "were so wretchedly constructed that if you are not so close

to the fire as to almost burn yourself, you cannot keep warm, for the wind blows through them everywhere." He went on, "Such are almost all the English houses in this country." Swedish homes on the other hand were "better and tighter." They were "nothing else than entire trees, split through the middle, or squared out of the rough, and placed in the form of a square, upon each other, as high as they wish to have the house; the ends of these timbers are let into each other, about a foot from the ends, half of one into half of the other. The whole structure is thus made, without a nail or a spike."[33]

On that note, twentieth-century historian Harold R. Shurtleff, the granddaddy of log cabin studies, found that "[Swedish colonial reports] are notably free from those complaints of sickness which in the early English colonies was often ascribed to 'wett lodging' or 'defective housing.'"[34] So solid were these Swedish and Finnish homes that a number stood the test of time, like the Lower Swedish Cabin in Drexel Hill, Pennsylvania, which dates back to between 1640 and 1650 and has stood strong as the world has changed around it: today it can be found by driving under a SEPTA station. Meanwhile, the potentially older C. A. Nothnagle House in Gibbstown, New Jersey, built between 1638 and 1643, currently sits around the corner from a Shoprite and Motel 6.

But, as adept at cabin construction as they were, Swedes and Finns weren't very good at the whole running a colony thing, and it wasn't long before New Sweden crumbled. Queen Christina ceded the land in 1655 to New Netherland, which in turn gave the land to the even mightier Britain in 1664. While some Swedes and Finns fled their former colony, most stuck around, keeping to their neat little log cabins even as framed houses went up around them. Now, you would think this would be the moment poorer, ground-dwelling Brits started adopting the log cabin, after they had seen that there was a better way to live, but you'd be wrong. Danckaerts saw no such cultural interchange in Upland, Pennsylvania, a Swedish town "overrun by English" by 1679,

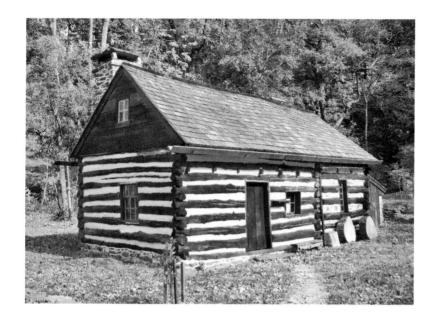

and he found English living in "nothing but clapboard" in New Jersey, near to where New Sweden once stood.[35] Nor did Swedish-Finnish botanist Pehr "Peter" Kalm spot any English-owned log cabins more than a century later, during a 1749 jaunt through the colonies, including the land formerly called New Sweden. He finds English there living in the most depressing conditions: "In one place I saw the people in a house with walls of mere clay;"[36] and others within scant hovels of plank and timber, "The wooden houses are not made of strong timber, but merely of boards of planks."[37] And neither's thin walls are weather appropriate: "The houses are extremely unfit for winter habitations. Hurricanes . . . carry away roofs and sometime houses."[38] But none of their homes appeared to be log cabins.[39] The Brits had been exposed to log cabins for more than one hundred years, yet still, contrary to all common sense, they refused to live in them. But *why?!*

It isn't that Englishmen and women were incapable of learning. They weren't completely daft. Their garrison houses and forts were

IMAGE 1.11 The Lower Swedish Cabin, one of the oldest log cabins in all the land, was constructed sometime between 1640 and 1650. Later, in the early 1910s, vanguard German filmmaker Siegmund Lubin used the structure as the backdrop for action movies (*Julian Fleisher*)

made of whole trees, and there's plenty of other evidence that Englishmen picked up other uses for logs. The original 1648 edition of Beauchamp Plantagenet's *A Description of the Province of New Albion* makes no mention of log structures, but the 1650 edition added this suggestion: Englishmen traveling to America should build themselves "a log house of young trees 30-foot square notched in at the corners." Few English folk took the author's advice. And though Maryland and Carolina colonial reports do refer to two log cabin-esque structures in 1669 and 1679, respectively, neither is a dwelling. They're both prisons, the Carolinian of which was specifically built for Thomas Miller, a colonial governor seized during Culpeper's Rebellion in 1677.[40] And so, too, did English colonists build "strong logg house[s]" as prisons in New Hampshire.[41]

The English of this era also used logs for pigpens and sheds, but living in a log building was beyond comprehension. It was the home of a lower person, the type of person the English conquered and colonized. Hugh Morrison writes in *Early American Architecture*, "English colonists were reluctant to use the log cabin for dwelling purposes, even in the eighteenth century."[42] They preferred to live in crappy dugouts like their nation's poorest rather than something foreign like a log cabin, despite its clear superiority. Custom, it seems, trumped comfort.[43] And, besides, even if the English wanted to make log cabins, they didn't have the right equipment: "The unwieldy European felling axe used by the first settlers was unsuitable for [felling trees]," writes Charles F. Carroll. "Its brittle iron head, weighing more than four pounds, often cracked when the weather was cold."[44] The Swedish and Finnish settlers, on the other hand, had the strong, broad felling axes and adzes, an arched tool designed for scooping out notches, giving them a leg up right off the bat.

Yes, there were a few exceptions to the "No Brits in log cabins" rule. A 1685 court manuscript shows Briton Patrick Robinson donated his "logghouse" on Philadelphia's Second Street to the local sheriff

(who then used it as a prison), and property deed shows that Englishman George Bartholomew built a "log house" elsewhere in Philadelphia in 1686, too. But these were isolated incidents,[45] as were the ones recorded by William Byrd, a British businessman aghast at finding his countrymen living among logs in Edenton, North Carolina. "Most of the houses in this part of the country are log houses, covered with pine or cypress shingles," Byrd wrote in 1728. "They are hung upon laths with peggs, and their doors too turn upon wooden hinges, and have wooden locks to secure them, so that the building is finisht without Nails or other Iron-Work."[46] Again, these were oddities, and the majority of early-eighteenth century America's Englishmen turned their nose up at the primitive log cabin, a miserable shadow of a house. If these colonial powers had their way, the log cabin would have remained a purely Swedish and Finnish anomaly, seen only in their small, scattered communities before fading into oblivion all together.

So while the Swedes and Finns introduced the log cabin to the American landscape, they weren't the ones who made it a permanent fixture. They were the first, but not the most influential. Cue the unwashed masses!

·2·

IMMIGRATION NATION:
THE LOG CABIN AS FREEDOM

HERE'S A FUN fact for any border-wall-supporting, "extreme vetting"-loving jingoists you may know: The log cabin, that patriotic, quintessential stand-in for the US of A, owes its American permanence to immigrants: men and women who came to the New World looking for new lives.

America was bomb diggity from the get-go. It's hard to keep a thing like a New World secret, after all, and it didn't take long for word of the New World's supposed infinitude to go viral, transforming this foreign land into a beacon of hope for millions of optimistic people. In no time, it was *the* place for displaced, disenfranchised people looking to build new lives. If immigrants are defined by running toward a new land, and emigrants by their escape from persecution, then these men and women were both: They fled religious persecution, war, and poverty while running toward the internationally renowned New World, the place where displaced, disenfranchised people could make a fresh start. Unlike Europe, where feudalism and monarchies held

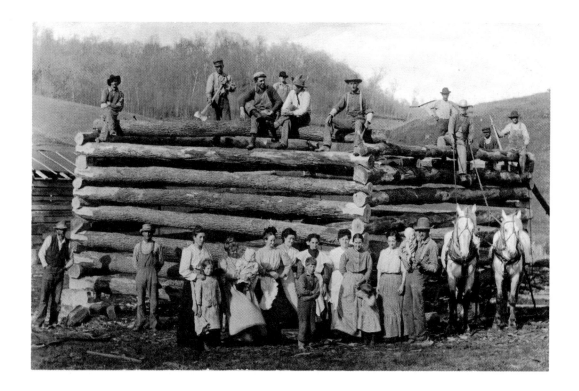

down the little guy, America offered anyone and everyone a reset, and the log cabin—free, efficient, and durable—was their in to this world of opportunity. The log cabin was democratic in this way, eventually becoming the living, breathing—okay, okay, dead and splintery—embodiment of the ideas that eventually inspired the Revolution.

First came the Germans. Apart from some notable examples, like Jamestown's Dr. Johannes Fleischer, there weren't many such people in the New World until 1683, when a dozen Quaker and Mennonite families founded Germanopolis, aka Germantown, Pennsylvania. This was the first trickle of what would become a full-blown torrent come 1710, when about 2,100 German people disembarked on American shores. Landing primarily in Pennsylvania, most of these folk were enticed by William Penn's calls for religious and social outcasts to settle his 45,000 acres of

IMAGE 2.1 Erecting log cabins was already an American tradition by the time this pioneering crew raised theirs around 1900. *(Vintage Images/Alamy Stock Photo)*

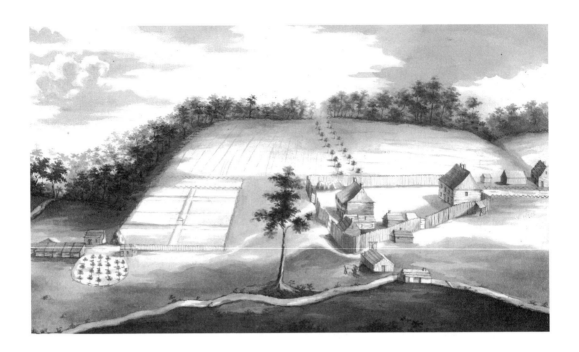

IMAGE 2.2 The prevalence of log cabins in this 1754 image of German-founded Bethabara, North Carolina, shows how essential the structure was to German immigrants, among others. *(The Moravian Archives, Herrnhut)*

pristine land, King Charles II's repayment of a family debt. Wave after successive wave of Germans flooded over, bringing their Pennsylvania-based population to 72,000 by 1747, and to about 100,000 by 1750, with the vast majority settling in log cabins, just as their ancestors had for centuries in the Black Forest and other wooded lands.[1] "They knew no other form of dwelling for people of modest means," writes Shurtleff.[2] And colonial records are rife with references to German log cabins, including forty German Palatine settlers' structures planted in 1723, near what is now Middleburgh, New York, and dozens of similar cabins that arose along the Susquehanna River between 1735 and 1736. (Among the Germans who most likely lived in a log cabin at this time was Johann Conrad Wolfley, President Obama's sixth great-grandfather, who settled in Lancaster County, Pennsylvania, in 1750. Don't be surprised if one day there's a "symbolic" log cabin in his honor.)

Single-minded in their determination to cultivate the land, Germans

IMAGE 2.3 Carl and Sophie Goth lived in this log cabin when they first emigrated to Wisconsin from Mecklenburg, Germany, in the early 1850s. *(From the collection of the Max Kade Institute, University of Wisconsin–Madison. Used with permission)*

cut trees, ripped out stumps, and cleared farmland as fast as could be, garnering a reputation for their "usefulness." Maryland lawyer Daniel Dulany[3] said in 1745 that Germans were "the best people who can be to settle a wilderness."[4] And later, in 1773, Maryland Royal Governor Robert Eden wrote: "[The Germans'] improvement of a Wilderness into well-stocked plantations . . . have raised in no small degree a spirit of emulation among the other inhabitants. . . . They are a most useful people."[5] So "useful" were the Germans that Thomas Jefferson later bandied about the idea of importing even more Germans to work alongside slaves in the struggling South. (This was just around the time, BTW, that President John Adams signed the new nation's first xenophobic, anti-immigration legislation, the 1798 Alien and Sedition Acts.[6])

Regardless where colonial-era Germans went, from Massachusetts to the Carolinas, there too was the log cabin, providing shelter and stability in the forbidding forests. Yet as productive as these Germans

were, and as important as their contribution was to the log cabin's place in American history, they would soon be lapped by a different set of immigrants, the Scots-Irish.

SCOTS-IRISH COPYCAT UNDERDOGS

The Scots-Irish never had much luck on the Emerald Isle. The dirt-poor descendants of Scottish people that were sent to Ireland in 1609 by King James IV, they suffered starvation, drought, and unfair taxes for generations. And yes, rest-assured, there was plenty of religious persecution among anti-Presbyterian Anglicans who ran the show. It was a real mess, and you can understand why they too jumped at the chance to head over to the storied land of plenty. It was really a no-brainer, and between 1717 and 1767 an estimated 200,000 Scots-Irish arrived, an influx, by the way, that sparked some of America's first anti-immigrant sentiments. "It looks as if Ireland is to send all its inhabitants hither," Pennsylvania provincial secretary James Logan remarked in 1729, after 5,600 Irish folk arrived in a year. "The common fear is that if they thus continue to come they will make themselves proprietors of the Province. It is strange that they thus crowd where they are not wanted."[7] Anti-immigrant sentiment is apparently a time-honored tradition here, in a place Massachusetts Bay leader John Winthrop and others—JFK and Reagan among them—have described as the "city upon a hill."[8]

In any event, the Scots-Irish should have delved into dugouts. Theoretically, at least. They were just like the Pilgrims, theoretically speaking: English subjects with no log cabin experience. Their hovels back home were mostly mud and clay, and a dugout wouldn't necessarily have been a step down. But, oppressed as they were by their overlords, they had no affinity for prevailing English customs, so instead of cowering in the ground and crying about it, like so many English still were—records show downtrodden Brits living in dugouts in Georgia as late as

1763—most Scots-Irish just copied Swedish, Finnish, and particularly German cabins.

Robert Parke's father put up a "log house" as soon as they arrived in Pennsylvania in 1725.[9] Ireland-born Robert Witherspoon remembers seeing dozens of log cabins as his family rode through Carolina's Scots-Irish lands in 1734: "Their little cabins were as filled that night as they could hold,"[10] he wrote. His family would soon settle in one just the same. And Virginia-based tutor Philip Fithian noted in 1775 that "all the houses are built with square log" in Scots-Irish-laden Abbottstown, Pennsylvania.[11] But those people are all "nobodies," right? Well, if you need some celebrities to make it more real, consider these tidbits: Scots-Irish President James Polk's ancestors called log cabins home in Pennsylvania and Tennessee in the 1720s; President Andrew Jackson's similarly Scots-Irish father Thomas built a comparable structure when he settled in North Carolina in 1765; and President James Buchanan's kin in Mercersburg, Pennsylvania, did, too.

These cabins weren't very tidy—F. A. Michaux noted in 1789 that these "carelessly" caulked cabins, "[gaps] filled with clay, so carelessly that light can be seen through in every part," were "exceedingly cold in winter . . ."[12]—but the Scots-Irish were a fecund people—they were the nation's third largest group by 1776, behind Englishmen and African slaves—and, being poorer than most, they invariably pushed farther into the forested frontier, where land was cheap or free, a one-two combo of mass and distance that made the Scots-Irish the most prolific contributors to the log cabin's early rise on the American horizon. "It was the Scotch-Irish who did most to popularize [the log cabin's] use," writes Morrison. "Penetrating to the frontier of Maine and New Hampshire, pushing westward across the Alleghenies and southward . . . the Scotch-Irish made the log cabin a symbol of the American pioneer."[13] Scattering the log cabin across the land this way and that, the Scots-Irish left an indelible mark on the American skyline—and language.

"LOG CABIN," AN ETYMOLOGY

The Scots-Irish, so low on the colonial totem pole, may have the impressive distinction of inventing "log cabin." The term, that is. The English colonial leaders of the early 1700s didn't even know the meaning. For them, "cabin" most often referred to something you slept in on a boat, or, if they were talking about a land-bound structure, "cabinn," "cabanes" or, more regularly "cabbin," meant a flimsy sleeping closet, a "temporary shelter of slight materials" used for hunters and which was sometimes called an "English wigwam."[14] It's this type of diaphanous structure that Sir Thomas Dale and Captain John Smith had in mind with their aforementioned references to "cabbins." Elsewhere, Englishman John Bartram's diary of his 1728 journey from Pennsylvania to Ontario employs similar usage: "It looking like rain, we made ourselves a cabbin of spruce bark."[15]

If referring to what we call "log cabins," most English speakers used the term "log hut" or "log house," while others referred to these homes as "cribb houses," as in Englishman Joshua Hempstead's 1747 diary entries about "Irish cribb houses" in Cecil County, Maryland, where the people's distinctive brogue hung thick in their air: "Here are mostly wooden houses in cribb fashion." And though he was a bit more descriptive in his mention of Nottingham, Maryland, he was no more impressed: "The minister & people here are very modist in their apparel & in their houses mostly Log houses Cribb fashion."[16]

But the Scots-Irish *did* have a specific "cabin" definition: "a dwelling infe-

IMAGE 2.4 A young Abraham Lincoln reading by firelight in his log cabin. (*Library of Congress*)

rior to a cottage, usually built of mud or fieldstone,"[17] and there's no reason why they wouldn't use the same word for a log structure, a theory buttressed by the slow integration of "log cabin" into official English after the group's arrival.

One early example comes from a 1749 Pennsylvania property record referring to Mary McGladen's "log house *or cabin*," a linguistic interposition seen again one year later, in colonial surveyor Richard Peters's remarks about finding squatters—William White, George Cahoon, David Hiddleston, and George and William Galloway[18]—living in "five cabbins or log houses" on Indian land: "Being asked by what Right or authority [the occupants] possessed themselves of those Lands and erected cabbins thereon, they replied by no Right or Authority but that the Land belonged to the Proprietaries of Pennsylvania."[19] The men didn't think they needed anyone's authorization. They were simply taking full advantage of the freedoms America afforded. But be that as it may, said Peters, relations with indigenous peoples were fraught, and the cabins would have to be destroyed to keep the peace, "The Cabbins or log houses which were burnt were of no considerable Value, being such as the Country People erect in a Day or two."[20]

Peters's remarks reveal two things: one, the log cabin we adore today was worthless to colonial-era Americans; and two, there was already widespread familiarity with the structure, so much so that it was being used in official records. And so it was again twenty years later, in 1770, when Virginia colonial authorities approved James McGavock's proposed "log cabinn" in Botetourt County.[21] This usage, the first time the compound "log cabin" appeared in American English, wasn't a "house" or a "hut." It was a "cabin"—straight from the bureaucrat's mouth. Though the extra 'n' would hang around for a few more decades, coming and going with the writer's whims and education, the log cabin was now officially a "thing." And it was becoming a distinctly American thing, at that.

MELTING POT

As uniform as cabins seem today, there was a time when immigrants' cabins were easily distinguished by distinctive ethnic markers. Swedish log cabins had dovetail notches with overlapping, protruding corners, and low, short doors that required serious crouching. "The doors are wide enough, but very low so that you have to stoop in entering," wrote Danckaerts.[22] Meanwhile, though the early German immigrants' doors were relatively normal-sized, they weren't without their own quirks: most were asymmetrically positioned, built either left or right of the structure's center. And, fastidious as always, the Germans made neat and tidy corners squared at the end, eliminating the unsightly bulges seen on their Scandinavian neighbors' abodes. As for the early Scots-Irish cabins? They were just messes. The Scots-Irish had no idea what they were doing when it came to notching, leaving vast chasms between logs, and they were equally clueless about chimneys. Where Swedes and Germans built their fireplaces into their homes—Swedes often in the corner and Germans in the center of the room—Scots-Irish folk tacked it onto the back, the last resort for ad hoc architects who had no previous experience, but a detail that would become widely popular as the years went on.

As time went on, and with so many people mixing, mingling, and marrying in places like the Carolinas and Georgia, and with others pouring into new territories like Ohio, ethnic demarcations faded away. Weslager writes, "When different ethnic or social groups are thrown into contact with each other, the unities that held each individual group together tend to dissolve and new patterns of common expression arise."[23] Second- and third-generation cabins became an amalgamation of cultures, each unique, like its occupants. Architectural choices like notches and chimney placement now depended on one's ability, not geographic background; "in this acculturation an American log cabin finally emerged."[24] One cabin may have a Swedish dovetail and a Ger-

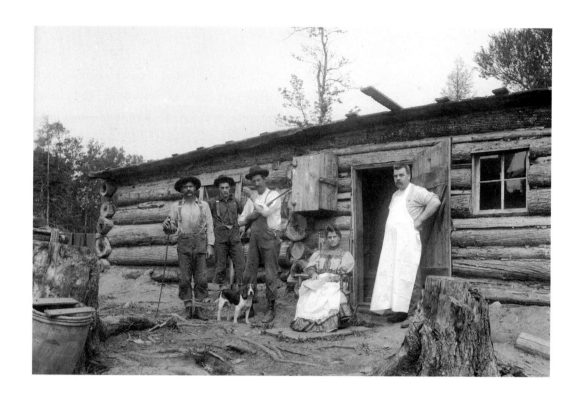

IMAGE 2.5 A motley crew in front of a cabin. The year is unknown but the all-American attitude is timeless. *(Wisconsin Historical Society, WHi-86352)*

man chimney, and another may display Finnish gables with a German offset door, but all were part of a larger architectural exchange that came from log cabin raisings' communal nature.

Sure, a single settler (or a couple) could and did erect a cabin in a day, maybe two, but it was far more common, and more fun, to do it as a group, especially in freshly founded settlements. "About forty people repaired to the spot; the songs, and merry stories, went round the woods," writes French-born J. Hector St. John de Crèvecoeur in his 1782 work *Letters from an American Farmer*, a "based on a true story" description of the typical log cabin raising in Pennsylvania. "Trees fell on all sides, bushes were cut up and heaped; and while many were thus employed, others with their teams hauled the big logs to the spot which Andrew had pitched upon for the erection of his new dwelling. We all

dined in the woods; in the afternoon the logs were placed with skids, and the usual contrivances: thus the rude house was raised, and above two acres of land cut up, cleared, and heaped."[25]

No money was exchanged, "nor would it be received," wrote Scottish naturalist John Bradbury in a similar anecdote jotted in 1809 or so. "[Helping] is considered the performance of a duty, and only lays him under the obligation to discharge the debt by doing the same to subsequent settlers."[26] Building a log cabin became a ritual, one passed from immigrant to immigrant. These new Americans traded ideas and styles, thus, "The log cabin became a syncrestistic American product, even thought its ancestry, like many other American institutions, lay in Europe."[27]

Once a Swedish novelty, the log cabin had within a few generations become the ubiquitous go-to for immigrants of all stripes, becoming a uniquely American structure in the process. It was the go-to homestead for villages and emerging towns from Maine to Georgia, speckling hills and valleys and offering tabula rasa up and down the coast. Pittsburgh was described in 1772 as "40 dwelling houses made of hewed logs."[27] The Scots-Irish settlement of Sunbury in central Pennsylvania circa 1775 consisted of about one hundred homes, ninety-nine percent of which were made of logs. And log cabins were so omnipresent by the Revolution that Joseph Doddridge, a Pennsylvanian of—gasp!—English stock, was seven before he first saw a stone building, during a 1776 road trip to Maryland. He noted in 1824: "The [Bedford] tavern at which my uncle put up was a stone house." And he could hardly believe his little eyes: "I had no idea there was any house in the world which was not built of logs . . . whether such things could be made by the hands of man, or had grown so of itself, I could not conjecture."[28]

Arriving by the boatload, these eager, budding Americans spread the log cabin far and wide, transforming it from a Scandinavian oddity into the quotidian American home. And, in turn, the log cabin shaped them, priming the pump for the coming revolution and making indi-

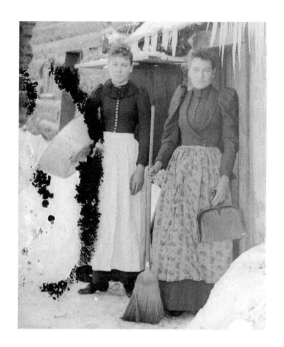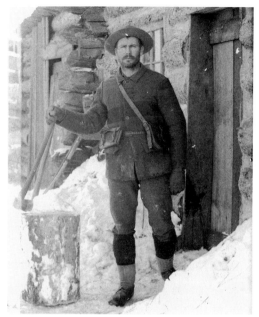

viduals out of the unwashed masses. The log cabin, erected anywhere men and women went in this new world, gave a ragtag group of immigrants and refugees the self-assurance to overthrow an unjust empire. As de Crèvecoeur wrote in 1782, the log cabin was one of the essential "progressive steps" that delivered the émigré-immigrant "from indigence to ease; from oppression to freedom; from obscurity . . . to some degree of consequence . . . by the gradual operation of sobriety, honesty, and emigration." We'll soon see that this Frenchman's soppy view of the log cabin was in the minority, drowned out by disdain and disrespect. But to the poor settlers who had relied on it, the log cabin was a ritualistic starter kit, one that unlocked a new life in the new world, turning immigrants into a "new man," one who "leave[s] behind all his ancient prejudices and manners" and "must therefore entertain new ideas, and form new opinions."[29] They were no longer just German and Scots-Irish immigrants.[30] They were Americans.

IMAGES 2.6–2.7 Only the hardiest of women and men could brave the log cabin, so far removed from civilized society. *(Wisconsin Historical Society, WHi-5776 and WHi-81388)*

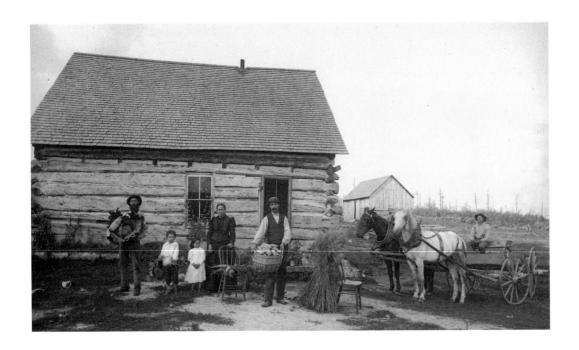

REALITY CHECK

Okay, let me hop off my soapbox for a second and acknowledge that colonial America was not all roses and rainbows. Nor was the log cabin a cure-all for the ills of the immigrant's experience. Scotsman Alexander MacAllister may have described the New World, specifically North Carolina, as "the best poor man's country" and implored his brother in 1736 to "advise all poor people . . . to take courage and come,"[31] but he was a successful landowner, an outlier among immigrants. Most new arrivals were greeted by much the same poverty they knew back home. And in addition to starvation, disease, and the occasional Indian attack on the borderlands, the log cabin's inhabitants had to contend with regional rivalries over land, cultural tensions, and self-segregations. One German minister in North Carolina

demanded "German blood and German language be preserved" by avoiding intercultural sexiness.[32]

And the log cabin itself rarely allowed easy living. In addition to elemental leakage and wind breaking through cracks, residents were no doubt outnumbered by bedbugs, fleas, hornets, termites, ants, and other creepy crawlies: "But o the fleas!" Philip Fithian griped in 1775 of log cabin sleepovers; "I rise spotted & purple like a Person in the Measles;"[33] and Minister and Yale president Timothy Dwight squawked, "They are of course the haunts, and the nurseries, of vermin in great number; subjected to speedy decay; gloomy to the sight; offensive to the smell; and unless continually repaired, are both cold, and leaky."[34] Nor were the one-room cabins, sometimes crowded with two or more families, particularly private.

Englishman William Faux's 1819 encounter with a newly arrived Englishman and his nephew paints a typical picture of the backwoods lifestyle so many revere today: "[Settlers] live in a little one-room miserable log-cabin, doing all the labour of the house and the land themselves, and without any female. We found them half-naked and in rags, busily greasing a cart, or mending a plough. They appeared only as labourers."[35] But Faux learned these were no ordinary laborers. It was the brother and nephew of a British parliamentarian, Henry Hunt, and soon: "good sense and breeding shone through the gloom of their forelorn situation."[36] And American minister John Mason Peck notes later, in 1836, "We have known a family of some opulence to reside for years in a cabin unfit for the abode of any human being, because they could not find time to build a house."[37] Everyone was equal within the log cabin's tight, bug-infested walls, even the otherwise upper crust.

Speaking of equality, let me be clear that not all of the immigrants who seeded our landscape had agency over their journeys. Countless were so desperate to come overseas that they voluntarily enlisted in periods of indentured servitude that could last from four to nine abuse-filled years, all so they could earn their freedom down the road. Other

IMAGES 2.9–2.10 Basil
Hall's camera lucida
captured the "bleak"
reality of log cabin
towns in 1818. "A
miserable log-hut is
the only symptom of
a man's residence," he
wrote. As we'll see,
he wasn't alone in this
anti-log attitude.[38]
(*Library of Congress*)

unfortunates were duped into coming over by tomes like the so-called
Golden Book: pro-colonial propaganda that promised transients eco-
nomic betterment but was really a ploy to entice poor folk into serf-
dom. And still more of America's first immigrants, mostly convicts,
prostitutes, and injured soldiers, were rounded up and forcibly shipped
overseas, part of England's mission to cleanse itself of so-called riffraff
and expendables.[38]

But while log cabin living wasn't free of strife, it *was* free of the
incessant psychological pressure of overlords and barons in Europe.
The bulk of colonial America's European residents came to the New
World to put poverty and/or oppression behind them, and the log
cabin made that possible. The log cabin was the occupant's own
piece of a new world. These people could work and live for them-
selves in atomizing log cabins. It was self-reliance in four walls, an
incubator for the liberty-loving spirit that sparked a revolution. The

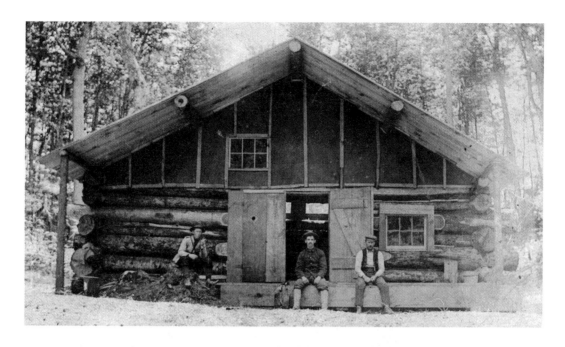

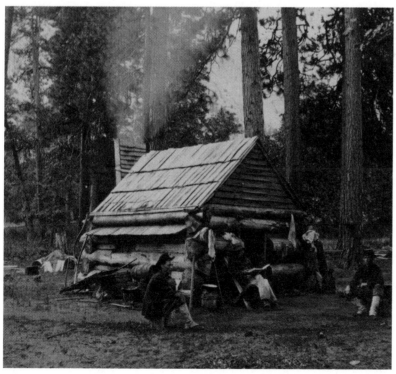

IMAGES 2.11–2.12 Up top we see some all-American Wisconsin men in front of their log cabin, circa 1890, and below there's James C. Lamon, the first settler in California's Yosemite Valley around 1870. *(Wisconsin Historical Society, WHi-3381, and Library of Congress)*

farmers, tradesmen, and settlers who made up the militias and Continental Army were thus already conditioned for independence by the time tea taxes, *Common Sense*, and the Declaration of Independence were arousing the colonists' revolutionary spirit. Self-determination had already saturated the zeitgeist, making the individual king of his personal kingdom. Having lived unbridled lives in log cabins, America's immigrants and sons and daughters of immigrants were more than ready to take up a united cause against the unjust crown. And so too was the log cabin: The Continental Army spent that bitter Valley Forge winter hunkered down in the ever-reliable, ever-present structure. It's in this light that the cabin shines the brightest. And it's in this version of the log cabin, as facilitator to personal deliverance, that we find the kernel of truth within the mass of lies we'll soon explore.

The log cabin would proliferate in this way for more than a century, charting new territories and leaving cities in its wake. Cheap and efficient, the log cabin was the vehicle of gentrification of the New World, appearing everywhere the white man dared to go (save for in the Great Plains, where there were no forests and settlers lived in hillside hovels similar to dugouts). The log cabin was there when Americans pushed the Western Reserve after the Revolution, and it popped up farther south as steamships delivered migrants up and down the Mississippi, too; the log cabin was esssential to settling what is now Michigan and Wisconsin in the early 1800s, and it sheltered early Houstonites soon after, too. And these cabins weren't just for domestic use. They were school houses, churches, taverns, and inns. British traveler Henry Bradshaw Fearon wrote of a "miserable log-house, or what you would call a dog-hole," that doubled as the Fountain Inn in 1817; "It was crowded with emigrants," he griped. William Faux found a tavern made of log around the same time and Cincinnati's elite Thomas Select School, like so many Midwest schools, started its life as a log cabin (that original 1810 cabin

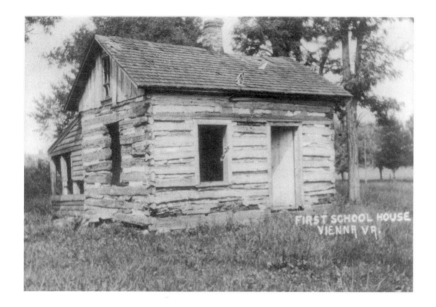

still stands today). Like Americans themselves, the log cabin is adaptable and enduring.[39]

At first, the log cabin served as an unofficial claim to the land. It was basically the marking of one's territory, a so-called "tomahawk right."[40] Orsamus Turner wrote in 1850, "By a law of Pennsylvania, such as built a [sic] log house, and cleared a few acres of land, [one] acquired a pre-emptive right; the right of purchase, at £5 per one hundred acres."[41] In time, though, the cabin-as-claim was instutionalized, embedded in laws like Indiana's "log cabin bill" (the Preemption Act of 1841), allowing settlers to take up to 320 acres on credit per the condition that they "cultivate" it and "raise a log-cabin thereon."[42] The US government passed a similar bill that year but ended up dropping the "log cabin" language, replacing it with "dwelling." Regardless, the log cabin was at the forefront in those heady days of Manifest Destiny, when white America hurled itself westward, certain that God

IMAGE 2.13 A log cabin schoolhouse in Virginia stood the test of time. *(Library of Congress)*

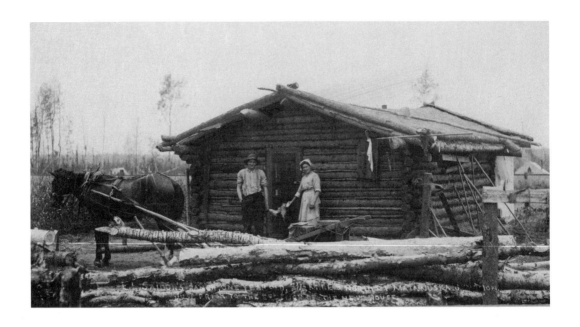

granted them ascendancy over the land and the other humans therein. Soon the log cabin fostered California dreams, providing safe havens for audacious explorers like Hale Tharp, the first white man to settle amidst the ancient sequoia trees, in 1856.

We'll later see that the cabin played a similar role well into the twentieth century, when displaced, Depression-struck farmers from Minnesota and Wisconsin relocated to far-off Alaska, then still a territory. Though the cabin's form changed between times and places—two cabins were sometimes turned into one via dogtrots; Southerners eschewed chinking to improve air flow; and Rocky Mountaineers of the 1880s added oversized awnings for easier indoor/outdoor living—the log cabin's content always stayed the same. No matter what lay over the horizon, it was an affordable and dependable passport to distinctly American freedom, a break from the rules, regulation, and/or monotony of urban life. The log cabin let one chart their own destiny, let them embark on a new beginning. This is the cabin helping

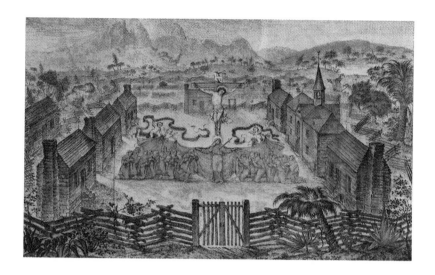

generations of Americans build a new country. This is the log cabin creating change. Adaptable and resilient, liberated and self-reliant, the log cabin in this isolated context embodied American ideals and traits before the States even existed. It was a durable house for resourceful people. And it was democratic. Anyone, rich or poor, could start anew in woods that would become towns that would become cities like Pittsburgh, future epicenter for the nation's steel industry.

This is of course easy to say now, in the twenty-first century, with twenty-twenty hindsight, but to colonists and early Americans, even the people who lived in them, the log cabin was nothing special. It wasn't yet romantic and it surely wasn't getting a whole lotta likes, if it got any kind of attention at all. It was a temporary, interim house meant to be abandoned ASAP, lest the occupants be damned to the lower rungs of society forever—or, as some feared, damned for all eternity . . . in Hell.

IMAGE 2.15 French and Belgian Catholics found their own slice of heaven in Loretto, Kentucky, where in 1815 Courtois of Malines drew this unsettling image of a dying Jesus encircled by log cabins. It's one of the few images from this era in which the cabin isn't depicted as dreary, rude, or miserable. But that was all about to change. *(The Cox Collection, Richmond, Kentucky, courtesy of the Kentucky Online Arts Resource)*

·3·

FOUNDING FATHERS
THROWING SHADE

F THERE'S ONE constant in this ever-changing world, it's this: haters gonna hate. It's true today, and it was true in 1783, at the end of the Revolution. Sure, the Founding Fathers talked a big game about equality, but they and their one-percent peers also believed only landowning, educated white men should write the rules. Everyone else should just follow. Alexander Hamilton makes for a great Broadway muse, but the late Treasury Secretary also said that government must be run by "landholders, merchants, and men of the learned professions,"[1] the class who knew better than the ignorant, "turbulent" common folk who "seldom judge or determine right. . . . Give, therefore, to the first class a distinct, permanent share in the government. They will check the unsteadiness of the second."[2]

You can therefore bet your bottom dollar that the elitist Founding Fathers were pretty highfalutin about the common people they claimed to represent, especially those unwashed masses in the log cabin. The Founding Fathers and

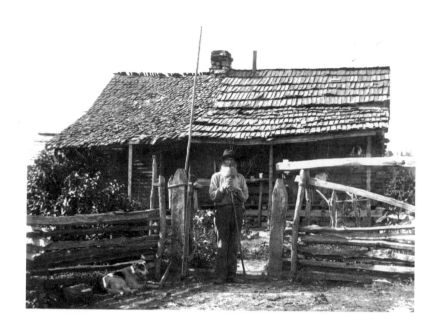

their friends didn't think the cabin dweller was a heroic pioneer. On the contrary. He was a imbecilic yokel in the "backcountry," a quagmire where people deviated from Christianity and common sense. He was a white savage and a deviant. He was a low-class, no-good squatter. He just did his thing, with no regard for law or reason or society at large. And his digs were just as crummy: they were the "rudiments" of a house, one typically preceded by words like "miserable," "wretched," and "grotesque." Benjamin Franklin described cabin dwellers in 1766 as basically itinerant "hunters who added little value to humanity."[3] And later, in 1780, the so-called "Prophet of Tolerance" told his grandson that there are "two sorts of people": "Those who are well dress'd and live comfortably in good houses, whose conversation is sensible and instructive, and who are respected for their virtue." And then there are the others: "The other sort are poor, and dirty, and ragged and ignorant, and vicious, and live in miserable cabins." These degenerates spent

IMAGE 3.1 The Founding Fathers would definitely pooh-pooh John Wesley Bruce and his Arkansas cabin, seen here in the early twentieth century. Aside from fashion, not much has changed since the 1700s. *(Central Arkansas Library)*

IMAGE 3.2 The photo of this creeptastic cabin, snapped around 1900, gives you a good idea of why early Americans were so wary of the log cabin. *(Library of Congress)*

their formative years "idle" and "wicked," "and now they suffer."[4] And Franklin was one of the nice ones.

Dr. Benjamin Rush, a lesser-known Declaration of Independence signatory who also served as surgeon general for the Continental Army, was far more biting in 1787, when he wrote that the first squatter is "generally a man who has out-lived his credit or fortune in the cultivated parts. . . . His first object is to build a small cabbin of rough logs for himself and his family."[5] But, despite this apparent domesticity, this man is still shiftless and anti-social, brazenly rejecting civilization and order: "He cannot bear to surrender up a single natural right for all the benefits of government, and therefore he abandons his little settlement, and seeks a retreat in the woods"[6] whenever new neighbors move in. Such folk, with manners "nearly related to the Indians," were so uncivilized, said Rush, that they teetered dangerously close to being anti-Christian:[7] "It has been remarked, that the flight of this class of

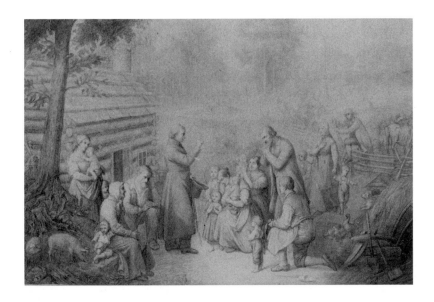

people is always increased by the preaching of the gospel. This will not surprise us when we consider how opposite its precepts are to their licentious manner of living."[8]

Dr. Rush wasn't alone in seeing sulfur and brimstone where there was log and daub. Reverend Charles Woodmason was repulsed by log cabin-living Carolinians, fuming in 1766, "The people around, of abandon'd morals, and profligate principles—Rude—Ignorant—Void of Manners, Education or Good Breeding—No genteel or Polite Person among them."[9] Another minister, aforementioned Yale president Dwight, was so overwrought that he warned log cabins could pervert a man's mortal soul. "The habitation has not a little influence on the mode of the living; and the mode of living sensibly affects the taste, the manners, and even the morals, of the inhabitants," he wrote of "log-houses" in 1798, in the midst of the Second Great Awakening. He continued, "If a poor man builds a poor house, without any design, or hope, of possessing a better, he will either originally, or within

IMAGE 3.3 One of the greatest ironies of the log cabin's American history is that the cabin Founding Fathers libeled as "licentious" would be the frontline for frontier proselytizing and worship, as seen in this image of Father Edward Fenwick blessing Catholics in Ohio in 1808. *(Library of Congress)*

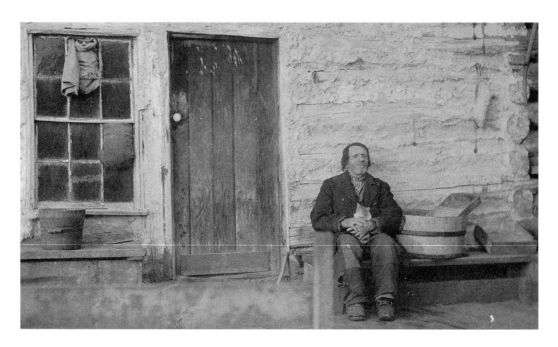

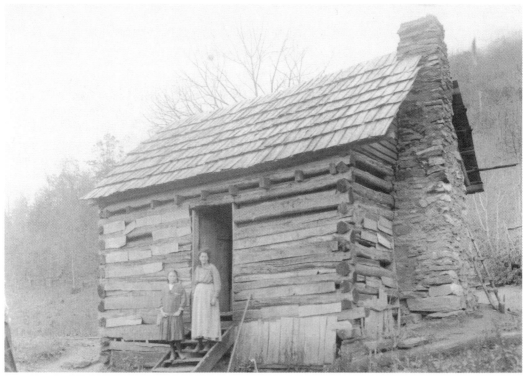

a short time, conform his aims, and expectations, to the style of his house. . . . The thoughts, and conduct of the family will be reduced to a humble level, and a general aspect of lowliness, and littleness, will be seen on whatever they contrive, or do."[10] "They appear not merely contented and unambitious, but unacquainted with the objects which excite ambition," Dwight wrote of back-settlers in upstate New York. "Life to them does not glide; it is stagnant."[11]

And, yes, even Thomas Jefferson, the "Man of the People" who preferred ploughmen to professors ("State a moral case to a plough-man & a professor. The former will decide it as well, & often better than the latter, because he has not been led astray by artificial rules."[12]), even *he* took part in denigrating the off-the-grid yokel and their "pens": "The poorest people build huts of logs, laid horizontally in *pens* [emphasis mine],"[13] the architect-statesman wrote in 1801.[14] And its inhabitants were equally animalistic. Actually, scratch that: They were less than animals. They were rubbish. Writing about his plan to recruit teachers for universal education, Jefferson dismissed wide swaths of the American public: "The best geniuses will be raked from the rubbish annually, and be instructed at the public expense."[15] There were a few diamonds in the rough backwoods, but the rest, the run-off, muck-level people, were interchangeable expendables. They were merely squatters, bums who sat on land, doing little to better themselves or society.

But trash or not, these people weren't *completely* worthless. They paved the way for the forthcoming squadron of immigrant settlers, productive farmers whose cabins are given a free pass for their crude attempts at civilization. They are accepted as a stepping stone, but nothing else. According to German historian Gottfried Achenwall's retelling of Franklin's explanation, the process goes like this: The icky hunter finds a tract of unclaimed land, builds a "cabin,"[16] and "lays out now a small garden and field, as much as he needs for himself and his family."[17] After accomplishing this elementary cultiva-

OPPOSITE

IMAGES 3.4–3.5
Benjamin Franklin would have never invited this man and his kitty to Independence Hall, nor would he be inclined to host this woman and her daughter. *(Wisconsin Historical Society and Photography Collection, The New York Public Library)*

tion, he then ekes out a miserable existence until the masses come calling, eager to gentrify the land in civilization's image. "Some years after this first cultivation, poor Scots or Irish come, who seek a place to settle. This they find in this half-improved condition. . . . [The first inhabitant's] place was only temporary, and he moves further on, builds himself a new cabin, and cultivates another piece of land."[18] Dr. Rush seconded this emotion, noting, "The small improvements he leaves behind him, generally make it an object of immediate demand to a second species of settler,"[19] that is, the more desirable tenants—"men of some property"—who clear greater amounts of underbrush and generally tidy the place up, prepping for civilization proper. And the first step to that end is replacing the squatter's cabin: "The first object of this [new] settler is to build an addition to his Cabbin," that is, building a proper house around the bark-covered monstrosity.[20] And even Dwight, the Bible-thumping Yale president who disparaged the remote cabin's squatter as "idle" and "shiftless" and as incapable of living in "regular society," confessed: "The business of these persons is no other than to cut down trees, build log-houses, lay open forested grounds to cultivation, and prepare the way for those who come after them."[21] And so the dejected, disrespected squatter is forced to move on, like when poor Bushwick residents are pushed out by hipsters and Whole Foods, forced to find cheaper, more isolated lands. His patch of freedom has been gentrified.

WHO ARE US?

There were a number of reasons why early Americans hated the log cabin so hard. One was, of course, run-of-the-mill classism. Looking down on the disorderly cabin allowed the prim, proper elite to feel superior. The cabin acted as an architectural scarlet letter, as a con-

AN EXCEPTIONAL CASE

Illustrious frontiersman Daniel Boone found fame and respect after John Filson cast him as the hero in his 1784 work *The Discovery, Settlement and Present State of Kentucke*, sure, but this unlikely folk hero's and his neighbor's houses were nonetheless described as "not extraordinary good houses, as usual in a newly settled country."[22]

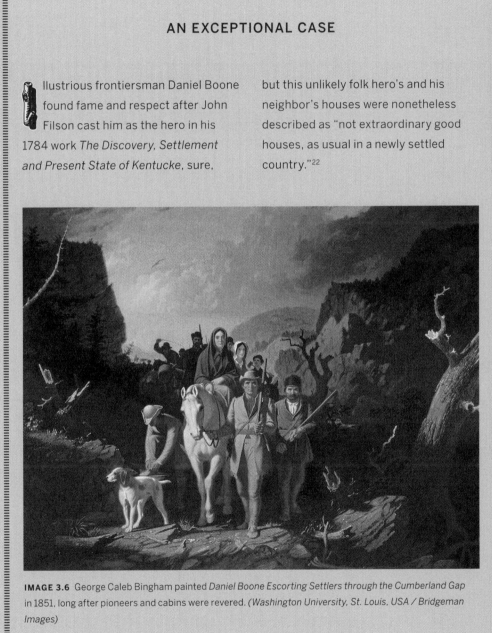

IMAGE 3.6 George Caleb Bingham painted *Daniel Boone Escorting Settlers through the Cumberland Gap* in 1851, long after pioneers and cabins were revered. *(Washington University, St. Louis, USA / Bridgeman Images)*

IMAGE 3.7 The young
nation was just opening
the door to a new
reality post-1776.
(Wisconsin Historical
Society, WHi-63410)

venient visual indication of who's in and who's out. Log cabins "were
outward signs of inferior character; they were unpolished, unambi-
tious, and simple." And, not to mention, "vulgar."[23] Harvard-based
minister Thaddeus Mason Harris was absolutely sickened by the
"rough and savage manners" of Virginia's "degrading" and "igno-
rant" settlers, the polar opposite of the more "intelligent, industrious
and thriving" folk over in Ohio. "[There] the buildings are neat,"
Mason wrote in 1803, contrasting them with the "miserable cabins"
of Virginia's "back-skirts."[24] #hater.

This status-focused distaste for the cabin and its inhabitants is
indicative of our nation's complicated relationship with the poor: They
stand in stark contrast to the American ideal, the myth of opportu-
nity and hard work, thereby eliciting revulsion, but at the same time
this well of cheap, "ignorant" labor provides a perverted ego boost,
a hardy "at least I'm better than them." Consider, for instance, the
poor-shaming in an 1810 letter sent by Scottish-American poet Alex-

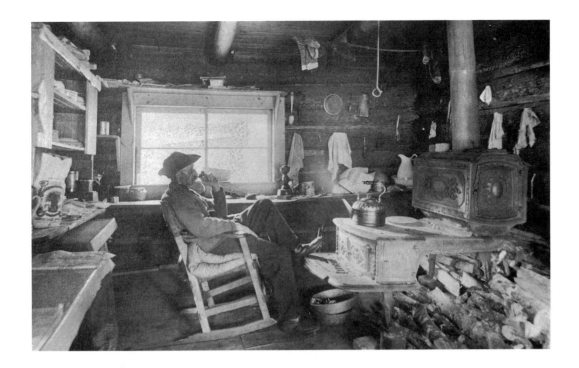

IMAGE 3.8 We beat the British, but the US still had some serious thinking to do. *(The Adirondack Museum)*

ander Wilson. Referring to the "grotesque cabin" and its inhabitants, those "immediate successors of savages," Wilson scoffs: "Nothing adds more to the savage grandeur and the picturesque effect of the scenery along the Ohio, than these miserable huts of human beings lurking at the bottom of a gigantic growth of timber." The sarcasm is strong with this one: "It is truly amusing to observe how dear and how familiar habit has rendered those privations, which must have been first the offspring of necessity."[25] Wilson's sneers against the log cabin are no different from contemporary Americans who smack-talk trailer parks and the so-called "trash" who live within. Log cabins, now an American icon, were the double-wide trailers of those early days.

But, as ever, there's more to the story behind all this anti-log-cabin antipathy, something deeper and more complicated than just station and class: post-colonial self-consciousness.

99 PROBLEMS, AND THEN SOME

As spectacular as the American Revolution was—a collection of colonies winning a ballsy war against an established empire really is incredible—it was no magic wand, and early Americans still had a lot going on in those years. There were still political tensions over the Constitution and the Bill of Rights. There was the threat of Spanish incursion, a need for infrastructure to support an ever-expanding population—roughly a quarter of Americans left the centralized eastern seaboard after the revolution, dispatching to new outposts in the lush Western Reserve, Maine's ever-fresh Northern woods, and the rolling Southern hills—and then there was that vexing matter of creating a viable economy in a competitive international market, a task that first required resolving $80 million in debt and, you know, creating a currency. And, as if that wasn't stressful enough, the colonies-cum-states were undergoing a serious identity crisis, wondering en masse, "Who are we? What are we about?"

Where once there were British outposts, there now stood independent states united in a radically uncharted course. They wanted to create something new, sure, but their cultural norms and expectations were still firmly influenced by their British roots, especially among the elite powers-that-be who still used Europe as a litmus test, a test that ranked the log cabin as decidedly basic. The new nation's very *raison d'être* dismissed the classist Kingdom as archaic, yet so many still sought to emulate it, creating a cognitive dissonance[26] in which "the Old World [is] both a negative and positive point of reference."[27] America's ruling class thus needed to strike a balance between their idealized "refined society" with the "vulgar populist and provincial values" of the common man.[28]

IT'S ONLY TEMPORARY

But classism, post-colonialism, materialism, and all those other-isms aside, the single most important reason late-eighteenth and early-nineteenth century Americans didn't revere the log cabin was because it wasn't meant to be revered. To be revered it would have to remain, and no one wanted the log cabin to remain. The log cabin was by-and-large an interstitial abode meant to be abandoned when better accommodations could be afforded. The structure would then be dismantled for firewood, converted into a barn or corncrib, or simply left to rot. The cabin of this era was a blight. Dr. Rush noted that the log cabin "generally lasts the lifetime of the first settler . . . and hence, they have a saying, that 'a son should always begin his

IMAGE 3.9 The dilapidated cabin above gives you a sense of what was meant to happen to log cabins back in the day— nothing. *(Wisconsin Historical Society, WHi-66543)*

improvements where his father left off,' that is by building a large and convenient stone house."[29] It was something replaced, not something to be cherished.

Log structures were, as Dwight said in 1798, "universally intended to be a temporary habitation, a mere retreat from the weather, till the proprietor shall be able to build a better." He went on, echoing de Crèvecoeur's comments on "progressive steps," "Such a building [is] a comfortable shelter for the family at the present time . . . as a step, and a short one, towards their future convenience, and prosperity."[30] Even the Swedes and Finns who first brought the log cabin to the New World had loftier architectural ambitions. "Respectable families [once] lived in low log- houses," Swedish pastor Israel Acrelius said in 1750, "Now they erect painted houses of stone and brick in the country."[31]

And botanist Kalm referenced wealthy Swede Andrew Rambo living in a two-story stone house during a 1748 journey through Pennsylvania.[32] The log cabin was fine as a launching pad for a new life, but it was expected to be replaced by what people called an "end house" as soon as humanly possible. And, if it couldn't be, the least you could do was cover the logs with clapboard and plaster the interior, to give the structure a more finished appearance. Though Dwight says the earliest cabins "increase [lands'] cheerfulness" for the prospect of cultivation and improvement, the idea of permanence instantly renders them grotesque: "[When] designed for a lasting residence, the cheerfulness vanishes at once."[33]

This doesn't mean *all* log structures were temporary. Some thrifty settlers brought their cabins along when they moved, deconstructing

IMAGE 3.11 Albert Bierstadt later glorified the ad hoc expansion of log cabins in this late-nineteenth century painting, an indication of cultural changes to come. *(Private Collection / Photo © Christie's Images / Bridgeman Images)*

LUCY SMITH

One short but telling story of the cabin's exclusionary stigma, and the compulsion to escape it, comes from an 1817 diary entry from Lucy Mack Smith, mother of Mormon founder Joseph Smith. Having recently moved to and built a log cabin in Palmyra, New York, Smith was invited for tea at a wealthier woman's house, a neat and relatively great home. Things started off well enough: The women, mostly wives of wealthy merchants, as well as a pastor's wife, exchanged personal stories and pleasantries, and Lucy appeared to be making friends. But the situation soon took a nasty turn when one of the women, awkwardly trying to praise their guest, took aim at Lucy's lowly abode: "Well I declare [Lucy] ought not to live in that log house of hers any longer; she deserves a better fate and I say she must have a new house." Lucy Smith laid into the women. Their lifestyles were built on the backs of the poor, she said: "[Our home] has not been obtained at the expense of the comfort of any human

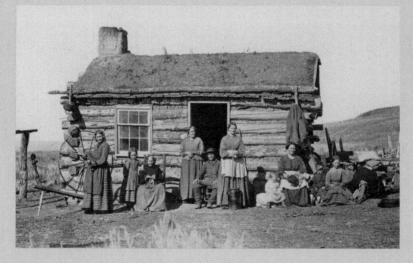

IMAGE 3.12 Like all Americans, Mormons relied on log cabins as they ventured out west. Lucy Smith ended up dying in one. *(Photography Collection, The New York Public Library)*

being"—and she reminded the minister's wife about her hubby's gambling habit. Nevertheless, Lucy self-consciously noted in her diary immediately after that she and her family were still "[making] preparations for a building a house." And they were: The family was hard at work on a fine house to keep up with the rhetorical Joneses, a race that eventually landed them in debt, costing them everything.[34]

and reconstructing them as they migrated west. And we'll see others used the squatter's cabin as the base for a better house, laying wood floors and building a more commodious abode around it. Yet others added their discarded cabins to their property's holdings, as seen in a June 1, 1767, *Pennsylvania Gazette* real estate listing for four hundred acres of Virginian land that included the original "log dwelling house." The family, one can assume, had made it big.

At this point in history, the log cabin's just a bug-ridden hovel of a strange, possibly anti-Christian nomad, and its odds of becoming an icon are looking pretty slim. It may have been an indispensible hero in the nation's birth, but it was unsung indeed. Isn't it ironic (don't you think?) that the log cabin deified in our national myth was once denigrated and disrespected like trailers are today? Of course, Jefferson, Franklin, and their friends had no idea that cabins would birth some of this nation's greatest leaders (and, as we'll see, some not-so-great ones, too). Even less did these elitists know that the log cabin's public image was about to be flipped on its roof, and that it would be done by that realm of the rich and cultured, the arts.

HARD NOTCH

The Log Cabin as Colonization

"My people cannot live independent of the
English. . . . Every necessary of life we have
from the white people."

—CHEROKEE CHIEF SKIAGUNSTA, 1745[1]

THERE WERE HUNDREDS of individual Indian nations in the
States prior to the European arrival, all with varying cultures and architectural traditions. The Algonquin of Carolina lived in rectangular, circular, and conical wigwams made of saplings and bark; the Cherokee of the southeastern states settled in domed mud huts in the winter and resided in squarer, airier homes in the summer months, to name just two. None of these Native American traditions, however, involved log cabins. There are colonial notations of Indian "cabins," but these refer to structures akin to the flimsy, bark-and-sapling hunter's cabins seen earlier. And while there is evidence that Indians used log forts,[2] and some used logs for fencing, American Indians, specifically the Lenape nation, didn't encounter the log *cabin* until the Swedes and the Finns came ashore. Other natives nations would be given similar exposure as more Europeans

penetrated their lands, like the squatters whose cabins Richard Peters' destroyed in Pennsylvania. In this sort of situaton, the log cabin wasn't a vehicle of freedom or one of de Crèvecoeur's progressive steps. It was a harbinger of destruction and dislocation. It was the first wave in an alien invasion.

Some tribes adopted the log cabin later, after as their land was taken away and their game trails were decimated—just as they adopted gun powder, metal tools, and, in some cases, slavery. A significant upgrade on their comparatively beta way of life, the log cabin was, as ever, a dependable and economic abode. It was in log cabins that Miami, Mohawk, and Wyandot tribes sheltered in Logstown, Pennsylvania, where the French helped them erect 30 cabins in 1747: a bribe for support in an upcoming war against the British over the fur trade. And George Croghan, an Irish-born immigrant-turned-fur-

IMAGE HN.1 Explorer William Clark giving Chief Skamokawa a ribbon. (*Washington State Historical Society / Art Resource, NY*)

mogul created an entire network of log cabins for Indian colleagues along Ohio's Miami River.[3] Colonial translator and peacekeeper Conrad Weiser noted in 1754 that Croghan's outpost in Heidelberg, Pennsylvania, had "above twenty cabins . . . and in them at least two hundred Indians, men, women and children, and a great many more are scattered thereabouts."[4] While Weiser doesn't specifically call these structures "log cabins," he does distinguish them from rickety hovels he called "hunter's cabins," so in all likelihood they were indeed of the log variety.

Meanwhile, about 150 miles east, colonial authorities built ten cabins for Delaware leader Teedyuscung and his people in 1758, a way to build rapport ahead of another skirmish against the French. The English wouldn't live in cabins themselves, no, but they were good enough bargaining chips for heathen tribes they ultimately didn't care about. And later, in the 1780s, Moravian missionaries showed Ohio's Shawnee and Delaware people how to build "neat log houses,"[5] part of an effort to "civilize" the "savages." But even the tightest log cabins weren't enough to save the displaced Indians from hatred and bigotry: In 1792, after forcing converted Indians off their land and interning them in a log cabin village, unimaginatively called "Captive Town," a hateful militia descended upon them, murdering 96 Christian Lenape people.

The log cabin vis-à-vis American Indians became even more of a tool of assimilation as the nineteenth century dawned, when the government worked toward what George Washington called "durable tranquility"[6] with native nations. The government would "attach [Indians] firmly to the United States,"[7] bringing them into the cultural fold by replacing their customs and traditions with the American way, including log cabins, passing them down to generation after generation of American Indians wherever and whenever possible. But where the log cabin helped white settlers *escape* institutions, in this context the log cabin was an institution, and a corrosive one at that. It ate away

at and then supplanted preexisting traditions. This is the log cabin as cultural toxin, and it would only get more virulent.

Between 1831 and 1842, the US government relocated just under 60,000 Indian people from the South and transplanted them to freshly christened "Indian territory" in Oklahoma.[8] To President Andrew Jackson and his men, the architects of the forced removals, this was a glorious sight: the ethnic cleansing of the East. To others, it was a horror show. Or, as Private John G. Burnett later wrote, "The trail of the exiles was a trail of death."[9] Writing in 1835, just before he was evicted from his log cabin in Georgia, Cherokee Chief John Ross wrote that the removals "denationalized" his people. "We are disfranchised. We are deprived of membership in the human family! We have neither land nor home, nor resting place that can be called

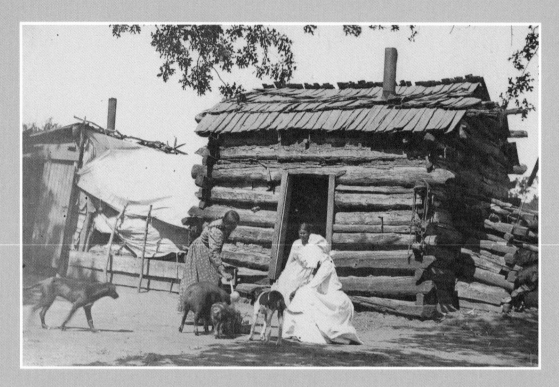

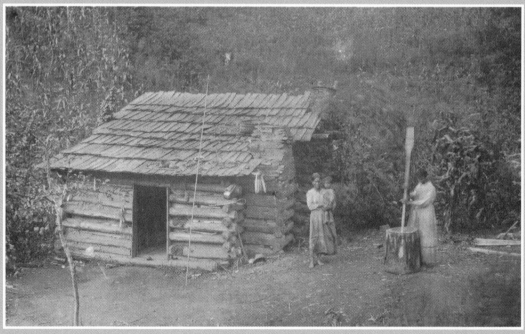

our own. . . . We are overwhelmed! Our hearts are sickened."[10] It was disgusting.

Cholera and starvation ran rampant along the trail that led to the newly invented "Indian Territory," and by the end of it at least 8,000, and possibly as many as 16,000, were dead, 4,000 from among Ross's Cherokee tribe alone. The displaced people who survived subsequently set up shop in log cabins like they had back home, but there was no mistaking these structures as a gesture of cross-cultural cooperation, as a way to fit in. It was simply the way of life in a land overtaken by an invading force.

Oh, and in an ironic and telling twist to all of this—that site where Richard Peters burned the cabins to appease Indian leaders? It came to be called Burnt Cabins, and today it's an unincorporated town in Pennsylvania. Look for it next time you're on US Route 522. The highway bisects it.

OPPOSITE

IMAGE HN.3 Delaware Lenape Indians outside their Oklahoma cabin, around 1897. *(Wisconsin Historical Society, WHi-28185)*

IMAGE HN.4 Cherokee women outside their North Carolina cabin, sometime between 1860 and 1920. *(Photography Collection, The New York Public Library / Art Resource, NY)*

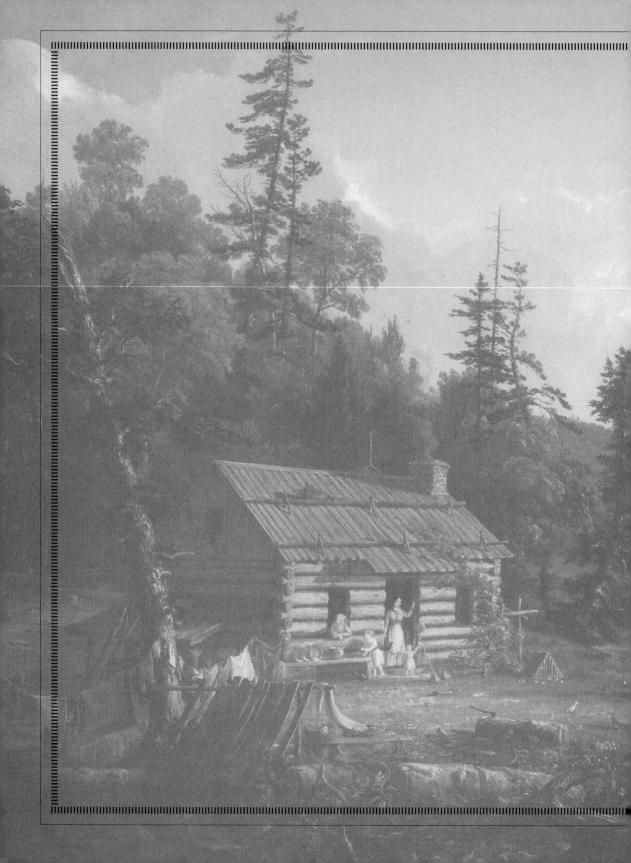

MYTH-MAKING (AND SELLING)

IMAGE 4.1 Thomas Cole's 1826 work, *Daniel Boone Sitting at the Door of His Cabin on the Great Osage Lake, Kentucky*, went a long way in revamping the log cabin's public image. *(Mead Art Museum, Amherst College, MA)*

· 4 ·

THE CABIN AS MUSE

IT'S JULY 17, 1841, and Thomas Cole is one of the most famous, sought-after artists in the world. But instead of jumping for joy, Cole's down in the dumps, feeling lower than the lowest English dugout. You know how artists are: all emo and junk.

"I am not the painter I should have been had there been a higher taste," he kvetched to his diary that July night. "Instead of working according to the dictates of feeling and imagination, I have painted to please others in order to exist." Had life been a bit different, had Cole been a little wealthier, he would have created works that "followed out principles of beauty and sublimity." Alas, "the result would not have been marketable."[1]

But Cole himself was instrumental in making that market. His glorious landscapes of unparalleled horizons and optimistic scenes of America unfurling fed off of and into the neophyte nation's fledgling sense of self, and that's particularly true of the painting here, *Daniel Boone Sitting at the Door of His Cabin on the Great Osage Lake, Kentucky*. The first serious piece of art to elevate the cabin and the woodsman within

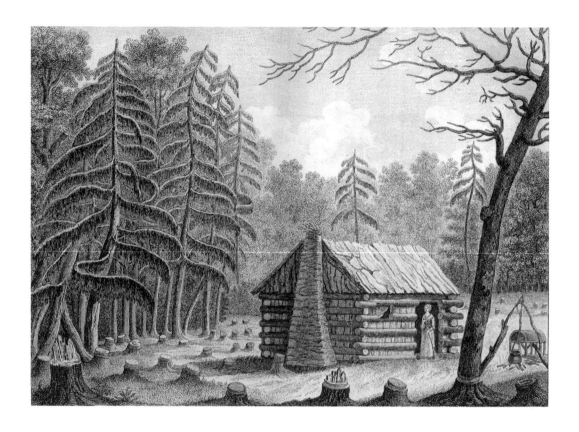

to such splendid visual heights, Cole's 1826 work helped solidify a still-fluid American identity.

There had been no true American arts scene in the post-Revolution years—no national self-expression, no native-born art star or literary sensation to get the public atwitter. England still dominated in terms of arts and letters, just as it did economics, and, again, everyday Americans had more pressing tasks than painting and penning, like making sure they had food to eat and roofs over their heads. Things like that. It wouldn't be until the early nineteenth century that pragmatic matters fell into place, allowing Americans the time to create their own cultural output. And, most import-

ant, they finally had the inclination to do so. With some chronological and psychological distance between them and Revolution, as well as with a whole other war under their belt—more on that in a moment—Americans, increasingly curious about their collective past and present,[2] were finally able to stop and reflect on themselves—and they liked what they saw.

Unencumbered by an infantile attachment to Mother England or European forefathers, the States at this point, 1800–1860 or so, are going through the national version of puberty. They're growing more impressed with themselves by the decade, and this self-pride starts to rub off on the log cabin and its rugged inhabitants. The cabin here becomes a stand-in for national progress and expansion, while the cabin-dweller, formerly a disdained squatter, grows into a mighty hero. And it was in large part thanks to Cole and his artsy-fartsy friends.

IMAGE 4.3 Allen Gaylord's 1800 sketch of Cleveland shows the Ohio town as just a smattering of log cabins. And, as in Collot's sketch, the cabin's flat and uninspiring. The romance was yet to come. *(Western Reserve Historical Society, Cleveland, Ohio)*

CH-CH-CHANGES

Just as classism and self-consciousness contributed to the founding generation's log cabin hate, so too did a confluence of factors awaken America's self-love. Economically speaking, the cotton gin and textile mills of the 1790s matured American manufacturing, turning an artisan market into a more massive, more mechanized affair, thus severing the nation's dependence on British goods and weaving "made in America" satisfaction.[3] And population shifts played a part, too. Immigration had slowed after the revolution, but our homegrown population was busy busy busy, growing from 2,780,400 in 1780[4] to 3,929,214 in 1790[5] and adding another few million by 1800, when the population was a whopping 5,308,483.[6] By 1820, after a new wave of immigration, the population was almost 10 million. Eager for fresh opportunities in untapped lands, Americans old and new pushed faster and farther than ever, turning footpaths and haphazard wagon routes into well-trod roads as they established hundreds of log cabin towns and hamlets in previously verboten areas like Ohio, Kentucky, Wisconsin, Mississippi, and Tennessee. "Almost every house in the whole settlement was built of logs,"[7] J. F. D. Smyth said of Kentucky in 1784, and Thomas Dillon found nothing but log cabins in Tennessee in 1796: "The truth is, that there are no Buildings in this State, a very few excepted but log cabins."[8]

Where settlement before the 1780s "had been an additive process that in most instances had nibbled off bits of 'wild' land and slowly ingested then into the colonial domain,"[9] Americans now swallowed entire swaths whole. Louisiana was purchased in 1803 and Lewis and Clark went out exploring the next year, sending back reports of rapturous wonders that captured the nation's imagination. On a similar note, eight new states were added to the Union between 1801 and 1821, and by 1828 Americans were moving so often and so far that one Bostonian noted, "There is more travelling in the United

States than in any part of the world." "Here, the whole population is in motion," unlike in the Old World, where "there are millions who have never been beyond the south of the parish bell."[10] And no matter where they went, there was the log cabin. Frenchman Alexis de Tocqueville, reflecting on his time in still-untamed upstate New York, remarked in 1831, "It is more difficult than one might think these days to come across the wilderness."[11] No matter where one treads, everywhere is the sound of the axe and other signs of man's arrival: the log cabin. Yet despite its ramshackle, "wretched"[12] appearance—"Like the field which surrounds it, this rustic property shows evidence of recent and hurried work."[13]—the cabin was an "oasis"[14] in the wilderness.

WE ARE THE CHAMPIONS

In the midst of all this upheaval came the aforementioned "other war," the War of 1812, a conflict sometimes called America's "Second Independence." Fought over a whole slew of issues—England's support for indigenous people, their kidnapping of Americans to fight Napoleon, and American hawks' thirst for new territory in Florida and Canada—the two-and-a-half-year conflict ended in something of a draw. There were some spectacular skirmishes, like the Battles of Lake Erie and New Orleans, but no territory was gained, no resources were traded. Nothing. Materially, it was a war that didn't matter. But the psychological impact on Americans was tremendous.

This, the States' second consecutive win over the British Empire, gave the struggling nation a much-needed ego boost. The scrappy, rustic United States, its armies still composed of volunteer militiamen, amateur farmers, and other ordinary Joes, its stable of seamen still relatively puny—5,000 to Britain's 140,000—had gone toe-to-toe with the world's largest naval power and wasn't completely destroyed.

Incredible! We had proven ourselves on an international scale, exhilarating the public's faith in the American purpose. "The war has renewed and reinstated the national feelings and character which the Revolution had given, and which were daily lessened," Secretary of the Treasury Albert Gallatin remarked in 1816, "[The people] are more Americans [sic]; they feel and act more as a nation, and I hope that the permanency of the Union is thereby better secured."[15] Then-Georgia Congressman George Troup, a veritable renaissance man of politics—he was later Senator *and* Governor—concurred, dramatically, "The farmers of the country [were] triumphantly victorious over the conquerors of the conquerors of Europe."[16] And Francis Scott Key was so moved by America's win at Fort McHenry, Baltimore, that he wrote the poem that would become our national anthem, "The Star-Spangled Banner." Yes indeed, after years of toil and self-doubt, after decades of stagnation and uncertainty, "the home of the brave" finally had something brag about. And they would.

GETTING FRESH

But the nation's ballooning self-obsession had as much to do with love as with rockets. Once just a seedling that wafted over from Europe around 1800, Romanticism had germinated, and came to fruition in the 1820s, when its raw fervor replaced the Enlightenment's drawn-out rationality. Reason was out, emotions were in, and the organic was now divine. "In the woods, is perpetual youth. . . . In the woods, we return to reason and faith," stereotypical Romantic Ralph Waldo Emerson wrote in 1836, the height of the movement. Coming of age amidst millions of acres of untapped land, it's only natural that Americans would be drawn to the woods and those within. We were greatly aware of our coveted connection to a New Eden. Nowhere else was like the United States. We were special. We were fresh and

fun. Britain, ugly and distorted, was the past; America, virginal and limitless, was the future, and all of this was very good news for the soon-to-be-adored log cabin.

There were few wisps of log cabin love before the War of 1812. Washington Irving's 1809 *A History of New York* describes the rote transition from log cabin to more acceptable home, from ferocious to fine: "Behold the prosperous transformation from the rude log hut to the stately Dutch mansion." Irving's work was satirical, but the next, wistful line of exageration still speaks—maybe even more so—to the log cabin nostalgia emerging in America at the turn of the nineteenth century: "The humble log hut which whilom [formerly] nestled this improving family snugly . . . stands hard by, in ignominious contrast, degraded into a cow-house or pigsty."[17] To be degraded something first has to be elevated, right? Well, the cabin was on its way, as seen in James Kirke Paulding's 1818 "The Backwoodsman," where the cabin is portrayed as essential to Ohio's success:

'Twas here they landed mid the desert fair,
Broke up their boats, and form'd a shelter there,
Till they could build them cabins snug and warm,
To shield from Autumn's rains, and Winter's storm.
Then, for the first, the woodman's echoing stroke,
The holy silence of the forest broke.[18]

This cabin is not miserable or rude. It's cozy and hearty, and, notably, it's worthy of a respectful ode.

The log cabin's biggest pop culture coup, however, came in the form of James Fenimore Cooper's novel *The Pioneers*, the first installment in his Leatherstocking series, a franchise that includes *The Last of the Mohicans*, aka "that '90s movie with Daniel Day-Lewis." First published in 1823, just as President James Monroe claimed dominion over the Western hemisphere, *The Pioneers* follows roughly the

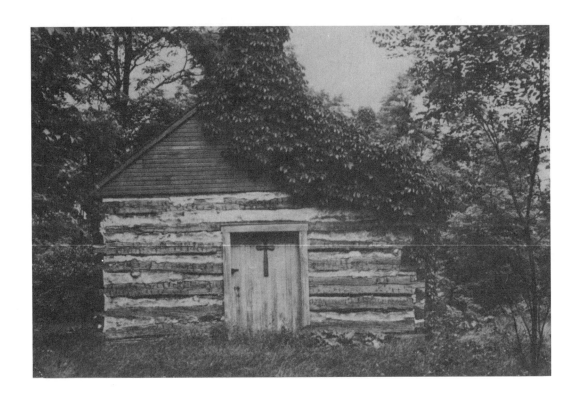

IMAGE 4.4 The log cabin was well on its way to redemption. *(Photography Collection, New York Public Library)*

same trajectory as Irving's *History*: the evolution of an upstate New York town from a smattering of log cabins "placed in every glen and hollow . . . or perched on the summits of the hills themselves"[19] into Templeton, a mighty farming community built around founder Judge Marmaduke Temple's great mansion, "the castle," the ultimate "end house."

This is a banal premise, yes, but *The Pioneers* was a sensation—and not because the plot is particularly compelling or because of some twist at the end, but precisely because it was banal. It mirrored the American experience. It reflected and affirmed so many Americans' actual experiences, including Cooper's own: His father, a judge like Temple, founded Cooperstown, New York, in 1786. *The Pioneers* resonated because it rang true. One contemporary reviewer remarked, "It might,

indeed, be called historical; for the historian can scarcely find a more just and vivid delineation of the first settlements of our wilderness;"[20] and Cooper's own introduction called his novel a "descriptive tale" full of "literal fact." To those who lived in the city, Cooper's work offered an optimistic and alluring glimpse of rural enlargement, the next chapter of America's story. To those who lived in cabins, Cooper's work was a pat on the back.

In Cooper and his self-assured audience's eyes, America's backwoodsmen aren't boors. They're honorable adventurers paving the nation's way to a better, brighter tomorrow. They aren't anti-social weirdos reluctantly respected for their drudgery; they're the X factor in American expansion. They're *pioneers*, a word rarely used positively prior to Cooper's novel. Backwoods folk had been a lot of things—licentious, anti-Christian, squatters, itinerant—but rarely were they called pioneers, and when they were, as with de Crèvecoeur's singular usage, it's translated as *les pionniers*, the military term for a first wave of soldiers, a "forlorn hope."[21] He elaborates, equating them with the licentious figure seen earlier: "They are a kind of forlorn hope, preceding by ten or twelve years the most respectable army of veterans which come after them. In that space, prosperity will polish some, vice and law will drive off the rest . . . making room for more industrious people, who will finish their improvements [and] convert the loghouse into a convenient habitation." Then, the money blurb: "In all societies there are off-casts; this impure part serves as our precursors or pioneers. . . ."[22] These aren't folk heroes worthy of artistic and literary adoration. Not back in the late eighteenth century, when de Crèvecoeur was writing. They're "off-casts." And although Timothy Dwight used "pioneers" to describe early Vermont settlers in an 1810 letter, he did so only in passing, and with no true regard: "A considerable part of all those, who begin the cultivation of the wilderness, may be denominated foresters, or Pioneers."[23]

Cooper repurposed "pioneers," imbuing it with new meaning. The

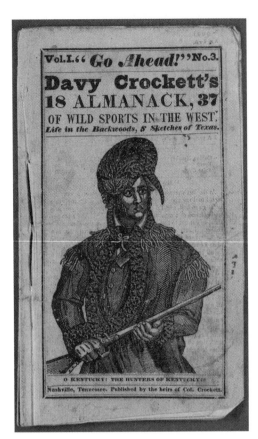

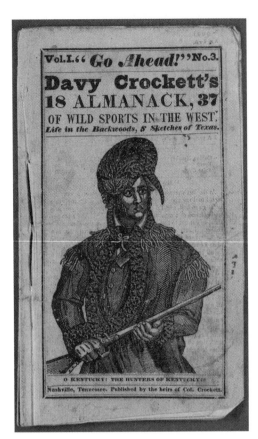
IMAGE 4.5 Davy Crockett's folksy backstory captured the American imagination after authors like James Fenimore Cooper remade once-derided pioneers into national heroes. Above, a cover from the *Davy Crockett Almanack* series that ran from 1835–1856. *(National Portrait Gallery, Smithsonian Institution / Art Resource, NY)*

pioneer is alchemical and elemental. In Cooper's version, and, increasingly, the westward-facing Americans', these men—they were always men—are doing essential work. Their cultivation, meager as it may be, is not a handy convenience for the next occupant. It's integral to American expansion. As Congressman Henry Clay testified in the House chamber in 1832, "Pioneers of a more adventurous character, advancing before the tide of emigration, penetrate into the uninhabited regions of the West," prepping the land for more civilized folk. Once that tide arrives, the pioneers move on, doing the same elsewhere, in an endless cycle of "only-in-America" progress. "What other nation can boast of such an outlet for its increasing population, such bountiful means of promoting their prosperity, and securing their independence?"[24]

Journalist Zachariah Allen praised the backwoodsman and his "persevering strokes" that year, too: "It requires a firm heart for a solitary individual to enter the wilderness alone, for the arduous enterprise of clearing up new lands," he wrote. "With a keen axe in his hand, the new settler penetrates many miles distant from any human habitation. . . . The log house is next constructed from the straightest trunks of trees." Now "master of the soil," he is "prepared to introduce with proud *feelings of independence* a youthful bride, who literally deserts the world for him and with him"[25] (emphasis mine).

A tender scene indeed, Allen's is a far cry from what Timothy Dwight wrote in 1818: "The business of these persons is no other than to cut down trees, build log-houses, lay open forested grounds to cultivation, and prepare the way for those who come after them.

These men cannot live in regular society. They are too idle . . . too shiftless."[26] But in the span of a few short years, these men had become the wave of the future.

But as respectable as they are for their contribution to civilization-to-come, these pioneers are also enviable for their intimate relationship with the land. They walk a middle ground between savage and civilized, acting as an indispensable bridge between the two, a special relationship evident in Cole's aforementioned Daniel Boone painting. A marked break from the artist's *View of Putnam County*, produced one year earlier and which featured a gentlemanly farmer with a fine, frame house, this idealized Boone image was inspired in part by *The Pioneers*, and shows the frontiersman and his dog, bathed in heavenly light, at one with the forest, while their log cabin, a far more honorable home than the "not extraordinary" abode Filson describes, stands by, keeping the darkness at bay. It was a crowd pleaser indeed when displayed in Boston the next year, establishing an aesthetic that was about to become a full-blown trend, changing American culture forever.

Thanks to Cooper and Cole, pioneers like Boone are taking on a respectability, and writers in the years ahead work overtime to counter the "dumb hick" stereotype. Charles Fenno Hoffman goggled at the apparently mind-boggling good sense of Missouri's log cabin folk circa 1835: "Upon entering into conversation with the occupants of the cabin, I found that degree of general cultivation which, though not unfrequently met with on the frontier, still always strikes a stranger with novelty."[27] De Tocqueville meanwhile noted, "Scarcely a single pioneers's cabin is without a few odd volumes of Shakespeare. I remember reading the feudal drama of *Henry V* for the first time in a log cabin."[28] And the Frenchman later marveled that these cabin dwellers are dressed just like city folk, too: "You enter this dwelling, which appears to be the refuge from every kind of poverty, but the owner of this place is clothed in the same way as you are . . . and on

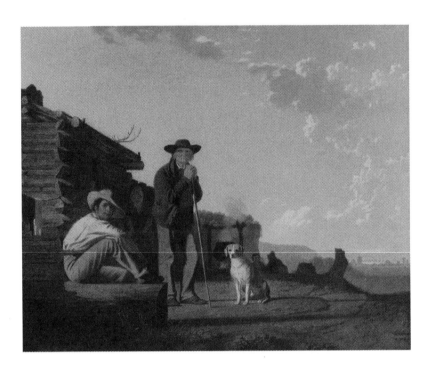

IMAGE 4.6 George Caleb Bingham's 1850 work *The Squatters* shows how these itinerants, earning fresh respect for their critical role in America's geographic growth. *(Museum of Fine Arts, Boston)*

his crude table lie books and newspapers."[29] These settlers weren't people grasping at straws of civility; they themselves were civilized— and they made America happen. They're heroes who make America possible.

And just as the squatter is made over in this era, so too is the land itself. No longer is the frontier a hinterland to be avoided. Cooper referred to it as "new country," but most of his contemporaries, those looking past the Adirondacks to the still-feral Ohio and Illinois, called it "the West." And they believed it was there that true America would be found. William Foster Otis of Boston, once-home to so many log-hating Founding Fathers, declared in 1831, on July 4, no less: "If we seek examples for our country and for ourselves, let us resort to the new-created West. There the fountains are uncorrupted. There civilization meets nature unimpaired. There we can behold how the young armed

American grapples with the wilderness, and thence we can return and imagine how our fathers lived."[30]

Dr. Daniel Drake concurred wholeheartedly with Otis' flowy remarks, and he himself described the West in 1834 as "the place where discoveries and new principles of every kind are received with avidity."[31] A rural setting "supplies [the pioneers'] mind with fresh material of thought, instead of ruminating on the old, i.e., the east and its forebear, Europe."[32] Those brave enough to enter, mostly emigrants, are "improved by the change of place, for it affords new objects and associations; their curiosity is awakened and their powers of observation are rendered more acute."[33] As Americans shaped the frontier, so too did it shape them.

Pre-Romanticism writings merely hinted at the log cabin's potential for change. Cooper and his successors made it explicit—and seemingly inevitable. Turner wrote in his *Pioneer History*, "[The cabin settlers] are destined to . . . congratulate themselves that they have been helpers in a work of progress and improvement, such as has few parallels, in an age and in a country distinguished for enterprise and perseverance."[34] Cooper, Turner, and their peers imbued the log cabin with metamorphic powers, turning the cabin into a fundamental foothold for something more substantial. The cabin tamed the wilderness, making it inhabitable, moving the march of progress ever forward. Once a necessary evil, the cabin was now worthwhile. It's a catalyst, one essential both to physical and psychic growth. Our old friend Doddridge, the Englishman who once marveled at stone houses, remarked on the cabin's transformative powers in 1824, "Our unsightly cabins . . . produced a hardy veteran race who planted the first footsteps of society and civilization in the immense regions of the west."[35] And here's Dr. Drake again: "When an individual from the depths of a compressing population, builds his cabin in the West, . . . [he is] speedily released from the requisitions of the society he left behind."[36] The cabin isn't an albatross pulling people down, as it did in Dwight's sermon. It's an

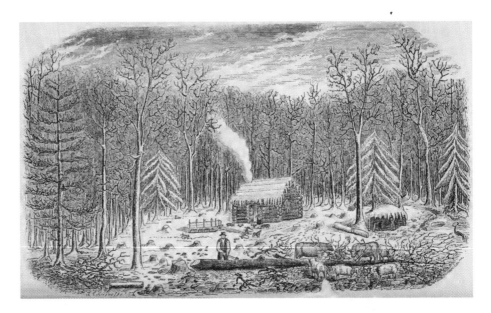

IMAGES 4.7–4.10 New York-born artist Orsamus Turner's 1849 illustrated work *Pioneer History of the Holland Purchase of Western New York* laid out the ideal transition from log cabin to end-house. The above image is called *The First Six Months*. Below that we see *The Second Year*, and over on the facing page there's *Ten Year's Later* and *The Work of a Lifetime*. *(Library of Congress)*

opportunity to break with old institutions and to create new ones. It's the complete opposite of the cabin vis-à-vis American Indians. What made the cabin dangerous before, its divorce from established society, was now an advantage.

IN LIVING COLOR

It was amidst all this log cabin love that Thomas Cole returned to the subject, satisfying market forces with *The Hunter's Return* (1845) and *Home in the Woods* (1847), the latter of which was sent far and wide by the subscription-based distributor American Art-Union. Again, the cabins here are ideal and upright, the centerpieces of quaint rural scenes. And likewise in works by other members of the loose group of artists called the Hudson River School, painters like Jasper Francis Cropsey and Asher Durand, both of whom played with light and dark to create idyllic, ethereal portraits of cabin life. Where earlier artists like Allen Gaylord and Basil Hall saw blight in the log cabin, as evinced in the images previously featured, Cole and his fellow Romantics saw glorious potential. The log cabin shouldn't be looked away from; it should be gazed upon and respected for its transubstantiation of nature and man alike. It should be fetishized.

As in Cooper's writing, these romantic cabins-in-oil inspire reverence for man's dominance over nature. The cabin is again physically and metaphorically a domesticating force, a precursor to civilization proper. Romantics treasured nature, yes, but it was still wild. Cole cheered the "loveliness of the verdant fields" and swooned over the "sublimity of lofty mountains," but he also confessed, "[Cultivated scenery] is still more important to man in his social capacity—necessarily bringing him in contact with the cultured; it encompasses our homes, and, though devoid of the stern sublimity of the wild, its quieter spirit steals tenderly into our bosoms."[37] And even Emerson

admitted, at the tail end of that earlier, oh-so-Romantic quote, "It is necessary to use these pleasures with great temperance. . . . Nature is not always tricked in holiday attire."[38] Nature was intoxicating, and, like a strong drug, it had to be cut with something more mellow like the log cabin. Settlers and cabins temper nature with civilization, subduing it lest someone OD on its organic glory.

If Cooper's work reflected the American experience, these artists were refracting it, editing out the pests and hardship that were part and parcel of log cabin living. They were making the struggles of sylvan subsistence more palatable and more valiant both. These paintings, revelations at the time, were kind of like a reality show: scripted and not at all like real life. Horace Greeley, a future newspaperman who grew up in New Hampshire, described his actual life on the frontier as "mindless, monotonous drudgery, instead of an ennobling, liberalizing, intellectual pursuit."[39] Cole and company glamorized the gauche, romanticizing cabin life in every sense of the word.

MIXED EMOTIONS

Yet even the most handsome, rose-tinted portrayals of log-cabin life weren't without their blemishes. The stumps that pepper *Home in the Woods* and Durand's *The First Harvest in the Wilderness* are an indication of internal discord between romance and reality, because as gung ho as they were about breaking down nature, these artists were equally ambivalent about man and the cabins' drive into the woods. They were well aware that man's spread brought death and destruction. Nature needed to be tamed, but there was a line that shouldn't be crossed. Man was walking that line.

Cole lamented the "blackened stumps and mutilated trees" in the Adirondacks in a July 8, 1837, diary entry. (It's worth noting that Cole also had choice words for the "half-civilized inmates" who lived in

OPPOSITE

IMAGE 4.13 Log cabin fetishization is explicit in Asher Durand's 1855 image *The First Harvest in the Wilderness*, a beatific scene of a settler's "improvements." The stumps here are a warning of things to come. *(Transferred from the Brooklyn Institute of Arts and Sciences to the Brooklyn Museum, 97.12)*

IMAGE 4.14 And so too does Jasper Francis Cropsey's 1858 contribution *Eagle Cliff, Franconia Notch, New Hampshire*, play into an ongoing artistic obsession. *(North Carolina Museum of Art, Raleigh, Purchased with funds from the State of North Carolina, 52.9.9)*

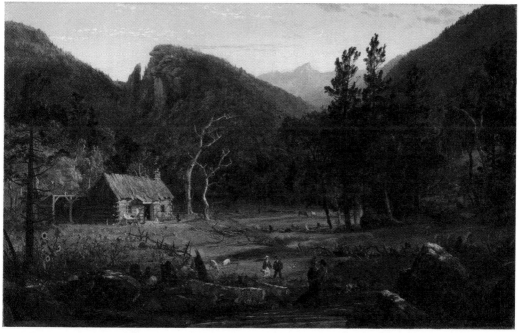

DOWN WITH TREES

America's distaste for forests is born from two related ideas. The first is pure superstition: a fear of ghouls, ghosts, and Blair Witches. God-fearing Christian men had a moral duty to scythe the hell out of it. As forest historian Michael Williams notes, defoliation was portrayed as "a heroic struggle to subdue the sullen and unyielding forest by the hand of man . . . to make it something better than it was."[40] Man-made clearings were "openings where God could look down and redeem the struggling inhabitants."[41] Similarly, De Crèvecoeur said in 1782 that the once "barbarous country," being remade into a "fertile, well regulated district," had been "purged."[42]

In clearing the land, man was enacting a "new creation."[43] Settlers were remaking the land in their civilized image. This was

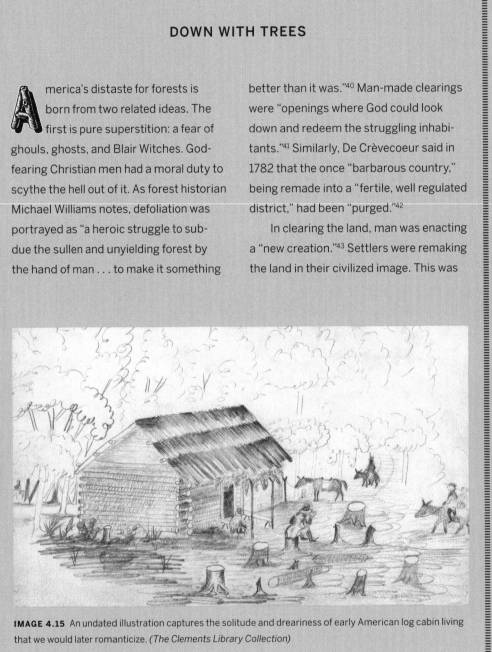

IMAGE 4.15 An undated illustration captures the solitude and dreariness of early American log cabin living that we would later romanticize. *(The Clements Library Collection)*

man controlling nature, becoming, to use Zachariah Allen's words: "master of the soil." He "has subdued [the land] with his own hands."[44] And James Fenimore Cooper gave the act graphic and telling blush in 1842: "There is a pleasure in diving into a virgin forest and commencing the labors of civilization [It] approaches nearer to the feeling of creating."[45] By clearing the land, anthropocentric Americans were *improving* it, an idea casually bandied about at first, as in Benjamin Rush's 1796 note about "improving a farm." "They prefer purchasing farms with some improvements," he wrote of Germans, who then make more "improvements."[46] But offhand usage eventually became official in 1860, when the census began distinguishing "improved" and "unimproved" land. The clearer the land, the more improved. And the more improved, the more money to be had.

And that brings us to the second source of Americans' aversion to forest: deforestation wasn't simply about spiritual salvation and casting out bogeymen. It was, as so many things in this country, about money. Improving the land imbued it with commercial value. In fact, Benjamin Franklin—whose, image, notably, adorns the hundred dollar bill—once said that agriculture, that "continual miracle," was "the only honest way" a nation could make bank.[47] He also described, in a 1751 essay, the "clearing America of woods" as "*scouring* our planet."[48] The emphasis on "scouring" was all Benji.

To Franklin and his ilk, progress was "converting the wilderness into a paradise of material plenty."[49] De Tocqueville paraphrases Americans' prevailing opinion of the day: "The true owners of this continent are those who are able to take advantage of its wealth."[50] And the more acreage cleared, the more coinage earned. It was a no-brainer: Every tree must go! Storied conservationist John Muir's later sneer about deforestation was right on the money: "Any fool can destroy trees. They cannot run away; and if they could, they would still be destroyed—chased and hunted down as long as fun or a dollar could be got out of their bark hides."[51] Think of that next time you fly over a planned community with pristine, treeless lawns. No goblins hiding in shadows here. In fact, no shadows here at all.

log cabins; these people were "too barren of ideas" to properly name landmarks: "Their whole vocabulary furnishes Blue Mountain, Bald Face, Whiteface, Potash Kettle, Huckleberry Mt."[52] It was only later, when the market had firmed up, that Cole would extol these "inmates" in oils. Money, it makes you do crazy things.) And Cooper, the writer who so venerated the axman for beating back the woods, griped about "disfigured" landscape left in man's wake. From 1845's *Satanstoe*, "The whole of the open space was more or less disfigured by stumps, dead and girdled trees, charred stubs, log-heaps, brush, and all the other unseemly accompaniments of the first eight or ten years of the existence of a new settlement."[53] And from the even-earlier *The Pioneers*, "Time was given for Elizabeth to dwell on a scene which was so rapidly altering under the hands of man, that it only resembled, in its outlines, the picture she had so often studied. . . ."[54]

These artists realized that Americans' ceaseless expansion, the movement of which we were so proud, also eradicated the very thing that made us special: the nature at the heart of our national identity. And so began a self-perpetuating cycle of longing for the very thing we destroy, the then-new but eventually perennial tension between the pastoral and the industrial, progress and loss. Americans of this era were looking forward to the future as they simultaneously pined for the past, instantaneously creating nostalgia that deepens in the decades to come. One Rochester writer noted in 1841, "The 'old folks' of the family look back with strong yearning to the 'log cabin' where they fixed themselves" before the city bubbled up around them,[55] and that same year Senator Silas Wright of New York described western settlers whose "increasing means enabled them to erect a more costly mansion, were wont to leave the old log cabin still standing near as a memento of their humbler circumstances."[56]

As with the cabins themselves, the Swedes were the vanguard here. Peter Kalm noted an old cabin in Philadelphia in 1748: "A wretched old building . . . belonging to one of the sons of Sven, [from] whom . . .

IMAGES 4.16
The colorization of
Basil Hall's 1828 black-
and-white image sums
up American artists'
love affair with the
cabin. Ever heard of
lipstick on a pig? That
basically sums up the
"cabin as romance"
aesthetic. *(Library of
Congress)*

the ground was bought for building Philadelphia upon, is preserved on purpose, as a memorial of the poor state of that place, before the town was built on it. Its antiquity gives it a kind of superiority over all the other buildings in town, though in itself the worst of all. . . ." He goes on, "It was unlikely at the time of its erection, that one of the greatest towns in America should in a short time stand close to it."[57]

But don't get it twisted: Americans of the 1830s weren't yet dancing around the log cabin like it was a maypole or something, and even in this post-*Pioneers* world, amidst all this pro-cabin art, there were still plenty of log cabin haters to be found. This was around the time Baptist Minister John Mason Peck called cabins "unfit for human habitation," and he also had this to say: cabins were "crazy," "cheerless," and "scarcely a shelter." So, you know, not a lot of love there.[58] And rest assured, the log cabin was still very much a temporary thing. Let's not forget that Templeton's fictional town folk, like real Americans, replaced log with

IMAGE 4.17 And here's a comparably optimistic scene circa 1870. *(Library of Congress)*

brick as the town solidified. The humble, replacable log cabin had done its job, acting as a stepping stone. Our old friend de Tocqueville sums up the general sentiment circa 1835 quite nicely, "In actual fact, the wooden cabin is for the American only a brief refuge, a temporary concession to the necessity of circumstances." In time "a roomier house, more suited to his way of life, will replace the log house."[59]

The cabin was ever-present, yes, and even idolized at times, but it was far from permanent. It was respected for its route toward tomorrow, not in and of itself. There was far too much residual hate for lovely paintings and compelling prose alone to counter. Those were still limited in scope. The cabin needed something more widespread and popular to achieve perpetuity. Fatefully for the little old cabin, Cooper and Cole's works were part of a bigger picture. There were other factors at play, ones that would cement the log cabin's place in American culture and let loose cultural trends that still swirl about us today.

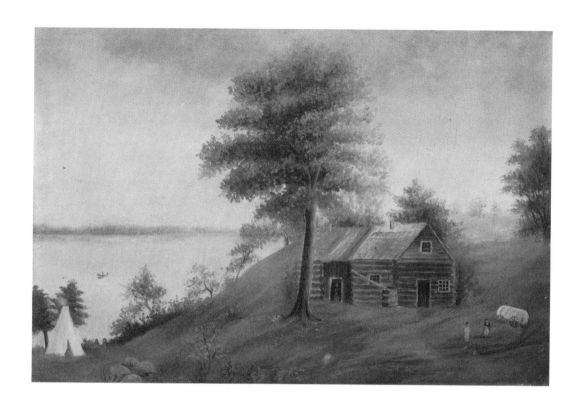

IMAGE 4.18 An unsigned painting of the Eben Peck Cabin. Built in 1837, it was the first permanent structure in Madison, Wisconsin. *(Wisconsin Historical Society, Whi-2859)*

· 5 ·

THE LOG CABIN, POPULIST ICON

BEFORE WE GET to the man responsible for cementing the log cabin's place in American iconography, we have to pause to discuss a man known for his vengeful temper and fanatical prejudice; a man whose broken campaign promises have made his name synonymous with "demagogue"; a man who himself admitted he was unfit for office and whose outlandish campaign shattered long-standing political norms and institutions, altering the face of American politics forever. I'm talking, of course, about Andrew Jackson.

The first candidate to run as an outsider aiming to disrupt the system—"I am not a politician," he said, an effort to appear disinterted in power[1]—and the first president from the West, Jackson rose to power by concocting a phony common man persona. Suppressing his personal wealth and pretending to know that the struggle is real, "rustic" Jackson exploited anti-elite sentiment to foment populist rage, pioneering a political formula that we know still works today, and one that would have direct impact on the log cabin's cultural ascent.

A DEMAGOGUE WITH NOTABLE HAIR

Famous for besting the British at the Battle of New Orleans in 1815, ambitious General Jackson wanted more than military honors. He wanted political power. And to get that power he needed to introduce himself to the public at large, and he did so with a biography, something to shore-up grassroots support before launching his electoral career. The resulting tome, written by friend John Eaton, published in 1817, was more or less the truth, only with a liberal amount of aggrandizing: Raised by a widowed mother and sustained by a "small patrimony,"[2] the young hero overcame these shortfalls to enroll at a "flourishing academy," rather than the small country school to which his siblings were sent.[3] Incensed by colonial injustice, Jackson joined the Continental Army at the age of thirteen—"He was no inactive spectator"[4]—and led American militiamen against the same nefarious forces in 1815, a victory that had "preserved" the American way of life.

IMAGE 5.1 Andrew Jackson was known as much for his trademark coif as for his conservative policies. (*Library of Congress*)

Thanks to Eaton's editorial magic, Jackson was now more famous than ever: Everyone knew him by his nickname, Old Hickory, a moniker that spoke as much to Jackson's adamantine determination as to his lanky figure, and by 1823 the general had secured himself a Senate seat representing Tennessee, a useful stopover for his path to the White House. But, as astute as he was power hungry, Jackson saw the national mood shifting. The rustic was being romanticized and the pioneer gaining respect. And, more germane to his purposes, political enfranchisement expanded in lockstep with pioneer-centric romanticism. Where

once only landed gentry could vote, freshly minted states like Alabama and Missouri lifted these restrictions, opening the ballot box to hundreds of thousands of landless white men. And these voters didn't see themselves as cookie-cutter Founding Fathers. They were rugged Daniel Boones. They admired modest roots, not Ivory Towers, and they wanted a president who spoke for and like them, someone who saw the world through their eyes. With his own eye on the 1824 election, Jackson intended to give it to them. Or, actually, Eaton would.

ENTER: FARMER J

Always eager to please his liege, sycophantic Eaton produced *two* pro-Jackson media projects in 1824, both of which recast Jackson as more rustic than warrior. There was an official biography that sanitized Jackson's pugnacious public image and that fabricated economic straits to make him more "self-made."[5] Not at all like the vulgar bully opponents made him out to be, Jackson was "easy, affable, and familiar . . ."[6] He was just a simple ploughman. Rather than going into law, where he could make mad money, Jackson preferred to "devote himself to agricultural pursuits; and accordingly settled himself on an excellent farm."[7] Eaton conveniently skipped over the fact that Jackson had a cadre of slaves doing the actual tilling.

Eaton's parallel endeavor, meanwhile, was a bit shadier: a series of articles penned under the name "Wyoming," and which took a two-tiered approach. On one level, they worked in tandem with the official biography to emphasize Jackson as ploughman. It pandered thusly, "Like Cincinnatus, he is on his farm and at his plough, contented and willing to remain there, yet willing too to leave it, if called to do so by the voice of his country."[8] And on the second level, the letters countered attacks on Jackson's rural upbringing, a symptom of the Establishment's Eurocentricism. Yes, Jackson was raised in the "interior,"

IMAGE 5.2 The log cabin was not yet worthy of political praise. *(Wisconsin Historical Society, WHi-3832)*

Eaton/Wyoming wrote, but that just meant he was that much further from European influence. "I am indeed sorry to see my country manifest such fondness and partiality for exotics. In manners, dress, and language we are imitators, and borrowers from abroad," read one letter. European trends erode our national resolve, it said. Only country folk can prevent the Europeanization of America. "In this wilderness, as if by magic, a new and different order of things has been produced; but vigilance apart, and that order will soon be encroached upon."[9] According to "Wyoming," and, we'll see, many more to come, only men like Jackson could save our psychological and political borders from such a Euro-tainted incursion.

It's worth mentioning that neither of Eaton's 1824 hyperbolic efforts mentioned the most relatable fact about Jackson: that he was born in a log cabin, just like so many other Americans. The structure was still too fringe to be celebrated in such a manner, a fact

made plain in upcoming opposition attacks on Jackson's wife. And clearly Jackson didn't need the log cabin, anyway: He won both the most electoral *and* the most popular votes that year, besting political scion and political favorite John Quincy Adams. Unfortunately, Jackson still fell short of the 131 electoral votes needed to clinch the election, forcing the House of Representatives to break the stalemate and ending in the infamous "corrupt bargain" in which Jackson rival Henry Clay supported Adams in exchange for the Secretary of State job, thus robbing Jackson of the presidency. Legendarily vindictive Jackson went nuclear. Decrying Clay as a "Judas of the West" and calling the quid pro quo the most "bare-faced corruption" in American history, Jackson spitefully quit the Senate to take the reins of the Democrats, a coalition devoted to squashing Adams and the establishment at large.

ADAMS V. JACKSON: THE SEQUEL

As with all sequels, the 1828 race was bloodier and more brutal than its predecessor, with both sides throwing unprecedented amounts of mud, though Adams definitely got in the most licks. He and his surrogates portrayed Jackson as, among other things, a gambler, a slave trader, a burglar, a bigamist, a murderer for slaughtering British soldiers in New Orleans *and* as an unhinged illiterate. "He spells government with one 'n,' " the president scoffed, and his allies followed suit: "He is destitute of historical, political or statistical knowledge. . . . His whole recommendation is animal fierceness and organic energy. He is wholly unqualified by education, habit and temper for the station of President."[10] And Thomas Jefferson, the former president who so extolled the archetypal ploughman Jackson was pretending to be, had this to say about the phony farmer: "I feel much alarmed at the prospect of seeing General Jackson President. He is one of the most unfit men I know of for such

a place. He has very little respect for laws or constitutions. . . . His passions are terrible. . . . He is a dangerous man."[11]

And then there were the vicious attacks on Jackson's wife, Rachel. She was marked as a hussy for being married before; a "black wench" for her tanned skin, the taint of toil among lily-white elites; and as "crude" for smoking a pipe: Such behavior may be fine in "every cabin beyond the mountains," it was unacceptable for the president's mansion, wrote anti-Jackson journalist James G. Dana.[12] (You can see why Eaton's otherwise homespun propaganda failed to mention Jackson's birth cabin.)

But these attacks only energized Jackson and his "Hurrah Boys,"[13] boosters who sang their candidate's praises at barbecues, parades, and party conventions: new-fangled public gatherings that were themselves a symptom of the populist energies at hand. Fanning out across the country, Team Jackson painted Adams as "alien" and "foreign." He had been brought up in part in Europe, where his mind was "warped to conform to the devious notions of his family."[14] Suppressing the fact that Jackson lived in an eight-room mansion, supporters insisted their candidate was "on the same plain level" as the common man."[15] "Wyoming" hyped that he was "reared in the interior;"[16] Robert Walsh bragged of Jackson in January 1824, "He is artificial in nothing. His reading cannot be supposed to be extensive nor his application to books very frequent;"[17] the *Illinois Gazette* declared, "by great designs he is fashioned by nature;"[18] upstate New Yorkers celebrated the candidate for "judgement unclouded by the visionary speculations of the academician,"[19] and Jacksonians in New York City declared that Jackson had "native strength of mind" and "practical common sense," both of which were "more valuable than all the acquired learning from a sage."[20]

It was Jackson's lack of education and his outsider status that made him so attractive. He didn't cede to institutions and he certainly didn't need no book learning. The general's smarts came "not from reading

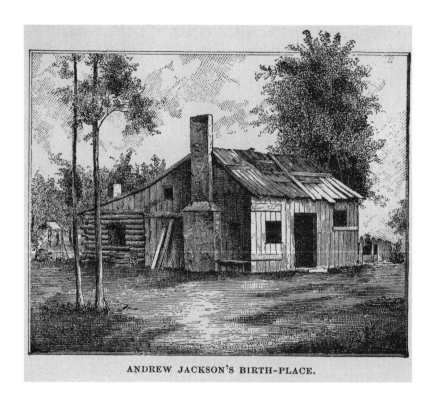

ANDREW JACKSON'S BIRTH-PLACE.

IMAGE 5.3 Andrew
Jackson's birth cabin,
ignored in his political
campaigns, wouldn't be
celebrated until 1892.
(*Library of Congress*)

books" but "from reading men." He was "unclouded by the visionary
speculations of the academician." If you're looking for the roots of
America's obdurate anti-intellectual bent, here it is. Embracing igno-
rance was the most extreme rejection of refined European mores, and
Jackson's act was award-winning.

Brawny Jackson trounced brainiac Adams that fall, winning 178
electoral votes to the incumbent's 83. And in terms of popular votes,
Jackson secured 642,553 over Adams's 500,897, a landslide the papers
immediately dubbed a "people's victory." And the people were *psyched*.
Thousands upon thousands crowded the White House for Jackson's
March 4, 1829, inaugural address, causing an unprecedented "scene of
confusion" that left a cascade of shattered china and crystal, a perfect

metaphor for the seismic sociopolitical shift underway. Washington doyenne Margaret Bayard Smith wrote about the scene in a letter: "The Majesty of the People had disappeared, & a rabble, a mob. . . . scrambling, fighting, romping. . . . Ladies fainted, men were seen with bloody noses. . . . [Jackson], who had retreated & retreated until he was pressed against the wall, could only be secured by a number of gentleman forming round him & making a kind of barrier of their own bodies. . . . But it was the People's day, & the People's President & the People would rule."[21]

But more than a win for the rhetorical people, this was a win for the actual, geographical West. After years of being the ridiculed boondocks, spoken *at* by the high and mighty East, the West had shown their mettle. Rustic had vanquished rococo. The common men were doing the talking, telling Washington they had the power. Capitalizing on the rise of the West and its admirable "new man," Jackson's campaign team turned a phony "common man" into the commander-in-chief, mainstreaming the rural in a way the Founding Fathers never imagined. The East was the old New World; the West was the new New World.

Jackson's election changed the political calculus. There was a new character in play, the outsider. This wasn't readily apparent at first. A few of Jackson's peers tried imitating him in the years that followed, beefing up country-fried backgrounds to win over voters. Henry Clay's 1831 biography reminded readers that the career politician "commenced life as a portionless orphan."[22] And Davy Crockett took matters into his own hands in his epic 1835 takedown of rival Martin Van Buren, Jackson's hand-picked successor. Angling to win the National Republicans' presidential nomination, Congressman Crockett starts off nicely enough, offering parallels between himself and his opponent: "Mr. Van Buren's parents were humble, plain and not much troubled with book knowledge; and so were mine. . . . He has become a great man without any good reason for it; and so have I." But then

Crockett brings down the hammer on "the heir-apparent": "Here the similarity stops. . . . [Van Buren] couldn't bear his rise; I never minded mine. He forgot all his old associates because they were poor folks; I stuck to the people that made me. I would not have mentioned his origin, because I like to see people rise from nothing; but when they try to hide it, I think it ought to be thrown up to them. . . . [He] ought once-in-a-while to be reminded of the mire in which he used to wallow."[23] *Snap!* But, alas, Crockett was snubbed by his party, and the public. And, yes, some politicians, like South Carolina Senator Willie Mangum, joined the Romantic bandwagon, praising the log cabin dweller: "The humble tenant of the humblest log cabin feels the inspirations of liberty and rises into dignity with a consciousness of its possession, as well as he who is clothed in [pricey] purple," Mangum said in 1833. "He feels that this is his country, the freest country under the sun, and that every part of it is his country."[24] But overall it seemed that Jackson's "play poor" tactic was a one-off, a complete fluke. And perhaps it would have been, but then came the presidential race of 1840, the so-called "log cabin campaign." Things would never be the same.

WHIGS FLIP THE SCRIPT

The presidential campaign of 1840 was very good for the log cabin. This was the structure's tipping point: the event that guaranteed the heretofore demeaned cabin's ascension into an emblem of all-American honesty and integrity—and it all started with a lie.

As with the 1828 race, 1840 was framed as an insider/outsider contest, but was really about two rich white men trying to outdo one another. In one corner we had seasoned incumbent President Martin Van Buren, and in the other, William Henry Harrison, a retired general and rather undistinguished politician. Though once a Democratic-Republican, Harrison ran that year as a Whig, a "com-

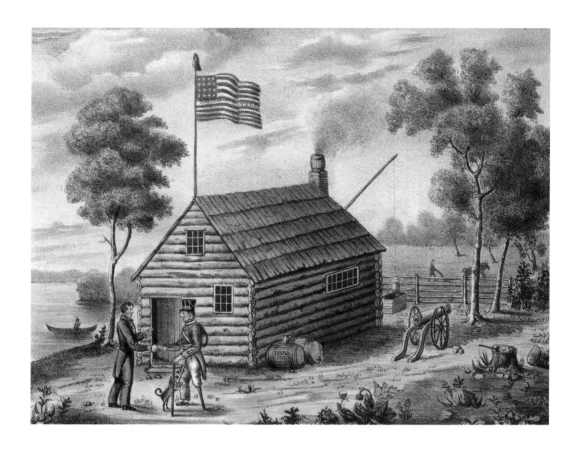

plex conglomeration"[25] of various, often self-contradictory interests and generally a party with zero ideological consistency. Some members were pro-slavery, others anti; some supported a national bank, others were vehemently opposed and a few even supported Manifest Destiny, a decidedly Democratic policy. But rather than try to iron out their differences, the Whigs simply labeled themselves as the party of "decency, refinement, wealth and cultivation,"[26] an indication of just how little credence Jackson's "rustic" strategy was given. The Whigs had no platform to speak of; they existed simply to destroy Van Buren and his allies.

But the Whigs' lack of ideological purpose was just fine by Harrison.

IMAGE 5.4 William Henry Harrison and his Whigs gave the log cabin a new, more colorful attitude in the 1840 election. *(Ohio History Connection)*

Despite two decades in various public offices, including twelve years as governor of the Indiana Territory and three as a US senator, Harrison was no political stallion. Nor was he particularly inclined to policy. (He would later tell voters, "No pledge should be made by an individual when in nomination for any office." Campaign promises only perverted the political process, giving elections over to "[he] who is prepared to tell the greatest number of lies."[27]) And Harrison actually had no apparent interest in higher office. He had retired from public life by 1829, and seemed intent on living out his days in his sixteen-room mansion. That is, until 1836, when the Whigs came calling, eager to remake Harrison over in Jackson's image.

Harrison's lackluster legislative career was nothing to write home about, so the Whigs decided the most efficient route to the White House was to dramatize Harrison's long-ago victory in the Battle of Tippecanoe, the 1811 conflict in which Harrison's militia crippled Shawnee leader Tecumseh's Indian Confederacy. "If General Harrison is taken up as a candidate, it will be on account of the past, not on the future," Whig adviser Nicholas Biddle said. "Let him then rely entirely on the past. Let him say not one single word about his principles, or his creed—let him say nothing—promise nothing."[28] And so now Harrison was branded "the hero of Tippecanoe," or "Old Tip" for short, a not-so-subtle echo of "Old Hickory."

IMAGE 5.5 Heroism was the original marketing theme for William Henry Harrison, but the general's war chops were later dropped in favor of a humbler and more marketable log cabin biography. *(Library of Congress)*

It should come as no shocker that Harrison circa 1836 was not a transformational candidate. He had nothing new to define him, nothing to set him apart. And though he came in second in the five-way race that fall, besting three of his fellow Whigs, Harrison still wasn't particularly popular within the party itself. Case in point: He nearly lost the 1840 nomination to perennial candidate Henry Clay. But Whig bigwigs knew that a career politician like Clay, already in office for thirty-seven years, was far too established to win the newly important frontier vote, so, in a move reminiscent of the corrupt bargain, but in reverse, party insiders spent the next three days stealing votes away from Clay to deliver Ohio-based Harrison the nomination. It was a bruising ordeal, and the exhausted, splintered Whigs were left less than enthusiastic. "The feeling among the Whig masses was one of depression," wrote William H. Seward, a then-New York governor who would later become Secretary of State. "General Harrison's strength lay in the fact that he was the most unobjectionable and therefore the most suitable candidate."[29] Harrison was merely a pragmatic choice, and one made more so by tacking on former Virginia Governor and Senator John Tyler as vice president, a bid to win the South. This was a cynical ticket, one based on electability, not energy, and was all in all a pretty dreadful start to what was a do-or-die campaign for the upstart Whigs. But then, in what may be the most ill-conceived political attack in American history, the Democrats gave the Whigs a political tool far more potent than Harrison's flimsy war record. They gave them the log cabin.

THE JEER THAT BECAME A CHEER

Known among his nemeses as "Martin van *Ruin*," President Van Buren was facing an uphill reelection fight. He had proven inept at containing the (economic) Panic of 1837, and the American public was long tired of the Second Seminole War, now in its fifth bloody

A BEAUTIFUL GOBLET OF
WHITEHOUSE CHAMPAGNE

AN UGLY *MUG* OF
LOG CABIN HARD CIDER

IMAGES 5.6A–5.6B
Snobbish Martin Van Buren rolled his eyes at "humble" Harrison. It was a politically fatal mistake. *(Special Collections Research Center, Syracuse University Libraries)*

year. But this Harrison enthusiasm gap looked to the president and his party like an opportunity to change the conversation. If the Democrats could hobble Harrison—if they could make the retired war man seem ill-prepared and inept, then maybe, just maybe, Van Buren had a shot at keeping his job. To that end, the Democrats dispatched journalist John de Ziska to smear Harrison's name, and, more than happy to help, the journo went whole hog, publishing a hatchet piece on December 11, 1839, with this central hypothesis: "Give [Harrison] a barrel of Hard Cider, and settle a pension of $2000 a year on him, and my word for it, he will sit the remainder of his days in his Log Cabin."[30] In other words, Harrison was an ignorant hick. De Ziska and the Democrats knew Harrison lived in a stately mansion, and they may also have known that he was a teetotaler who never touched

hooch, cider or otherwise, but most voters didn't. If all went according to plan, they would see Harrison as a Cletus Spuckler: a slack-jawed yokel who would happily trade the august office of the presidency for a dilapidated cabin and some sauce. Voters would have no choice but to support seasoned, well-mannered Van Buren. Right? Not by a long shot, bub.

The "log cabin" jibe backfired—completely and miserably. Millions of Americans still lived in log cabins, and they were mad as hell. Who did the Democrats think they were, insulting these hardworking cabin dwellers in such a manner? As historian John Bach McMaster later observed, "No sneer could have been more galling than this insult to the early homes of the builders of the nation."[31] Within days, pro-Harrison papers were cheering the candidate and his fictitious log cabin. "The poverty of General Harrison, however he may be reproached with it by his opponents, is the result of his honesty," read a *Baltimore Chronicle* op-ed that was published and republished in the days after de Ziska's attack.[32] Harrison had had "ample opportunity . . . to amass sufficient wealth to have translated him from his 'log cabin' to a palace," but he knew "that honesty is always the best policy."[33] The *Delaware State Journal* was similarly enraged, writing that December: "After having spent many a year of toil and danger for the defence [sic] of this land against foreign and savage foes, and having sat down in poverty in his cabin, General Harrison is to be made the object of scornful and contemptuous jest."[34] The New York *Daily Whig* described the rebuff as coming from "pampered office-holders [who] sneer at the idea of making a *poor man* President."[35] And the unwaveringly pro-Harrison *Baltimore Chronicle* continued their championing in the days ahead: "Revered patriot" Harrison may be "contented with his lot," but "the people are not contented that he shall remain where he is. . . . They intend to take possession of the president's mansion. The owners of the 'log cabins' have determined upon that measure [to elect Harrison]—they possess the power and

they intend to use it. Huzzah for Old Tippecanoe!"[36] The log cabin was thus transformed, relatively overnight, into a badge of honor and honesty. It was now a rallying cry, a point of pride. To be from a log cabin was officially admirable, not embarrassing.

The Whigs couldn't believe their luck. Here, right in their lap, was the ticket to their victory—and they were going to milk it for all it was worth. "There was nothing gross or very abusive in this sentence, but it very possibly carried the election," Whig journalist Richard Smith Elliott later wrote of backroom meddling he and party leader Thomas Elder put in in the weeks following de Ziska's column. "Elder had noted the slur on Gen. Harrison by the Baltimore paper, and thought we ought to make use of it: build a cabin, or something of that kind, which would appeal to the eye of the multitude." Elliott went on, "He was a shrewd old gentleman . . . and well knew that passion and prejudice, properly aroused and directed, would do about as well as principle and reason in a party contest."[37] That is, the American people could be duped. And they would be. Subbing in rustic airs where "decency" once stood, the well-heeled Whig leadership proceeded to reinvent themselves and their candidate as ordinary cabin dwellers who spoke for the working man and farmer alike. And they wouldn't do it alone.

NEW MEDIA

One of the most potent forces at play in 1840 were penny presses, cheap newspapers that focused on pedestrian news. First bubbling in the 1830s, these ink-stained manifestations of the populist times "[reflected] the activities of an increasingly varied, urban, and middle-class society."[38] Where the elite-driven six-cent papers covered business and international affairs, these new dailies reported on the everyday local news that appealed to the common man. Speaking

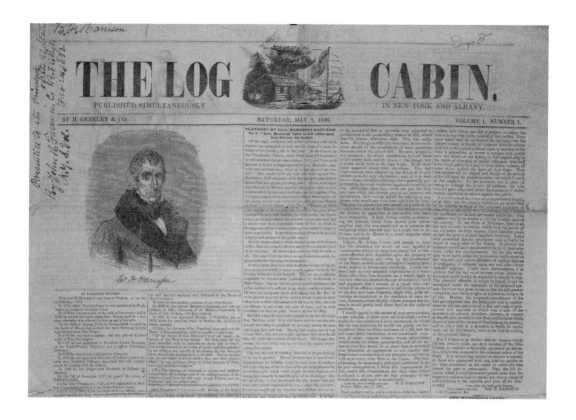

to and for the people, penny presses kept poorer Americans up-to-date with the freshest reports on things that mattered to them, the average Joes.

The social media of their day, penny papers spoke to specific groups, shaping and validating people's opinions, reinforcing political identities and becoming echo chambers for an increasingly partisan society. Some even became (or were founded as) unofficial party organs, like when the Whigs used Horace Greeley's newspaper *The Jeffersonian* to win over New York voters in the 1838 midterm. It worked like a charm, helping the party sweep the gubernatorial and congressional elections that year. It's therefore no surprise that the party redoubled their efforts for the 1840 presidential election, when they supported or

IMAGE 5.7 First published on May 2, 1840, Horace Greeley's *The Log Cabin* was just one in a field of penny papers that fed off of and into the log cabin love. *(David M. Rubenstein Rare Book & Manuscript Library, Duke University)*

directly churned out an incredible ninety-eight different penny-press titles, far more than the Democrats' measly fifteen.[39] And while some of the Whigs' 1840 penny papers had on-message but otherwise bland names like *Yeoman* or *The Daily Whig* or, snooze, *The Harrisonian*, most stuck more closely to the new, freshly flipped script. Here, a list of the "log cabin" papers, their base of operations, and their run dates:

Log Cabin Advocate, Baltimore, Maryland, March–December 1840

Log Cabin Herald, Chillicothe, Ohio, May–October 1840

Log Cabin, Dayton, Ohio, March–October 1840

Log Cabin Patriot, East Bridgewater, Massachusetts, August–November 1840

Log Cabin Rifle, Harrisburg, Pennsylvania, June–July 1840

Cabin Democrat, New Lisbon, Ohio, June–October 1840

Log Cabin Daily, Philadelphia, Pennsylvania, August 1840

Log Cabin, Pottsville, Pennsylvania, October 1840

Log Cabin, Rochester, New York, April 1840

Log Cabin Hero, St. Louis, Missouri, May 1840

Log Cabin Farmer, Steubenville, Ohio, April–October 1840

Tippecanoe Standard and Log Cabin Chronicle, Dedham, Massachusetts, September 1840

Log Cabin, Albany and New York, New York, May 1840–November 1841[40]

That last one, the Albany-based *Log Cabin*, was another Greeley publication, and it was by far the most successful of all the "log cabin" papers in 1840, both in terms of circulation—80,000 copies a week—and in longevity: it published its last edition in November 1841, well after the election and, in fact, after Harrison's death thirty-six days into his term.

Greeley chalked his particular *Log Cabin* paper's longevity up to

two things. One, his use of slang: "Writing for the common people, I have aimed to be lucid and simple. I write for the great mass of intelligent, observant, reflecting farmers and mechanics."[41] But as useful as plain English was, lyricism played a role, too: "Our songs are doing more good than anything else. . . . I think every song is good for five hundred new subscribers."[42] And Greeley's *Log Cabin* wasn't alone in pumping up the jam. Harrison boosters penned dozens of songs, ditties, promenades, jingles, and jigs that year, all singing the candidate's allegedly rustic praise. There was "The Log Cabin Song," "Old Tip and the Log Cabin Boys," "The Rough Log Cabin," and, for those who had to dance, "The Log Cabin Two-Step." There was also the memorable melody "Log Cabin and Hard Cider," which goes to the tune of "Auld Lang Syne" ("Should plain log cabins be despised, / Our fathers built of yore?"); the official Whig theme ("They say he lived in a log cabin / And lived on hard cider, too. / Well, what if he did, I'm certain / He's the hero of Tippecanoe"); and let's not forget "Tippecanoe and Tyler, Too," aka "Tip and Ty," a long-lasting hit most recently performed by They Might Be Giants:[43]

What's the cause of this commotion, motion, motion,
Our country through?
It is the ball a-rolling on
For Tippecanoe and Tyler too.

So rousing were Whig sing-alongs that more than forty years later, in 1888, Harrison voter D. W. Thomas told his local Missouri paper, "The campaign was the grandest this country has ever known, and one of the factors that made it so successful was the great number of songs, the glorious Tippecanoe songs, that were sung everywhere."[44] The log cabin campaign was one big party, and millions of Americans RSVPed.

COME ON PEOPLE, NOW

Penny presses were powerful, yes, but they were hardly the most important weapon in the Whigs' arsenal. That would be party conventions. First pioneered during Jackson's institution-busting campaign, part of a broader effort to bring politics to the people, the Whig gatherings were larger and more boisterous than any previous engagement. Thousands of coonskin-flashing, cider barrel-hoisting revelers swarmed the event, all marching behind horse-drawn log cabins erected in Harrison's name. "Some of these cabins were fifty feet long . . . and were drawn by ten or twenty horses, and each horse carried a rider, dressed to suit the momentous occasion. There was no organization and no speaking to amount to anything, the whole

day being taken up in marching, hurrahing and singing," *Democratic Banner* editor Lecky Harper said of the Whigs' first 1840 convention, held in Columbus, Ohio, on February 21.[45] And the *Washington Whig* reported that July, "The cabins are all on fire west of the mountains. . . . There is something which has gone to the very heart of the farmers and working men of this land. The days of the Revolution have returned."[46] Described as absolutely "electrifying,"[47] the singular Columbus convention was a game changer, cementing the log cabin as an icon of people's power. "It started a new epoch, and began a revolution that no human power could check. . . . The people were in it; they made it apparent to unbelievers, infidels, and heathen throughout the world that 'the voice of the people is the voice of God.' "[48] Norton wrote, "Every banner and device and emblem spoke out in rebuke and expressed the honest indignation of the people of Ohio." Norton goes on, "The log cabins spoke in language not to be misunderstood."[49] The Whigs were basically giving Democrats a rhetorical middle finger, and it looked like a log.

Similar scenes flared across the nation in the months ahead: from Utica to St. Louis, Dayton to Winchester, the latter of which saw 10,000 people descend on the small Virginia town to flaunt cabins of various sizes and shapes. And then there was the Baltimore "Young Whigs" convention held in Baltimore on May 4, the same day as the Democratic convention a few blocks away. Relishing the opportunity to flex their muscles in front of their foes, Whig delegates from all twenty-six states brought their A game: The crew from Pennsylvania's Fayette County paraded behind a log cabin pulled by six horses; neighboring Washington County's gang had eight horses pulling theirs; and delegates from Harrison's hometown built a cabin from buckeye trees cut from Harrison's own farm. Taken together, the procession was eight men across and two miles long,[50] and at the end of it stood Pennsylvania Congressman and political powerhouse John Sergeant roaring,

IMAGE 5.9 A campaign button from Harrison's 1840 election.

IMAGE 5.10 A campaign ribbon from the 1840 presidential election, when the Whigs co-opted the log cabin for political gain. *(Cincinnati Museum)*

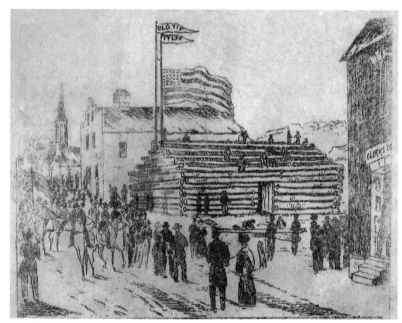

IMAGE 5.11 James Wolcott Adams's 1912 reimagining captures the populist energy of 1840 Whig parades, complete with a mobile log cabin. *(Library of Congress)*

IMAGE 5.12 An engraving of a pro-Harrison log cabin raising in Chillicothe, Ohio, May 1840. *(Ross County Historical Society)*

" 'BOOZE,' AN ORIGIN STORY"

og cabin raisings and sing-alongs are good family fun, sure, but there were more adult outpourings of log cabin love, too. (Emphasis on "pouring.") Entrepreneurial bar owners capitalized on the nation's yen for log cabins and hard cider by covering their taverns in halved logs or, if they were truly enterprising, by throwing together a log cabin expressly as a watering hole. The growing temperance movement was absolutely apoplectic. *The New York Evening Post* grumbled about the Broadway Log Cabin that arose on the city's famous thoroughfare: " 'Log cabins,' with a provision of hard cider, [have] been celebrated with the most beastly origes [sic]." Clergyman and Yale lecturer Leonard Bacon bemoaned, "Intemperance has become the badge of a political party! . . . More than ten thousand men will be made drunkards in one year, by this hard cider enthusiasm."[51] One can only imagine what Bacon thought about the most elaborate of the alcohol-soaked politicking: log cabin-shaped bourbon bottle emblazoned with Harrison's familiar moniker. These bottles were so popular that the Philadelphia-based manufacturer E. G. Booz replicated them from 1858 until about 1870, forever ingraining his surname in American slang.[52]

IMAGE 5.13 An 1860s log cabin bourbon bottle.

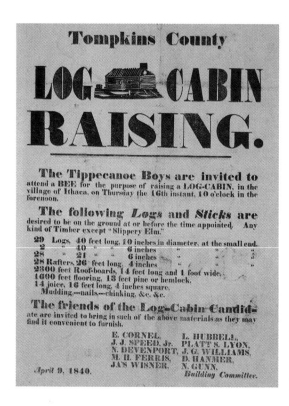

IMAGE 5.14 An early example of experiential marketing, log cabin raisings were an interactive way for the Whigs and Harrison to court new recruits and, as an added value, construct party headquarters in places like Albany, Annapolis, Auburn, Ithaca, and beyond. *(Walnutts Antiques)*

"What have you come for? I will answer. [You came] to bring back to the people, and through the log cabins of the country, the neglected and lost Constitution."[53]

PATRIOTISM, MASS PRODUCED

Barkeeps weren't alone in cashing in on log cabin mania. Factory-driven mass production had replaced the small-scale mercantilism of yore, allowing entrepreneurs to embellish the log cabin on all manner of crap: soap, buttons, bookends, hairbrushes, tea sets, commemorative coins, umbrellas, sandwich plates, paperweights—you name it, it was part of the cornucopia of log cabin merchandise that hit stores that fall. Log cabins were so en vogue that wealthy women wore silk scarves emblazoned with its image. Once just a straightforward hut, the log cabin, an overnight celebrity, was now smack-dab at the nexus of cash and country. Here's the birth of a whole new form of patriotism: to purchase was to pledge allegiance. Today it's almost mandatory for candidates to slap a pithy slogan on a T-shirt or red trucker hat and sell the shit out of their self-branded wares, but mass market political consumerism was innovative back in 1840. Thanks, log cabin!

WILLIAM, ACCOMPLICE

You may be wondering where old Willy Harrison was during all this hoopla. Well, he was running with that log cabin lie, of course.

The political novice pivoted like a pro, seamlessly morphing himself from heroic general into the yeoman farmer the press and his party demanded. Trading silk suits for farmers' cotton and adopting a faux modesty as he traveled around the country, Harrison wasted no time turning the log cabin into his platform's central plank.[54] Far from the prim figure he'd been before, Harrison now claimed that journalist de Ziska, "the unlucky wight who put me in a log cabin," was "nearer the truth than he probably supposed. . . . It is true that a part of my dwelling is a log cabin."[55] Sure, Harrison's sixteen-room mansion *had* once been a log cabin, but that was a long, long time ago. He and his equally wealthy wife had clapboarded the gauche old thing almost immediately, insisting on adding three more rooms before they deigned to move in in 1829, and adjoining another twelve in the years ahead, well before Harrison started stumping as a commoner. But clearly Harrison was more than willing to whitewash this inconvenient truth, appealing to the poor masses as he played coy: "I would have preferred to remain

GENERAL HARRISON,
The true friend of the people!

with my family in the peace and quiet of our log cabin . . . rather than become engaged in political or other disputes." But the Democratic attacks on cabin dwellers like "himself" left him no choice but to take the bull by the horns. The crowd ate it up.

J/K!

Well-aware that their log cabin attack had boomeranged, the panicked Democrats tried to mend their self-inflicted wound by doing something rare in American politics: They told the truth. Harrison was rich and the Whigs were playing voters for fools. "General Harrison is not a poor man, nor does he live in a log cabin," Ohio Democrat Alexander Duncan proclaimed on the floor of Congress in April 1840. "General Harrison is neither to be cherished nor repudiated by the log cabin fiction: the whole is a hoax, attempted to be played off for political effect."[56] The Democratic *Extra Globe* railed, "The real truth is that city Whigs consider the political log cabin a device to gull the inhabitants of the real log cabin, and their course in using it is an insult to the latter."[57] And a pro-Van Buren cartoon blared that the log cabin was but a trap "invented by the 'bank-parlor, Ruffle-shirt, silk-stocking' Gentry, for catching the 'votes' of the industrious and laboring classes."[58] This was all true, of course, but the laboring classes weren't hearing it. Voters were too enthralled by the log cabin fib. The ardor was so overwhelming that eyewitnesses who visited Harrison even described his manse as a "cabin." One admirer told the *Rochester Democrat*, "Gen-

IMAGE 5.16 Harrison was more than willing to don political drag to win over voters. *(Ohio Historical Connection)*

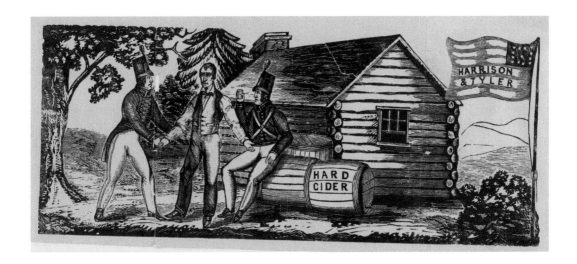

eral Harrison came from his Log Cabin" when she pilgrimaged to his farm. She gushed, "Indeed, to see him actually called from his home in the forest, where he dwells in such quietness and peace, to receive his plaudits of the people . . . seemed to me one of the most glorious, enobling scenes that could be conceived of . . . He remarked that he had never sought to change his position—HE GLORIED IN BEING AN AMERICAN FARMER . . ." And, yes, that emphasis is all her. Only later did this rabid Harrison fan edit her remarks about the "log cabin," "The house is large and the logs covered and painted white."[59] Ah, the tell-tale clapboard. Yet the story stuck, and even 175 years after Harrison's campaign and the truth was well-established, you can find historians claiming that Harrison had actually built the fantastical log cabin himself![60]

In case you hadn't guessed, Harrison's win in that election was an absolute landslide. Securing 234 electoral votes to incumbent Van Buren's slim sixty, Harrison's popularity helped the Whig majority in both the House and the Senate. But the biggest victory of all was for the log cabin. The Whigs had used misdirection and mendacity

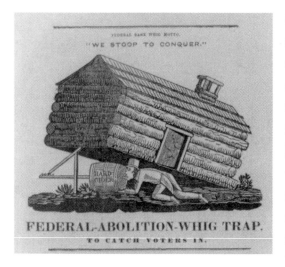

FEDERAL BANK WHIG MOTTO.

"WE STOOP TO CONQUER."

FEDERAL-ABOLITION-WHIG TRAP.

TO CATCH VOTERS IN.

IMAGE 5.18 This cartoon, one of the Democrats' last-ditch attempts at debunking Harrison's log-cabin lie, included a caption reading, "The 'log cabin' is raised to blind you with the belief, that they are your friends." *(Library of Congress)*

to reclaim and rebrand the once-dismissed structure, turning it into something greater than just a building. And voters, already predisposed to idolizing the log cabin, willingly overlooked facts for the sake of palatable fantasy. They *wanted* Harrison to live in a log cabin. As with the Jackson election, 1840 voters were professing the countryman's role in inventing tomorrow, showing that their voices mattered. They were declaring themselves equally as qualified to run the White House as any career politician—this was the land of opportunity, after all. "The great mass of the American people never will suffer the poor man to be shamed and despised," a the *Washington Whig* declared in late July 1840. "His claims shall never be put down because he lives in a log cabin and not a marble palace."[61] The log cabin was no longer something to be ashamed of; it was now a source of pride. It was dignified. Now greater than just a structure, or even a mascot for a particular candidate, the log cabin had become a shared symbol that both reinforced the common man's ascendant self-image and told the powers-that-be to take a long walk. (This, we'll see later, also helps support the rags-to-riches/logs-to-luxury parable that grows in the years to come.)

But the log cabin's symbolism here was more than just "speaking out in rebuke." It was on its way to becoming a larger, cross-class concept. Far more potent than just a proxy for populism, it was becoming a stand-in for allegedly universal American characteristics, like fierce self-reliance, exemplary ruggedness, and untiring but inherently honest resolve. Political machination and mechanized mass production remodeled the once-contemptible log cabin into the archetype of "authentic" American values, into an indelible and unimpeachable insignia

of national virtue. The log cabin was morality in four walls. Hannah Farnham Sawyer Lee's best-selling 1844 work *The Log Cabin: Or, The World Before You* was sold as a "doctrine" on downhome ethics, complete with an editor's foreword declaring the fictional memoir a template for "moral and intellectual culture." Future congressman Thomas Allen mused in 1846, "When I see the humblest dwelling, adorned by a yard of shrubbery and flowers, however small, laid out and preserved in order and neatness, I consider it a good mark . . . an evidence of better things unseen."[62] This is a far cry from the log cabin's licentious public image only a few decades hence.

Log cabins were now so revered that Orsamus Turner, in his 1849 history of western New York, turned the famously "miserable" and vermin-infested structure into a luxury: "[The settlers'] log houses—their rude, imperfect accommodations, were luxuries in those primitive times; havens of rest and comfort for the weary emigrant and his fam-

IMAGE 5.19 An 1840 vote map contrasts the Whigs' 1836 loss to their mega win come 1840, the year they used the log cabin to dupe the masses. *(Library of Congress)*

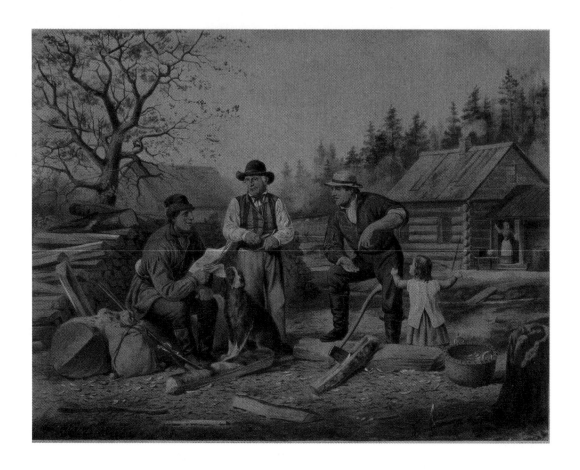

ily, and the land explorer."[63] And though Buffalo-based businessman Lewis Allen echoed judgy Yale president Timothy Dwight in an 1852 grouse about "squalid" abodes' deleterious moral impact ("A miserable tenement . . . can lead to no elevation of character, no improvement in condition, either social or moral, of its occupants"), Allen held the log cabin respectfully apart: "A log cabin . . . and I speak of this primitive American structure with profound affection and regard, as the shelter from which we have achieved the most of our prodigious and rapid agricultural conquests,—may be so constructed as to speak an

air of neatness, intelligence, and even refinement in those who inhabit it."[64] Even the unwashed could have an air of dignity.

It was this implicit, assumed moral code that secured the log cabin's place in the political realm, and the next decades see it trotted out election after election, readily deployed to give candidates an extra dose of realness. Nathaniel Hawthorne's 1852 biography of Franklin Pierce diluted the candidate's enormous wealth by emphasizing his log cabin childhood; James Buchanan's biographer did the same in 1856; and though split rails were the official mascot of Abe Lincoln's 1860 campaign, biographer William Dean Howells made multiple references to the candidate's childhood cabins. "The rude cabin of the settler is hastily erected,"[65] he wrote of the home Lincoln's father built in Indiana; and later, after the nomadic family moved to Illinois, "father and son built a log-cabin, and split rails enough to fence in their land."[66] A completely different 1860 biography meanwhile noted, "Like President Harrison, Mr. Lincoln has spent about one third part of his life in a log cabin,"[67] and Greeley's *New York Tribune* reminded readers that Lincoln, full of "the genuine, whole-souled manliness of a Kentucky-born, Western raised, self-educated, and self-made man,"[68] learned to read "by the evening firelight of rude log cabins."[69] Lincoln, the paper wrote, should be "hugged to the people's hearts like a second Andrew Jackson." Naturally Lincoln's foes tried to fight back, criticizing Abe and his Republicans for regurgitating the log cabin "doggerel" of 1840,[70] but they were barking up the wrong tree. The log cabin was simply too irresistible. And in this case hardship was actually real. Fiction or non, in all these cases, the crudity of the log cabin made the subject's rise more remarkable. The rags-to-riches aspect made it absolutely alluring to a nation increasingly obsessed with breaking social ranks. "To be the architect of your own fortune [in America] is honorable," said one visitor in 1798. "It is the highest recommendation."[71]

The log cabin remained a politically potent tool long after Cadillacs replaced locomotives and nuclear arms overtook cannonballs. It

rises like a phoenix in the 1950s, and in the 1980s, the political journalist Howard Fineman took wealthy candidates to task for misrepresenting their moneyed pasts: "Many of the candidates' early lives were as placid as *Leave It to Beaver*. But to hear them tell it, their characters were formed in crucibles as hard as *The Grapes of Wrath*."[72] And the log cabin's rustic silhouette is there whenever a candidate dresses themselves down to appear more common. Bill Clinton was only half-joking when he remarked in 2012, "One of the greatest chairmen the Democratic Party ever had, Bob Strauss, used to say that every politician wants every voter to believe he was born in a log cabin he built himself."[73]

But even still the log cabin was already so much more than just a political tool. It was mutating into a marketing gimmick, a piece of prepackaged, mass-produced kitsch sold as a talisman of American authenticity, exceptionalism, and purity. With the Romantic

era laying the groundwork, and Jackson and Harrison leading the way, altering the sociopolitical DNA of America, the lines between fact and fiction, authenticity and assembly line, are here starting to blur, and they would grow only hazier in the years ahead, eventually being obliterated entirely as the log cabin was catapulted into full-blown myth.

IMAGE 5.22 A ticket for the 1896 Republican National Convention featuring late leader Ulysses S. Grant's log cabin, Hardscrabble, the second most famous presidential log cabin. *(Missouri History Museum, St. Louis)*

· 6 ·

AN AMERICAN MYTH, VOL. 1

IT'S MAY 13, 1857, and John Tyler is happier than a pig in shit. It had been twelve years since the unpopular former president was nudged from the White House, an office he inherited after poor William Henry Harrison died. Tyler was never meant to be president; hell, the Whigs didn't even want the Democrat-leaning Virginian to be veep. He was only on the ticket for the Southern vote, and his behavior after Harrison's death 32 days into his term didn't help matters. This being long before the post-JFK 25th amendment, people weren't really quite sure how to proceed when a president kicked the bucket. So, as everyone else was scratching their heads over what to do next, power-hungry Tyler just assumed the position, no questions asked, and then, gallingly, proceeded to veto almost all of his own party's legislation. Revolted by "His Accidency," the Whigs officially ousted him from the party a few months later. Now persona non grata as far as the Whigs were concerned, Tyler found little friendship among Democrats repulsed by his past Whiggery. With no one to put him up for reelection, the disgraced politico retreated into a lonely, self-imposed exile on his palatial, slave-run Virginia plantation, a property once known as Walnut Grove,[1]

THE TURN OF THE TUNE.
TRAVELER PLAYING THE "ARKANSAW TRAVELER"

but which wannabe martyr Tyler renamed Sherwood Forest, an allusion to another famous outlaw, Robin Hood. But all that was in the past. This fine May morning was Jamestown's 250th birthday, and Tyler was the keynote speaker at the spectacular event. Seven thousand spectators had turned out, marching behind a military parade to the symbolically consecrated spot where the Jamestown colonists allegedly landed over two centuries before. Sixteen streamer-adorned steamers shot water arches across the James River, and the playing of "The Star-Spangled Banner" "seemed to send throughout the great assemblage a thrill of patriotic joy."[2] Newspapermen from all over the world had turned out to cover the commemoration, a landmark event for the young country. But in Tyler's mind, everyone was there just for him—this was his triumphant return to the national stage!—and Tyler planned on taking full advantage.

Clocking in at just under three hours, Tyler's remarks that day recalled in great fabricated detail how Jamestown's supposed log cab-

IMAGE 6.1 The log cabin myth-making we know so well today was just getting started when E. P. Washburn completed this jolly image in 1859. *(Ackland Art Museum, The University of North Carolina at Chapel Hill / Art Resource, NY)*

ins spawned an empire for the ages. "On this day two hundred and fifty years ago, those tempest-tost [sic] vessels swung quietly on their anchors in yonder stream, and that body of adventurers landed on this beach and prepared to make it the place of their abode." Then, in the next revisionist instant: "The log cabin is built, its covering of reeds." The land, thus "reclaimed" from "its long night of barbarism and deep gloom," grew into a "mighty empire," said Tyler, an ardent proponent of expansionist[3] Manifest Destiny.[4] And it was with this imperialist zest in his heart that Tyler concluded, "[Our empire] sprung up, its growth at first sickly . . . but finally it grew and flourished, until at this day millions of the human family shelter under its branches, and its leaves are watered by the dews of two oceans."[5] What a sap.

But if you think Tyler was dramatic, check out Virginia Governor Henry A. Wise's graphic depiction of Jamestown's pretend log cabins as the nation's great white hope—and, yes, the racialized capitalizations are his: "This place is sacred. . . . Here the White man first met the Red, for settlement and colonization. Here the White man first wielded the axe to cut *the first tree*, for *the first log cabin*!" Note his special emphasis on "cut the first tree" and "first log cabin." Wise continues, "Here was the very foundation of a nation of freemen which has stretched its dominion and its millions across to continent to the shores of another ocean."[6]

Reprinted from coast to coast, these men's words were instrumental in spreading the log cabin legend: the self-creation narrative that Pilgrims and early colonists, those commendable "first Americans," invented the log cabin on the spot, using it as a springboard to create an underdog country that became a global power. But Tyler and Wise weren't alone. They were part of a growing cluster of authors and artists who purposefully overlooked actual facts to project the log cabin into the past, to create a foundation narrative in which the log cabin was a colonial invention that secured America's future. In this distorted, oddly Anglocentric worldview, the English—and no

FIRST MEETING HOUSE.

one else—were responsible for this miraculous turn of events.[7] They and they alone had planted the log cabin, that acorn from which our sprawling, divine, great oak of a nation had grown. All nations need mythical origin stories, and here we see ours coming into focus. It was a more expansive version of the rags-to-riches story first applied to people like Harrison and Jackson. Now it covered the whole nation. And the cabin was its centerpiece.

It was a slow process at first, this collective historic revisionism, and some of the instigators were cautious. Though a Whig writing in 1840, the height of log cabin mania, Reverend Alexander Young managed remarkable restraint by adding a qualifying "probably" to this 1841 note about Plymouth's Pilgrims living in log cabins: "Their houses were *probably* log-huts, thatched and their interstices filled with clay" (emphasis mine).[8] There's no such "probably," however, in George Bethune's 1852 essay claiming Puritans, Presbyterians, Quakers, and the like were too busy to make fine art because "men living in

IMAGE 6.2 David E. Field, and his 1853 image of Middletown, Connecticut, was one of the first artists to take license with America's origin story. (*The Widener Library, Harvard University*)

Another early reimagining of America's beginning, this one by Washington Allston. *(Library of Congress)*

log cabins and busied all the day in field, workshop, or warehouse, and liable to attack by savage enemies at any moment, were indisposed to seek after or encourage what was not immediately useful."[9] The logic's right, but the architecture's wrong.

Meanwhile, Henry Bronson firmly set Connecticut's Anglo settlers in log cabins in his 1858 history of Waterbury, Connecticut: "dwellings [were] made mainly of logs prepared by an axe."[10] Two years later we see historian C. M. Endicott claim that Salem circa 1670 included "half score of log cabins."[11] And that same year, John G. Palfrey included this tentative but impactful note in his *History of New England*: "At the very earliest period, it was necessary for the [colonists] to be content with any sort of shelter from the weather . . . the [first] settlers, it is probable, made themselves comfortable in *log-houses*, of construction similar to those which are still seen in new settlements, wherever made in the United States."[12] Here the Pilgrims' landing and then-present-

day expansion are directly linked. Palfrey's "probable" is notable, yes, but it's also clear he and his peers saw contemporary settlers as a new generation of founding fathers.

Considered the "law and gospel of New England history,"[13] readers and fellow historians took Palfrey's remarks sans salt, and icing was added in the form of Washington Allston's sketch of the quotidian *House of the Early Settler*, complete with this note: "[The image] will convey a substantially correct idea of what was probably the home of a majority of the New England colonists for a considerable period." But Palfrey's "probably" would soon be in the solid minority, because these little flurries of false histories were joined by more forceful, more assertive flakes, all whipping up a blizzard of anachronisms that would whitewash American history, and all in the name of a pristine, self-ennobling national origin story.

YESTERDAY, ALL OUR TROUBLES . . .

Harrison's log cabin campaign alone can't explain this delusional grasp on the past. It's partially influenced by the nostalgia seen in the Swedes' 1748 memorial mentioned earlier, of course, and in Erastus Worthington's 1827 claim that founding farmers of Dedham, Massachusetts, concocted "very rude and inconvenient" houses that "were probably log-houses."[14] The first known cabin-as-American-origin-story, Worthington's version most likely sprang as much from historical ignorance as from the inchoate nostalgia of an accelerating culture, even if Worthington wasn't conscious of it. And it was this same longing that was mutating the log cabin myth in this post-1840 landscape. The world was moving at an incredible speed, hurled ever further into a new era by technological leaps. Railroads had upended old ways of life, compressing time and space with their seemingly supernatural speeds. Baltimore and Ohio were linked by rail by 1830, and much of the Eastern

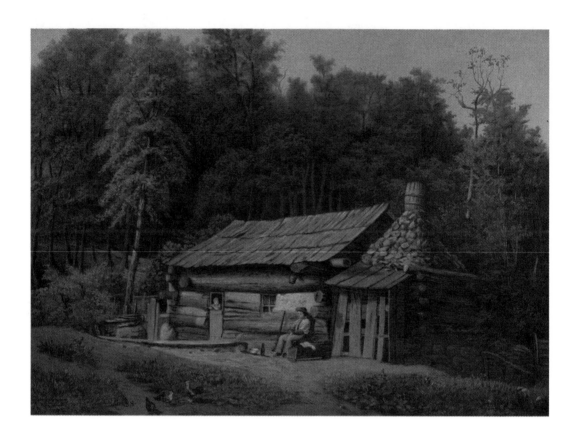

IMAGE 6.4 Entered into the Library of Congress in 1870, this unsigned work's cider-barrel chimney is a shout-out to 1840, the election that released the log cabin's symbolic potential. *(Library of Congress)*

seaboard had similar routes come 1835. By 1850, more than 9,000 miles of rail had been laid, bringing both the promise of dizzying progress and the nostalgic anxiety that comes with it. This complex was of course compounded by the insatiable lumber industry that was gobbling up huge stretches of the Northeast and would soon move into Minnesota, Wisconsin, and the South, threatening the natural resources that had defined us for generations. And long-simmering tensions over slavery didn't help matters: The nation was confronting its dark side and staring into an abyss. All this and more contributed to a sinking feeling that the nation, on such an upward orbit, was headed for a reckoning. With so much change on the horizon, so much destiny manifesting, so much

THE HUNTER'S SHANTY.
IN THE ADIRONDACKS.

land being trampled, the American people needed to know where they came from before it was all gone.

A continuation of Cole, Cooper, and company's purposeful reminiscing, Americans of the 1850s and 1860s were looking back to make sense of the present, creating a clear, coherent trajectory: a shared sense of past and purpose. As President Tyler said that May day, right before launching into his log cabin lie, "The memory of a glorious ancestry should be kept bright in the recollections of their posterity; and their noble daring in the cause of civilization."[15] To him and so many others, the log cabin was a touchstone of the past, a venerable relic that brought

IMAGE 6.5 *The Hunter's Shanty* gussies up shacks that were far flimsier than actual log cabins. *(The Museum of the City of New York / Art Resource, NY)*

relief and direction in troubled times. Jackson and these historians were trying to maintain constancy in the face of relentless change, concocting the history people wanted, not only the one they deserved—and their efforts would become even more desperate in the trying days ahead.

BRO V. BRO

Six hundred twenty thousand confirmed dead. An estimated 420,000 wounded. At least 50,000 civilian fatalities and hundreds of thousands of acres destroyed. The Civil War was devastating. It was, to quote Mark Twain, "cataclysmic." Obliterating the old way of life, The War for the Union "uprooted institutions that were centuries old."[16] It forever "changed the politics of a people, transformed the social life of half the country, and wrought so profoundly upon the entire national character that the influence cannot be measured short of two or three generations." And more immediately, the war's 1865 end left the shattered states with millions of new citizens and the daunting task of reconstructing themselves into a more perfect union, a duty made even more harrowing after President Lincoln's violent death. As Greeley wrote in 1868, antebellum America was an "anxious, plodding age."[17]

It was the greatest trauma the nation had ever faced, leaving stunned Americans gaping into their most uncertain future yet forcing fresh debates over what it meant to be American—ten million formerly enslaved people had just become citizens, after all—and there was still the cognitive dissonance surrounding steely, alienating industrialism, a threat to traditions and resources alike. The prewar problems remained, only bigger. The steady, stable log cabin was one of the only things that made sense, and this era sees it grafted onto America's past with greater ferocity as the nation tried to reconstruct itself. Once stigmatized and now coveted, it was a totem around which North and South could both rally. Northerner Benson J. Lossing even extended Jamestown the cour-

tesy of made-up log-cabin roots, writing in 1875, ahead of the nation's centennial, that this epicenter of American civilization began with "a large number of humble log cabins."[18] That said, it should come as no surprise that phony log cabin histories had a renaissance in these years.

There was a veritable library of new "log cabin as American seed" stories. Edward E. Atwater insisted in 1881 that New Haven's colonists built log huts "similar to the modern log-cabins in the forests of the west;"[19] Yale president Noah Porter claimed in 1883 that New England meeting houses, the community hubs whose "erection was the starting point of every one of the earlier New England communities,"[20] "were doubtless built of logs and thatched, with here and there a possible exception."[21] We know now that exceptions "here and

IMAGE 6.6 A burning tree lights Union troops' way in journalist Edwin Forbes's illustration, *Night March. (Library of Congress)*

IMAGES 6.7–6.8 As in 1776, the log cabin doubled as triage during the Civil War. Here, a field hospital during the Battle of Chancellorsville, by Edwin Forbes, the same artist who sketched Union soldiers building log cabin winter lodges, below. *(Library of Congress; Photography Collection, The New York Public Library)*

there" were actually "everywhere," but the log cabin misinformation was too entrenched and too attractive to be undone, as seen in William B. Weeden's highly stylized 1890 version of Boston's evolution: "The 'hovels and huts,' *i.e., log cabins of the settlers*" (emphasis mine) were later "transformed into 'orderly and well-built' houses."[22] Meanwhille, though we hear from more southern revisionists after the turn of the century, when myth-making becomes myth-perpetuating, Virginian historian Philip Alexander Bruce did his region proud with his 1896 avowal that "undressed logs were doubtless the material principally in use" in early Jamestown.[23] (Not incidentally, this was also the start of the earthy, organic, arts-and-crafts arts movement, which put a premium on traditional craftsmanship—kind of like wares catering to lumbersexuals and prairie women today.)

Yes, a few brave historians tried to dislodge the dubious, Anglo-centric log cabin origin story. Palfrey even issued a clarification in the 1872 reprint of his New England history, "We have no positive knowledge respecting the construction of dwellings of the generality of settlers. It is *probable, but not certain*, that they first erected log-houses, like those commonly used, at the present day, in the new settlements of America"[24] (emphasis mine). But Palfrey's protests were lost in an avalanche of myth-making. Any and all efforts to squash romanticized log cabin lore fell on deaf ears. It was—and is—far too tempting to cast our Founding Fathers as log cabin-dwelling pioneers, an image that nurtures the nation's own rough-and-tumble self-perception. We wanted—and want—to believe that the high and mighty United States sprang from something as elementary as a log cabin. We wanted to believe that we had defied the odds, and would continue to do so. Gazing upon the "uncouth" but "noble" cabin, Reverend William Barrows wrote in 1884, "create[s] a marvel in our minds, that we of to-day are living so near to the era of ancient history in America, and yet so far advanced in our development and institutions."[25]

ARRIVAL AT JAMESTOWN, 1607.

BLOCK AND HIS COMPANIONS ON MANHATTAN ISLAND BUILDING A VESSEL.

IMAGES 6.9–6.10 David B. Scott gave Tyler's Jamestown lie new life with this 1878 illustration, part of a children's history lesson. Scott was so hot on log cabins that he placed them on Manhattan, too. *(Library of Congress)*

Omnipresent, respected, and already imbued with transformative powers, the log cabin remained the perfect American origin story for North and South alike: It reinforced the rugged, independent, somewhat brash but meritorious self-image we had created for ourselves. This cabin-shaped foundation narrative catered to the appetites and prejudices of a society that preferred self-aggrandizing to actual fact, standardizing a fable in which the underdog United States defied every odd, overcame every obstacle, and crushed every "it," whatever it is.[26] Like a "self-made man," we were a "self-made country," all thanks to that universal, democratic launching pad, the log cabin. The log cabin's simplicity fed into our ripening notions of American exceptionalism:[27] the idea that we are somehow above and beyond any other people on Earth. That's why Alfred Dennett's "Lincoln birth cabin," the one we encountered in the first chapter, was such a hit at the Tennessee Centennial in 1897, and why, five years earlier, the 1893 Columbian Exposition included a replica of the cabin Abe's father Thomas built in 1840, after his son had moved away. These were the physical manifestations of ongoing myth-making.

THE ART OF THE LOG

False histories went a long way in establishing the "log cabin as American roots" myth, but they weren't nearly as enchanting, as all-pervasive, or ultimately as persuasive as the colorful, cheery, and equally specious illustratious that arose alongside them, perpetuating the same erroneous notions, only in vibrant color. Just as newly up-and-running penny presses transformed publishing and politics in the 1830s, so too did the new visual media of lithography create a whole new audience, completely reconstruct art and history, blending the two into a hodgepodge in which the log cabin represented both the quaint, far-off past and the buoyant route to progress. They were essentially four-color advertise-

The
lithograph company
Schaerff and Brother
integrated a simple
geological survey
into a larger national
fable when they mass
produced George
Swallows' *Granby in
1857.*

ments for Manifest Destiny and the unfettered, unapologetic, unques-
tionably "divine" westward migration that went with it.

Take, for example, *Granby in 1857.* It originally ran in an 1859 geo-
logical report on the Missouri mining town's explosive growth: "In
the fall of 1854, there was not a cabin on the site where Granby now
stands with several thousand inhabitants."[28] A mere five years later
there was a booming economy that promised to deliver fresh riches to
the region again, as ever, thanks to the log cabin. Eager to feed the cult
of progress, the vanguard lithograph company Schaerff and Brother
licensed the optimistic image and reproduced it by the hundreds, and
sent it out as a expansionist-soaked piece of propaganda. Log cabins
were once again a civilizing force.

And so it was too over at Currier and Ives, an influential and mono-
lithic company that described itself as the "Grand Central Depot" for

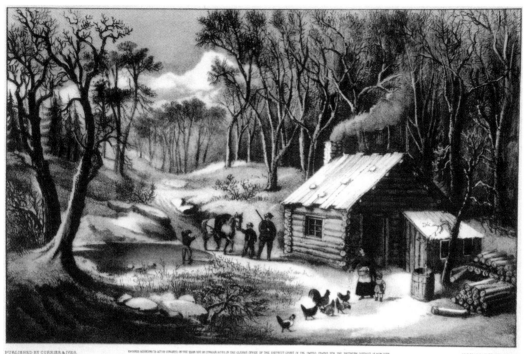

PUBLISHED BY CURRIER & IVES.

A HOME IN THE WILDERNESS.

152 NASSAU ST. NEW YORK

"color engravings for the people." They wanted to bring art to the common man—and they did, using an assembly line of elderly women, mostly German, to hand-color black-and-white images created by a stable of art stars that included A. F. Tait, Louis Maurer, and Frances Flora Bond Palmer, the first American woman to "make it" as an artist—that is, to be given assignments and get paid for her work. And like so many others, Palmer's assignments required satisfying the discordant appetites for progress and stability.

Lithographs weren't the only new media of the day. Travel brochures and postcards soon joined the mass market, too, delivering imaginative, illusory images to the reader's door, saturating the market with spirited figments of log cabin Pilgrims and peppy scenes of western

IMAGE 6.12 The 1870 lighograph *A Home in the Wilderness*, another of the prolific Currier and Ives's hit singles. *(JT Vintage / Art Resource, NY)*

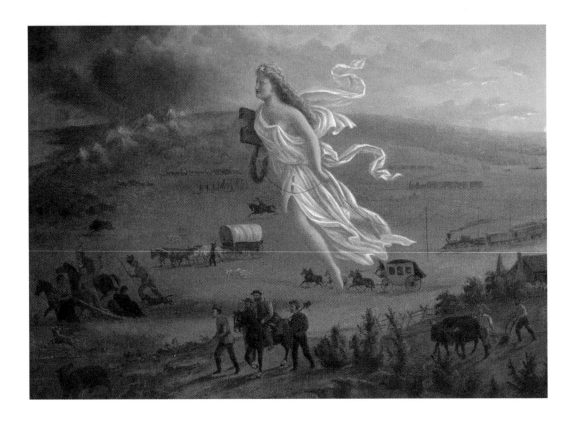

sprawl. There was no crudity here—none of the bugs and bother associated with actual log cabin living. More like crudités—all sunshine and delight. Taken as a whole, these images, whether postcard or lithograph, were essentially four-color advertisements for ego-boosting Manifest Destiny and the unfettered, unapologetic, and unquestionably "divine" westward thrust that went with it, and the log cabin's place therein. But more than just myth-making and expansion-championing, these images are a continuation of the patriotic consumption first seen in 1840.

Perhaps the most illuminating example of this trend is John Gast's 1872 oil painting *American Progress*. Though revered as a masterpiece today, it was originally commissioned by publisher George A. Crofutt as a cheap one-off for a travel guide, but the image, an immaculate

W. L. WILLIAMS

o Gast goes the glory, but there was another, less famous painter who deserves recognition for establishing the log cabin origin story: W. L. Williams. Not much is known about Williams, but we do know that at some point in the early 1890s he was commissioned to create a series of "historic Plymouth" postcards, including the *First Meeting House* image in the introduction. Looking for inspiration, Williams turned to the long-dead Isaack de Rasieres,[29] a Dutch diplomat whose detailed 1627 notes of early American architecture had become a go-to primary source for artists and historians of the era. Reading through the diary, Williams came upon this entry about Plymouth: "Upon the hill they have a large square house . . . built of thick sawn planks stayed with oak beams."[30] Awash in log cabin adoration of his era, Williams mistranslated de Rasieres's description of "oak beams" as "oak logs," thus reimagining the actual clapboard homes as the log cabins with which our nation is so familiar. But reading de Rasieres's entry in its entirety, it's clear the houses weren't log cabins at all: "The houses are constructed of clapboards, with gardens also enclosed behind and at the sides with clapboards."[31] Williams either didn't see or willfully ignored the "clapboard" reference. (The artist Samuel Chamberlain did the same thing with his image "Leyden Street, Plymouth in 1627."[32]) In any event, Williams went ahead with his assignment, and though he didn't become famous, his images did. *Extremely*. Especially the one below, *Plymouth in 1622*.

Hawked as real history, this fantastical depiction was subsequently reproduced by the boatload, first by an independent souvenir dealer named Alfred Stevens Burbank, who published a book claiming, "Leyden Street is pictured as it appears in the old plan of 'the original laying out,' "[33] and then by the Detroit Publishing Company, the pioneers of the modern postcard. And it must have been a huge moneymaker, because the company distributed thousands of copies of Williams's *Plymouth in 1622* to schoolhouses across the land, presenting it as actual fact and from thenceforth indoctrinating generation upon generation with the erroneous

notion that English colonists invented the log cabin. And nevermind decades' worth of evidence demystifying this myth, *Plymouth in 1622* can still be found in classrooms today. R. W. Emerson Junior High School in Davis, California, used it in a lesson plan as recently as 2013. But it wasn't just schoolmarms peddling this crap. *Plymouth in 1622* has appeared in dozens of books, from Winnifred Cockshott's 1909 offering *The Pilgrim Fathers: Their Church and Colony* to the 1983 book *Settlers: The Mythology of the White Proletariat from Mayflower to Modern*, reprinted in 2014. In between, the image was seen in Edwin Markham's 1914 tome *The Real America in Romance*, William Chauncy Langdon's 1937 offering *Everyday Things in American Life, 16071776*, and more recently in a biography of George Washington published in 2012, long after this little piece of bunk had been deflated. What was that Hunter S. Thompson quote again?

COPYRIGHTED AND PUBLISHED BY A. S. BURBANK PLYMOUTH, MASS.

COPYRIGHT BY A.S.BURBANK 1901. STORE HOUSE. P. BROWN. J. GOODMAN. W. BREWSTER. J. BILLINGTON. LALLERTON. F. COOKE. E. WINSLOW. OLD FORT. **PLYMOUTH** IN **1622.** GOV'R BRADFORD.

13997 PLYMOUTH COLONY IN 1622

IMAGE 6.14 W. L. Williams' imaginative postcard soon became standard issue, spreading log cabin lies across the land. *(Library of Congress)*

encapsulation of the Manifest Destiny mind-set—an angelic Columbia leads pioneers into the darkness, leaving light and civilizing log cabins in their wake—immediately took on a life of its own. Reprinted the world over, it went far in reinforcing the impression that the log cabin was more than just a humble structure: The cabin was a divine force unleashed by the righteous. Hell, it *was* righteous.

That's certainly the thesis of Frederick Jackson Turner's 1893 eulogy to the frontier, written in a panic after the 1890 US Census declared the erstwhile hinterlands conquered, destiny completely manifested. Settlement had stretched so far that "there can hardly be said to be a frontier line,"[34] read the government report, spurring Turner to glorify the lost land thusly, "It was a naturally radical society . . . characterized by the small farmer, building his log cabin in the wilderness, raising a small crop and a few animals for family use."[35] He went on, "The pioneer had the creative vision of a new order of society. In imagination he pushed back the forest boundary to the confines of a mighty Commonwealth; he willed that log cabins should become the lofty buildings of great cities."[36] Turner sees the cabin as the indispensable epicenter of our democracy, our empire, and our selves. Not a bad gig if you can get it.

IMAGE 6.15 Patent medicine maven and marketing guru H. H. Warner built a wide-ranging log cabin-branded empire that included tonics; sarsaparilla; consumption remedy; rose cream; liver pills; scalpine, a nebulous extract; something called blood purifier; and an arts book for kiddies. *(Courtesy of Stephen Jackson, Warner's Safe Blog)*

THE LOG CABIN, AN AMERICAN BRAND

With all this log cabin fervor, it's only natural that America's capitalist class would tap into the hoopla, adopting the log cabin as a brand mas-

cot to lend their products an automatic air of authenticity and home-grown goodness. One of the most successful businessmen to use the log cabin's popularity to sell their respective, sometimes less-than-respectable wares was advertising guru Hulbert Harrington Warner, who in 1887 launched an entire line of "Log Cabin" patent medicines. But he wasn't alone: 1887 also saw the emergence of Towle's Log Cabin Syrup, and both were soon followed by Peacemaker Coffee in a log cabin-shaped tin.

Elsewhere in the free market, William M. Thayer launched his *From Log-Cabin to the White House* franchise in 1880; W. H. Milburn's 1892 book *The Lance, Cross and Canoe* finally acknowledged Andrew Jackson's birth cabin seen earlier; and two years later the children's book publishers McLoughlin Brothers produced a board game called "From Log Cabin to White House." And the first hints of Lincoln cabin worship gurgled too, when Thomas Lincoln's log cabin was displayed at the Tennessee Centennial in 1897. All these

IMAGE 6.18 A mid-century ad for log cabin-branding stalwart Towle's Log Cabin Syrup. *(Courtesy the Hoboken Historical Museum)*

IMAGE 6.19 The log cabin would become a powerful marketing tool in the late nineteenth century, selling everything from fabricated history to cocaine! *(914 collection/Alamy Stock Photo)*

and more perpetuated the great American notion that if you can make it there, i.e., the log cabin, you could make it anywhere else in the States, a concept that becomes more prevalent, and not to mention more materialistic, in the twentieth century.

The log cabin, not too long ago a contemptible hovel, had taken on some major new identities over the past four decades or so: it was a populist icon, an at-once-coarse-yet-dignified memento of the past, and an optimistic vehicle toward the future. Manifest Destiny reinforced the idea that the erection of a log cabin is a divine act, while improved methods of mass production turned it into a businessman's dream: a trusted image that built brands that still exist today. Needless to say, things are starting to get complicated for the formerly straightforward little cabin. But you ain't seen nothing yet.

IMAGE 6.20 New York-based publisher Street & Smith used the log cabin's market appeal to sell dime novels from 1889 to 1896. *(Hess Collection, Children's Literature Research Collections, University of Minnesota Libraries, Minneapolis)*

HARD NOTCH

The Log Cabin and that "Peculiar Institution"

> "Our cabin was separate and distinct from
> the others. It contained two rooms, one
> up and one down, with a window in each
> room. This cabin was about 25 feet from the
> kitchen of the manor house . . . from which
> each slave received his or her weekly ration,
> about 20 pounds of food each."
>
> —ANNIE YOUNG HENSON, FREED SLAVE,
> NORTHUMBERLAND COUNTY, VIRGINIA[1]

MS. HENSON'S REMARKS, given to the Slave Narrative Project in 1937, sum up the slave cabin's distinct place in America's log cabin lore. It's removed and apart. It's segregated, both physically and symbolically. Just as bugs and insects were expunged from Romantic paintings and cheery postcards, the horrors of slavery are carefully erased from the log cabin fiction, lest they tarnish the nation's "for the people" credo. This sort of selective memory is a necessary evil in concocting national myths. Willful ignorance is bliss when creating origin stories: The dark must be eclipsed by the

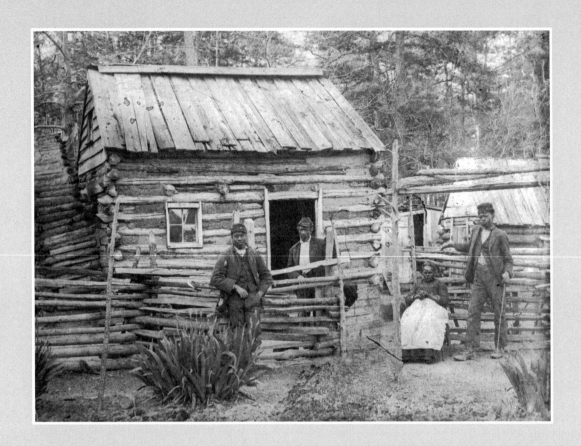

IMAGE HN.1 Slave cabins like this one were carefully removed from the log cabin myth. *(The Valentine)*

light, and lore must be whitewashed to cover any and all blemishes, especially one so ruinous and self-contradictory as slavery in America.

As well-built as some slave cabins may have been, like Henson's, with its airy, light-giving windows, many, *many* more were rundown shanties, including the Alabama cabin in which Mary Ella Grandberry was confined: "There was a lot of cabins for the slaves, but they wasn't fitten for nobody to live in. We just had to put up with them."[2] And while Harriet Beecher Stowe idolized Uncle Tom's Cabin as a symbol for subservient Christian righteousness, "dilapidated" was the more accurate word, as used by Frederick Law Olmsted in describing slave cabins in Virginia.[3] And up to fourteen slaves were kept in a single-

room cabin at J. Eli Gregg's Georgia plantation, caged like dogs at night so they could be sent into the field come sunrise. This was not the expansive freedom of the white settlers' log cabins. There was no agency in these "slave quarters," a sobriquet that further disconnects these stockades from mainstream America's beloved log cabin. Slave cabins were prisons, pure and simple, and were often lined in orderly little rows, all the better for an overseer to surveil. These cabins were about oppression, not autonomy.

Yes, there were rare pre-Emancipation instances in which log cabins represented self-determination for black people. A few slaves fortunate enough to buy their freedom lived in log cabins, as did runaways who miraculously escaped physical bondage, often by hiding in log cabins along the Underground Railroad before settling ones of their own. German botanist Johann Schoepf writes, "Fugitives lived in security and plenty, building themselves cabins, planting corn, raising hogs and fowls."[4] Blacks in free states also lived in log cabins: a woman named Sarah Bass and her children lived in an Arkansas log

IMAGE HN.3 Will S. Hays's 1871 minstrel song "The Little Old Log Cabin in the Lane," captures a slave or former slave's longing to escape the cabin:

Oh I ain't got long to stay here what little time I've got
I want to rest content while I remain
'Til death shall call this dog and me to find a better home
And leave th' little old log cabin in the lane.

The song would later be adapted into "The Little Old Sod Shanty on the Claim" and "The Lily of the Valley," a Salvation Army gospel first sung in 1881. *(Duke Rubinstein Library)*

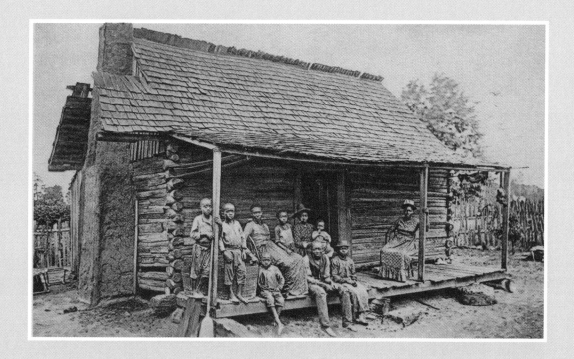

cabin in the early 1800s, and so too did the interracial couple Mr. and Mrs. James Atkinson, thereby experiencing some of the independence white settlers felt everywhere and anywhere. But for most blacks there was no liberty or independence in the log cabin. No agency. Not until after the Civil War, during Reconstruction, were millions of slaves afforded the same opportunity, constructing log cabins as their first independent abodes, often on the grounds of their former plantations, where they worked as sharecroppers. "Most of us slaves stayed right there and raised our own crops," Marriah Hines of Virginia said.[5] "Some of us worked on the same plantation and bought our own little farms and little log cabins, and lived right there till master dies and the family moved away." The more adventurous or wealthy, meanwhile, struck out for new lands, founding towns like Nicodemus, Kansas; Sugarland, Maryland; and nearby Jonesville, Maryland. Never, how-

IMAGE HN.4 This family is a picture-perfect example of post-Reconstruction living for former slaves: Their log cabins weren't always pretty, but they were free. *(Photography Collection, The New York Public Library)*

ever, were these cabins cited as confirmation of American exceptionalism.

Though black Americans now lived free and clear of slavery in the log cabin, they were still largely removed from the myth at large. Postcard companies would feature free men and women, distributing their images for a curious market, but the tales of heroic pioneers forging frontiers or rags spun into riches were still largely reserved for white folk. There are, however, two notable exceptions.

One, Jean Baptiste Point du Sable, the first non-native settler in Chicago. A mixed-race man of Haitian descent, he arrived at Lake Superior in the 1780s, setting up a cabin along the Chicago River's north bank. This story is well-known in the Midwest, but du Sable's real log cabin biography never captured the American imagination quite like John Smith's fictional one. And I must mention that there was an exception within this exception: Point du Sable was a foreign-born freeman, facts that held him apart from American-born blacks. He was removed from the institution of slavery.

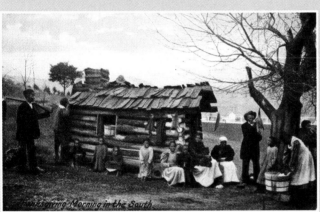

IMAGE HN.5 The US postage stamp celebrating Booker T. Washington's birth cabin is a rare instance of black people being included in the nation's log cabin idolatry. *(Smithsonian's National Postal Museum)*

IMAGE HN.6 The Detroit Publishing Co. distributed this image of this Reconstruction-era family, one of many such othering images. *(JT Vintage / Art Resource, NY)*

The more germane but equally rare example of a black, cabin-living folk hero is Booker T. Washington, the great American educator whose very first memories are of the earthen-floored slave cabin where he was born in 1856. He writes in *Up from Slavery*, "The earliest impressions I can now recall are of the plantation and the slave quarters—the latter being the part of the plantation where the slaves had their cabins."[6] He goes on: "The cabin was without glass windows; it had only openings in the side which let in the light, and also the cold, chilly air of winter.

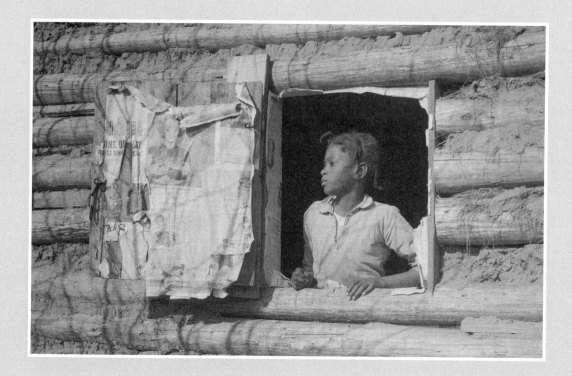

There was a door to the cabin—that is, something that was called a door—but the uncertain hinges by which it was hung, and the large cracks in it, to say nothing of the fact that it was too small, made the room a very uncomfortable one."[7]

So respected was Washington for bridging racial divides that the US Postal Service in 1956, the height of segregation, honored his hundredth birthday with a stamp depicting his exact birth cabin. The former slave was now an official member of the nation's log cabin elite: those admired Americans who pulled themselves up by their bootstraps to the country's highest echelons. And, unlike William Henry Harrison, the club's founder, Washington actually *had* pulled himself up.

IMAGE HN.7 Arthur Rothstein's iconic 1937 image *Girl at Gee's Bend, Alabama*, which sees a black girl juxtaposed with white newspaper model advertising cake, captures the larger African-American experience during the Great Depression. *(Library of Congress)*

Part III

SPLINTERS

IMAGE 7.1 Americans entering
the twentieth century had a
compulsive urge to look backward.
*(Special Collections, University of
Illinois at Chicago)*

· 7 ·

AN AMERICAN MYTH, VOL. 2:
THIS TIME IT'S PER$ONAL

THE TURN OF a century is enough to make a nation pause and rose-tint its past. But the early 1900s were unprecedented in their innovations, each more inorganic and world-altering than the last: the Wright brothers took their first flight in 1903, promising to slice through space and time far faster than trains ever could; and so too did Ford Motor cars offer equally astounding speed and convenience; silent motion pictures, first premiered in the preceding decade, were growing longer—the 1902 sci-fi vanguard *Le Voyage dans la Lune* ("A Trip to the Moon") came in around 17 minutes—and sound effects were only a few years away; Bakelite, the first synthetic plastic, was announced in 1909; and wireless technology was being rolled out at the same time, powering early radio broadcasts that fed off of electricity creeping across the nation, and all amplifying the need for a counterpoise. You can guess what happened next: a resurgence of cabin-shaped myth-making. But while these years, 1900 to 1944, bring the same lore-concocting and perpetuating as before,

7701. OLD LOG CABIN, NEAR GERMANTOWN, PHILADELPHIA, PA. DETROIT PUBLISHING CO.

Easter greetings Rose "Gram"

with historians slinging the very same log cabin claptrap of the glorified cabin as springboard for American greatness, all is not what it seems, because past, present, and future are being blended into a more robust, powerhouse of a narrative, one still being told today.

Change makes one want what's familiar, and what's familiar becomes quaint and comforting in the face of the future, so just as during the industrial revolution's heady early days, early twentieth-century Americans were grasping for a seemingly tranquil past while barrelling into immense and incomprehensible transformation. Drama-queen frontier-eulogizer Frederick Jackson Turner, so anxious at the end of the nineteenth century, didn't calm down any in the twentieth, harping on the cabin in 1903, "Let us see to it that the ideals of the pioneer in his log cabin shall enlarge into the spiritual life of a

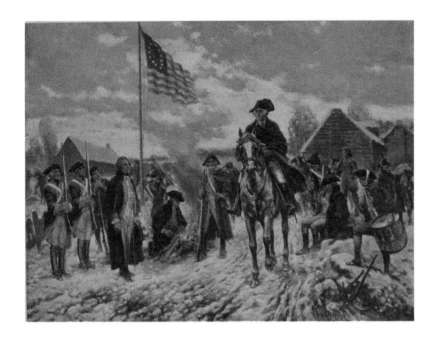

democracy where civic power shall dominate and utilize individual achievement for the common good."[1] President Tyler's son Lyon kept his father's 1857 lie going with a 1906 claim that Jamestown, "cradle of the Republic," began as scant cabins: "In Jamestown the first houses were log cabins."[2] A 1908 history of North Carolina bowed down to the colonists' revolutionary spirit—"In all history there is no finer example of the spirit of freedom than in the open defiance of England by [those] few thousand colonists living in their rude log cabins"[3]—and Pittsburgh journalist Erasmus Wilson made similarly slanted remarks in 1915, "It is with no little pride that we recall many of the fathers of the state and of the national government who lived in log cabins. . . . We are proud of these men because they were of that hardy, rugged type from which we get our really strong, honest, righteous rulers."[4] The most affected such remarks, however, came from historian Warder Stevens' commemoration of an Indiana coun-

IMAGE 7.3 The log cabin's an art star once again in colonial revival works, like Edward Percy Moran's rendering of *Washington at Valley Forge. (Library of Congress)*

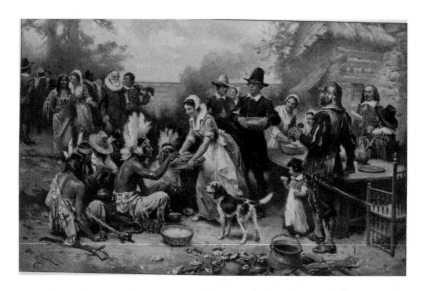

IMAGES 7.4–7.5 Jean Leon Gerome Ferris and Jennie Augusta Brownscombe's imaginative oil paintings also went a long way in perpetuating the "log cabin as national foundation" story. *(Library of Congress and Pilgrim Hall Museum, Plymouth, Massachusetts)*

ty's centennial, and which cast the log as the progenitor of all that is good and bright and wonderful. "The story of America is written in log cabins," he trumpets. "All down the past through centuries, the log house has marked the outpost of civilization. . . . [And] the log cabin never stopped until myriad miles of ocean, the great Pacific barred the way. The log house is branded deep into the story of American liberty and American men."[5] Stevens calls out a number of "humble," allegedly log cabin-dwelling patriots—Harrison, Lincoln, and backwoodsman James Calhoun, too—and even wealthy, mansion-living General-President-Founder George Washington was wedged into the fold: "Washington was far from penniless, yet the most momentous months of his existence were 'log cabin days,'" i.e., those winter months in Valley Forge. "It was only by the erection of log cabins . . . that the remnant of an army was kept alive," writes Stevens. "And so the story of America goes on, always written in log cabins."[6] It's the original *NeverEnding Story*. Or so these historians desperately wanted to believe.

There's a similar vibe among the artists of this period, too: painters like Edward Percy Moran and Jennie Augusta Brownscombe. Like the romantics before them, they put the cabin front-and-center in their oil paintings, only with far more patriotic and laudatory flair. And just as a spate of historical societies followed 1800, so too did the twentieth century see the rise of pioneer societies devoted exclusively to an idolized past. Those groups sprang up from San Bernardino, California[7] to Towanda, Pennsylvania, where in August 1902 the town's senior citizens came together to commemorate "the days of 'ye olden time,' when our pioneer ancestors dwelt in log houses."[8] Meanwhile, more hands-on aficionados were reclaiming rotten old domiciles to restore to their former glory, and one could build an entire cabin village with all the DIY books being published, including 1908's *Wilderness Homes*. Written by *Saturday Evening Post* artist Oliver Kemp, it opens with a great summary of this brand of log cabin devotion: "[Cabins] crystallize and

IMAGES 7.6–7.7
Arist Samuel
L. Schmucker's
poppy 1920s-era
Thanksgiving
postcards, distributed
by vanguard publisher
John O. Winsch,
went a long way in
perpetuating a log
cabin myth in full
swing.

bring into reality that vague longing which you have felt for a lodge in the wilderness."[9]

The log cabin in this context is still an old-school antidote to the alienation of an industrial world, and that's particularly true in the case of Staten Island real estate mogul Cornelius G. Kolff's "medita-

tion cabin." Erected on his estate, in the shadow of Manhattan, Kolff dedicated the public structure to "thinkers generally" to enjoy "as a temporary place of retreat and contemplation."[10] Popular with statesmen and citizens alike, the cabin motivated New York City Parks Commissioner Charles Stover to propose in 1913 that the city erect copies across Manhattan: "This past Winter I had the pleasure of spending a day or two in [Kolff's] 'Philosopher's Retreat,' as he calls his cabin on Emerson Hill, and I fell in love with the snug little affair,"[11] said Stover, slightly mangling the name. (Kolff actually called the cabin "Philosopher's *Hall*," an even more grandiose name that shows the burden being put on the cabin.)

But there was another side to the log cabin's public image in these days, too, one that diverged from the typical myth-making. This side was born not out of anxiety, but out of promise, because as alluring as the past may be, the future calls just as loudly, it's innovations promising vast potential and opportunity. The nation was being pulled between enticing yesteryears and an expectant tomorrow. The cabin's caught in this nexus, too; and nowhere is this tension more evident than in the "concrete log cabin" in Yankton, South Dakota.

Built in 1911 by a water and sewer engineer, Arthur Ellerman, the structure appears to be just another generic cabin—rounded, seemingly bark-covered, age rings at the ends—but closer inspection shows it's actually precast concrete molds notched together in a classic style. *Popular Mechanics* reported on the house soon after its completion: "American pioneers have handed down an affectionate regard for log architecture, and many a city dweller would prefer a plain log cabin to a modern mansion. . . . A builder in Yankton, S.D., has combined both in a pretty and homelike bungalow. . . . The exterior is finished to a natural effect with a wood-brown stain, preserving in form all the esthetic value of the rustic model, but with the cleanliness and sanitary value of the modern material."[12]

A nifty mélange of modernity and tradition, Ellerman's structure pretty much captured the national mood at large, that tension between the yesterday and tomorrow. Part immortalization of the past, part embrace of the future, and entirely spray-washable, Ellerman's home is hailed as an exemplar of artistic trompe l'oeil, or trick of the eye. It's an illusion. Kind of like log cabin myth-making/perpetuating itself: It's a chimera of history, lore, and wishful thinking.

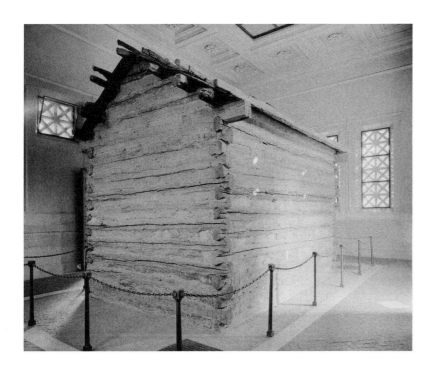

LET'S GET PHYSICAL

And this brings us back to where we started: The Lincoln "birth cabin" and the accompanying fanfare. Definitely the most elaborate, illusory, and costly of all log cabin commemorations, Ol' Abe's was just one of many questionable replicas that arose after the century's turn. And not all of these cabin replicas were memorials, either. President Theodore Roosevelt was very much alive and indeed still in office when North Dakota bought a log cabin from Teddy's former ranch there. The cabin, later known as the Maltese Cross Cabin, was a meaningless outbuilding from his massive property built by Big R's staff, not the president. The New York-based heir only visited it a few times, but these pesky minutia were edited out when the cabin was displayed that year at the Louisiana Purchase Exposition, and

IMAGE 7.10 Lincoln "birthcabin" in its $200,000 shrine. *(Photography Collection, The New York Public Library)*

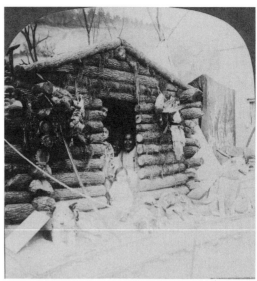

heralded as evidence of a great man's humility.[13] To Americans, the
Roosevelt cabin was, as Lincoln's memorial would be, the physical
manifestation of American opportunity; to the rest of the world, it
was a projection of a rugged Americanism.

And Roosevelt's wasn't the only cabin around the expo in St.
Louis. Elsewhere in the hall, attendees could view Hardscrabble,
the large double-pen cabin the very dead Ulysses S. Grant built for
his family in Missouri in 1854, after the alcoholic general and future
president was ousted from the army.[14] Installed by local business-
man C. F. Blanke, Hardscrabble was and remains the only surviving
cabin actually built by a former president, a distinction deserving
of patriotic consideration. But Blanke didn't care about bolstering
national pride, American exceptionalism, or even the dead presi-
dent. A prototypical hipster, Blanke was exploiting Grant's legacy
to sell his artisanal coffees. And clearly the log cabin remained a
viable marketing gimmick: Blanke became one of St. Louis's most

IMAGES 7.13–7.14 A postcard of Fred Grant visiting Hardscrabble, the cabin his father built and that C. F. Blanke displayed as a marketing gimmick, and another of the Daniel Boone memorial cabin, a replica of the famous frontiersman's legendary abode. *(Ulysses S. Grant National Historic Site and University of Kentucky)*

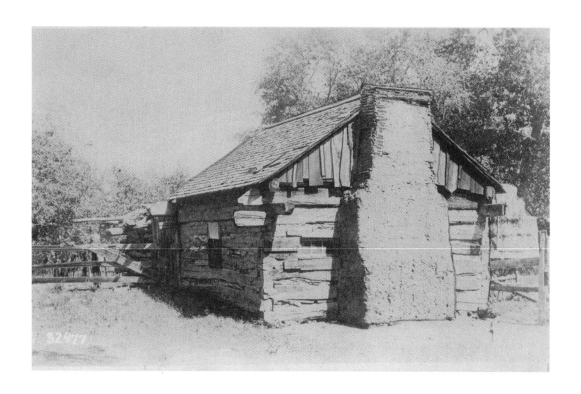

IMAGE 7.15 Fellow Kentucky folk hero Kit Carson was also memorialized in this era. *(Photography Collection, New York Public Library)*

successful businessmen. Later, in an odd twist, an even more successful St. Louis beverage purveyor, beer tycoon August A. Busch Sr., bought Hardscrabble and moved it next to his family's 225-acre estate, right on the land where hard-drinking Grant erected it so many years ago.

It was around this time, in 1910, right after Lincoln's neo-classical shrine arose, that folk hero Daniel Boone's "vigorous young manhood" was memorialized with a replica in Beaver Creek, North Carolina. "Reposed snugly in a grove of majestic oaks tottering with age," the Boone cabin was expected, like Lincoln's, to become a "Mecca for patriotic pilgrims."[15] And in 1911 the Kansas state legislature safeguarded the Osawatomie cabin where abolitionist John Brown hid following his 1859 raid on Harpers Ferry, a failed effort to arm a slave

revolt. He died a martyr for his cause when pro-slavery vigilantes hanged him, and it was only later, well after slavery was dismantled, that the valiant fighter was widely respected enough for log cabin honors.

And it wasn't just famous folk celebrated via log cabin memorials, either. Regular people were being brought into the mix, too. The people of Dayton, Ohio, erected a log cabin memorial for that city's settlers in 1908; Oshkosh, Wisconsin did the same in 1909; Lansing, Michigan, in 1912; and Kansas City, Kansas, joined the fun in 1915—all

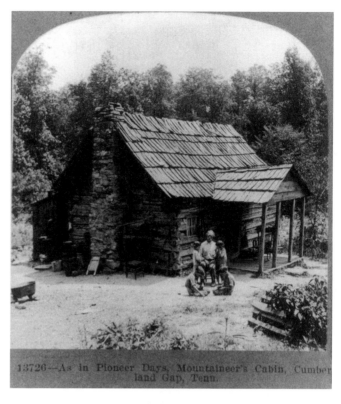

13726—As in Pioneer Days, Mountaineer's Cabin, Cumberland Gap, Tenn.

honoring anonymous Joes and Janes, unnamed pioneers who were regarded as just as essential to our history as Lincoln and Boone. In the same way that squatters were remodeled into settlers, the poor and humble folk of America past and present are here being remembered as democratic heroes.

The log cabin fable here is being enlarged to encompass everybody, part of the broader "New History" movement away from the titanic characters toward the little guy. Unlike the nineteenth century's myth-making, which was primarily about great leaders, this latest expression was more personal and more present. After being told to see themselves in great men like Harrison and Lincoln, to bask in vicarious glory, everyday citizens were now told to see greatness in their own forebears—and themselves. As then-vice president-elect James Sherman said at that 1909 dedication of Lincoln's Hodgenville

IMAGE 7.16 A 1919 image of a Tennessee family captioned "As in Pioneer Days, Mountaineer's Cabin" skirts the line between reverence and exploitation, providing a great view of the era's fascination with old-timey living. (*Library of Congress*)

GREAT ESCAPISMS

Log cabins of this era weren't just the building blocks for myths and memorials. With industrialism continuing to encroach on national splendor, early twentieth-century Americans flocked to log cabin refuges, places like Yellowstone's 1904 Old Faithful Inn, places where they could enjoy nature before going back to concrete jungles.

And so too did log cabin vacations remain popular after the war, when middle class Jews created cabin colonies in the Borscht Belt in New York's Catskills; Ever-hard Keithley's Colorado health resort, a village of log cabins, opened around the same time; and in 1922, Indiana, a state that was mostly log cabins only a few decades before, was getting vacation cabins of its own. "A whole row of real log cabins right in the center of Indiana—yes, cross my heart," read an excited *Indianapolis Star* report. "There are plenty of cottages which aren't log cabins but most folks nowadays are willing to pay a little extra to live in the style of their forefathers."[16]

COPYRIGHT BY HAYNES INC., YELLOWSTONE PARK, WYOMING

© 28478—OLD FAITHFUL INN AND GEYSER

IMAGE 7.17 Yellowstone's Old Faithful Inn invited regular Americans to enjoy awesome splendors.

"birth cabin": "Lincoln was not a child of destiny, but an American boy, a man of America."[17]

President Woodrow Wilson emphasized this point at the same site in 1916, after the US government took over the management of the cabin. "No more significant memorial could have been presented to the nation than this," Wilson said. The Lincoln cabin "expresses so much of what is singular and noteworthy in the history of the country. . . . Every man can see how it demonstrates the vigor of democracy, where every door is open, in every hamlet and countryside, in city and wilderness alike, for the ruler to emerge . . . and claim his leadership in the free life." The log cabin embodies "the *validity and vitality* of democracy."[18] Emphasis added—and for good reason.

The United States weren't yet involved in the churning European war, but the nation was stressed out about it just the same. Democracy was under fire overseas and many Americans were wondering if the nation was still safe here at home. Wilson was using the symbolic Lincoln cabin to both assuage an anxious America and as a call to arms. He was reassuring Americans they were on the right side of history, but they had to fight for it: The cabin was "an altar upon which we may forever keep alive the vestal fire of democracy," said Wilson, "For these hopes must constantly be rekindled, and only those who live can rekindle them."[19] The log cabin is again, even more vigorously, being cast as a throughline from past to the present, and into an unimaginable future. The cabin's past glory was a cheer for present-day Americans as they stepped hesitantly into the future. Here the log

IMAGE 7.18 Woodrow Wilson claimed Lincoln's alleged birth cabin represented the "vigor of Democracy." The uninitiated see just an old shack. *(National Park Service)*

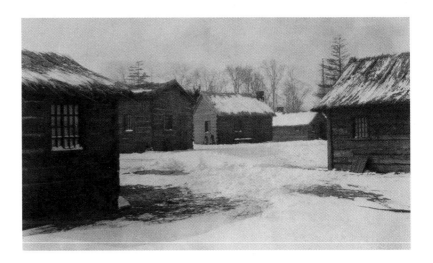

IMAGE 7.19 The producers of the 1924 movie *The Pilgrims* were so hopped up on heady myths that miscast the log cabin as Plymouth's first home. *(Photography Collection, The New York Public Library)*

cabin is a stand-in for cohesive narrative and shared democratic ideals, inculcating a new generation of distressed Americans with a common history and purpose. The fables of the nineteenth century were being calcified into a touchstone, one that would become even more important as the nation crawled from beneath World War I's wreckage.

THE GREAT WAR

Singular in size and scope, this unprecedented conflict was the war to end all wars. Americans were promised happy, placid days ahead. The future held only "pastures of quietness and peace such as the world never dreamed of before."[20] Or that's what Woodrow Wilson said, at least. But clearly not everyone was convinced, because Americans, weary of Europe's seemingly ceaseless strife, turned inward in this isolationist era, becoming more and more enthralled with our own struggle and our own history. Or what we *thought* was our history.

Yet again there's a proliferation of histories projecting the log cabin

onto America's earliest days, presenting it as our once and future moor, facts be damned. Prominent Southern historian Mary Newton Stanard claimed in 1917 that log cabins were known as "the Virginia house" for their essential role in establishing the colony there: "Ere long the flimsy plank hut gave way to the sturdier if equally primitive log-cabin, which deserves to be called the earliest form of colonial architecture, for so much the rule did it become that it was known as the 'Virginia house.'"[21] C. E. Kemper perpetuated this same erroneous idea in a 1922 essay on the colonization of Virginia's interior: "The first homes were cabins built of logs, after the 'Virginia manner of building.'"[22] Northerner Truslow Adams, the historian who coined the term "American Dream," wishfully contrived log huts on colonial Plymouth in 1921;[23] and Yale's 1925 anthology *The Pageant of America*

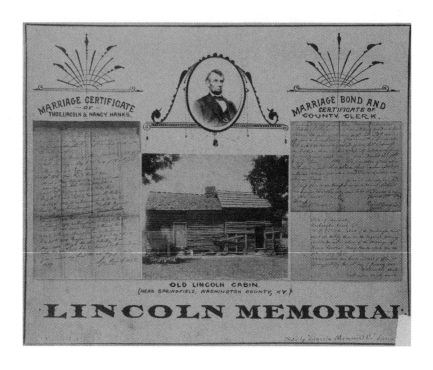

OLD LINCOLN CABIN.
(NEAR SPRINGFIELD, WASHINGTON COUNTY, KY.)

LINCOLN MEMORIAL

IMAGE 7.21 This era's Lincoln adoration was so fevered that ardent admirers erected a replica of his parents' marriage cabin. *(Library of Congress)*

featured images of both Williams's error-riddled Plymouth picture *and* an all-new, all-wrong image of an all-log Jamestown.

Elsewhere on the bookshelf, how-to guides too were preaching the log cabin's indispensable impact on America's unparalleled trajectory. *Popular Science* offered this summation in 1934: "Nothing could be more American than the simple cabin. . . . [It was] a foundation upon which to build a great empire."[24] An absolute "necessity" to America's success, it remained just as essential in postwar America, especially in terms of healthcare: "A cabin can be a real health investment. If you doubt this, try erecting one with you own hands, and note how quickly indigestion or nervousness disappear."[25] It's also essential to note that frontier days were celebrated in a number of Hollywood productions, including *The Last Frontier* in 1932 and a retelling of Daniel Boone's life and adaptation of *The Last of the Mohicans* in 1936, among others.

Meanwhile, in terms of memorializing the past, average Americans are once more incorporated into the larger narrative with newly established museums like the 1923 Pioneer Log Cabin in Cassopolis, Michigan; the Tuck Museum in Hampton, New Hampshire, founded in 1925; and, my personal favorite, a 1931 commemoration for Pioneer Mothers in St. Paul, Oregon. And you can bet your sweet bippy post-WWI America enjoyed yet another uptick of dubious restorations and replicas honoring famous folk, too.

The "John Morton Birthplace" cabin in Prospect Park, Pennsylvania, is a prime example: Morton, a lesser-known signer of the Declaration of Independence, wasn't born in this cabin, though the structure *was* built by his great-grandfather. Like Andrew Jackson's mother, Morton's mama was on the go when the future politico came into this world, and all this "birth cabin" business was just a rumor started around 1877. The story grew over the decades, evolving from hearsay

IMAGE 7.23 A 1939 government-sponsored woodcut called *New Cabin. (Wisconsin Historical Society, WHi-104867)*

IMAGE 7.24 A young member of the Civilian Conservation Corps (CCC) builds a log cabin shower room at Grand Teton National Park. The structure was being erected left and right. *(Library of Congress)*

to fact, and finally culminating in a government seal of approval in 1926, when it was christened the "John Morton Birthplace." And so it was until 1957, when the truth was revealed and the structure was downgraded to the "Morton Homestead."

And of course there were cords' worth of Lincoln-related cabins. It was almost compulsive, and maybe even a little desperate, as "Lincoln cabins" were raised this way and that, a frantic effort to materialize a myth. What's more, many were government issue: The federally-funded Civilian Conservation Corps (CCC) was dispatched in 1934 to Menard County, Illinois, to furbish a facsimile of New Salem, the log cabin town where Lincoln lived in his twenties, and then to Charleston, Illinois, to erect a replica of the cabin in which Lincoln's father and stepmother moved in 1831. Lincoln never even spent the night there, but his legacy has its own gravity, yanking in structures and locales with even the scantest, most tangential connection, the most tenuous of which may be The Lincoln Pioneer Village in Rockport, Indiana, put up in 1935 by the government-backed Works Progress Administration to honor a spot where Lincoln once borrowed books. The powers-that-be were really hyped up on Lincoln, huh? So too were regular Joes.

Enterprising Kentuckians set up spots like the Nancy Lincoln Inn (1928) and a replica of Lincoln's Knob Creek home (1932) to entice patriotic tourists. There were also cabins dedicated to Lincoln's mother, grandmother, and his parents' marriage, and all were adored as if Lincoln had built them himself with his hand tied behind his back while signing the Emancipation Proclamation. They were buttressed by blind faith. (But that doesn't mean they weren't without controversies: the Sinking Spring site, the neoclassical shrine to the "birth cabin," was criticized in 1936 for selling foreign-made souvenirs, including a hope chest made in Germany and a miniature spinning wheel made in Czechoslovakia.[26] What would Honest Abe have to say about that?!)

The New Deal government's cabin habit didn't stop at Lincoln.

IMAGES 7.25–7.26 The cabin may have been part of a national myth, but it remained essential housing for millions of Americans, including these Alaskans and Idahoans. *(Library of Congress)*

The CCC went to Cincinnati in 1935 to restore a 1775 cabin,[27] and they traveled to Alaska that same year to build a log cabin colony for farmers displaced by Depression and drought. They were meant to start new lives in log cabins, just like settlers of yore. Once ridiculed by the Founding Fathers, the cabin had become government housing. And clearly President Franklin Roosevelt approved: he extolled similar cabins in 1938.

"The standard of life in a log cabin amid fields still blackened with half-burned stumps was not high, but it was certain," said Roosevelt, appearing at a memorial to Western pioneers in Marietta, Ohio. "A family, or at most a township, could be a whole self-sufficing economic system [in a log cabin]." And those little systems, scattered in Ohio and beyond, were essential to the nation's democratic evolution: "Right behind the men and women who established Marietta one hundred and fifty years ago moved that instrument of law and order and cooperation—government." This was, you know, back when Americans believed big government could and should help their struggling countrymen.

But more than a pitch for the New Deal's government assistance, Roosevelt was creating a link between past and present, playing the

IMAGE 7.27 The inter-war period's commitment to the log cabin myth is loud and clear in this government-commissioned 1938 mural, *Pioneers Tilling Soil and Building Log Cabin. (Smithsonian Renwick Gallery/Art Resource, NY)*

IMAGES 7.28–7.29 The log cabin had doubled as a drinking and dining establishment before, but post-1900 America saw a striking rise in its commercial repurposing. *(Western Reserve Historical Society, Cleveland, Ohio)*

"all is well" game in times tinged by depression and the potential for another world war. "Every generation meets substantially the same problems under its own different set of circumstances. Anyone speculating on our great migration westward is struck with the human parallel between the driving force behind that migration and the driving force behind the great social exploration we are carrying on today," Roosevelt said, "The people who went out to Ohio in 1788 . . . went to improve their economic lot. In other words, they were following the same yearning for security which is driving us forward today."[28] And they couldn't have done it without the log cabin. Once again, the comforting log cabin is being invoked as an example of our American resiliency. It sustained us in the past and it will do so in the days to come. But there was still another, even more American trait within this log cabin myth-perpetuating, and it's not nearly as honorable.

CHILDREN = THE FUTURE

It wasn't just the New Deal government and historians getting in on the log cabin idolization. Kids, those adorable capsules of potential, the target audience for eternalizing patriotic lore, were exposed in a myriad of new ways, too. Groups like the Boy and Girl Scouts, founded in 1910 and 1912, respectively, as well as the Camp Fire Girls of 1910, all sent tots out to build log cabins, a hands-on, myth-indoctrinating experience. Log cabins actually became so ingrained in the Boy Scouts' philosophy that long-time Scout and one-time chief executive Elbert K. Fretwell likened building one to a spiritual act, writing in the introduction to yet another "how-to build a cabin book," "[From this book] you can learn how to fashion *your* cabin, but more, you may become more fit to live in a 'house not made with hands, eternal in the heavens.'"[29] *Heavy.*

Meanwhile, back on earth, John Lloyd Wright, son of Frank Lloyd

IMAGE 7.30 Camp Fire Girls raise a flag above their log cabin campground, 1941. (*Corbis*)

Wright, invented Lincoln Logs in 1917. Some say Wright's imagination was stirred by the elder Wright's use of interlocking timber in his reconstruction of Tokyo's Imperial Hotel. Others say that Wright just stole early inventor Joel Ellis's 1866 toy "Log Cabin Playhouse."[30] Either way, Lincoln Logs were on many-a Christmas list after their 1922 debut, when they were marketed as "interesting playthings typifying the spirit of America." And another ad campaign one year later added: "Here is a building toy that builds character." As clumsy a pun as this is, it says a lot. Lincoln Logs were more than just interdigitated beams. They're playful agitprop, little pieces of patriotic propaganda, that reinforced preexisting ideas about American opportunities. "If Lincoln can do it, so can you!"

The log cabin of this era was becoming entangled with the money-coveting, "self-made man" strain of American lore, the "up by your bootstraps" story captured in Horatio Alger's *Ragged Dick*, the seminal 1867 story of a street kid whose grit and determination elevate him from the gutter to the upper echelons of society. Intermingling over the years, the related ideas were officially merged with Thayer's aforementioned 1880 James Garfield biography, *From Log-Cabin to the White House*, and it wasn't long before the "White House" becomes synonymous with a generic "mansion."

IMAGE 7.31 This Lincoln-starring "From Log Cabin to White House" game ran in *The Chicago Tribune* in 1923, perpetuating a long-held American dream: getting out of the sticks. *(The Leo Pascal Collection)*

"All things are possible to the American youth, whether he was born in a log cabin or mansion,"[31] a Missouri superintendent told children in 1899. Erasmus Wilson, the same journalist who praised the "hardy, rugged" pioneer, in that 1915 article, boasted, "All this [steel-rich Pittsburgh, home to Andrew Mellon] had its inception in the log cabin." He went on, equating the log cabin with moral righteousness, "No doubt many of our more prosperous citizens owe their thrift and prosperity to their early training in the cabin home."[32]

IMAGE 7.32 In addition to puffing up nation's ego, the log cabin myth was indoctrinating children with dreams of making it big. *(Library of Congress)*

Not long after, readers clamored for the 1922 book *The Log-Cabin Lady: An Anonymous Autobiography*, that era's *The Log Cabin; Or, The World Before You*: a broad American ethos tucked within a personal memoir that starts in a log cabin. Though addressed to women who had pulled themselves from log cabins to the upper echelons, book editor Marie M. Meloney presented the work as a more universal parable, one "laden with adventure, spirit and the American philosophy." She then writes, "It is a wonderful thing—this democracy of ours in which a Lincoln could make his way from the pioneer log cabin to the White House."[33] A similar trajectory is touted in a 1922 article celebrating Jonathan M. Davis's recent election as Kansas governor: "Goes From Log Cabin to Mansion," read the headline.[34] And tobacco magnate James B. Duke's rise was framed in the exact same terms only one month earlier, in a 1922 *Cleveland Star* report, "How Three Poor Boys Paved Careers from Rags to Riches." Fawning over Duke's $325 million ($4.5 billion today) fortune, it reads: "And all [this] from the humble beginning in a log cabin and the dream of a young boy."[35] Where's Robin Leach when you need him?

The pecuniary side of the log cabin parable is especially bla-

IMAGE 7.33 James
Garfield's cabin was
an exemplar of the
"logs-to-luxury"
myth. *(Western Reserve
Historical Society)*

tant in a 1936 log cabin replica honoring James Garfield, which is
fitting, since he was the first president Thayer celebrated for his
"log cabin to the White House" drudgery. Originally installed at the
Great Lakes Exposition in Cleveland, the Garfield cabin has all the ele-
ments of the Lincoln and Morton commemorative cabins. Its mere exis-
tence satisfies the glorification of the humble requirement, and there's
certainly America's endemic bending of truth for the sake of myth—the
"Garfield cabin" was actually a random 1818 schoolhouse retrofitted to
look like the president's first home—but it's what happened *after* the fair
that's most telling: The cabin was moved to the nearby town of Mentor
and installed next to the twenty-six-room mansion where Garfield later
lived, a setup meant to highlight privileged Garfield's allegedly only-
in-America ascent. An editor for *Midwest Museums Quarterly* spelled it
all out in 1943, "The juxtaposition, in the same yard, of the log cabin
and the home from which he was elevated to the presidency furnishes
one of the most graphic representations of the meaning of opportunity
in America today."[36] Graphic indeed. And fraudulent: Garfield's father

IMAGE 7.34 Reverend William Robinson's 1913 book about his rise from slave to preacher was titled, in Thayerian fashion, *From Log Cabin to The Pulpit*. *(Schomburg Center for Research in Black Culture, Jean Blackwell Hutson Research and Reference Division, The New York Public Library)*

was relatively wealthy compared to his neighbors.[37]

In this light, the log cabin myth, already part of the broader rags-to-riches yarn, is an opiate for the masses. It universalized exceptional cases, making them seem not only plausible, but also likely, thus keeping people in their place with the promise of unlikely progress. It's important to teach children to believe in themselves, yes, but this was something else. In the ever-growing shadow of the Gilded Age's surging inequality, Americans were now being told that they are guaranteed greatness by dint of their Americanness, that opportunity was their birthright and that being American opened doors. And these weren't the doors of some humble, homely farm house; they opened into garish mansions in glittering cities. Americans wanted glitz and glamour and the rest of the accroutrement that went with multi-million dollar fortunes and, let's face it, which most never obtain.

This growing emphasis on material gain didn't go unnoticed, especially as booming economic inequality isolated wealth among a smaller and smaller population.[38] The Illinois-based *The Edwardsville Intelligencer* criticized dollar-dominant mindsets in 1936: "Horatio Alger took the rags-to-riches myth, the log-cabin-to-the-White-House saga, and *riveted it into the brains of whole generations of Americans.*" Emphasis mine, but totally implied. The editors go on: "Over and over again Alger chanted this lay; and how many millions of young

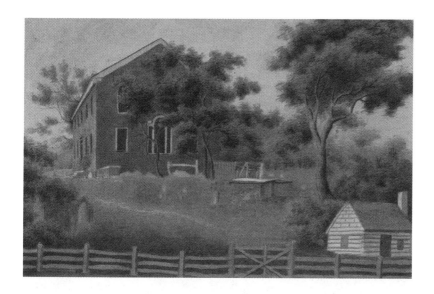

Americans lapped it up is beyond computation. . . . It was *the* American credo. . . . And we have made a good deal of trouble for ourselves . . . by refusing to admit that life isn't quite so simple as Horatio Alger told us it was."[39]

Journalist Robert Quillen brought up the same point, only with more outrage, after reading an alarmist sociologist's 1940 report claiming that poor people's high birth rates spawns rising crime: "Their assumption [is] that the prosperous who have few children are the 'best people,' while the prolific poor are low-grade stock. This assumption is rather astonishing to a generation taught to regard the rags-to-riches saga as the glory of America." The outraged writer goes on, getting to the meat of the matter, the hypocrisy and tension around vilifying the poor in a country that allegedly valorizes poverty: "For a century or more our young people have been inspired by true stories of the great and successful men who rose from dire poverty. There was a time when birth in a log cabin was one of the qualifications for the Presidency. And there was a general belief that poverty and its hardships developed

IMAGE 7.35 Painted around 1790, this image shows a fancy brick house looming above the old log cabin, reminding us that the log cabin was never an end unto itself. *(Library of Congress)*

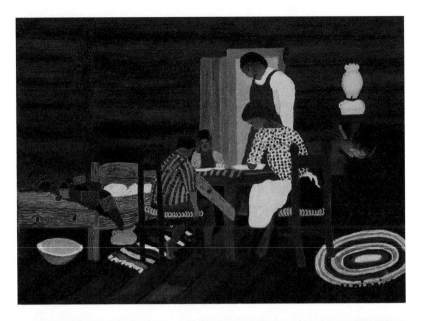

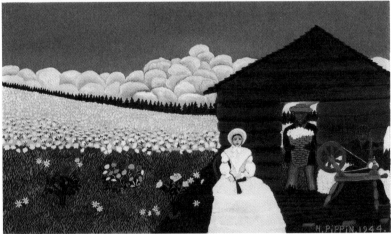

IMAGES 7.36–7.37 Horace Pippin's 1942 painting *Giving Thanks* and his 1944 offering *Cabin in the Cotton IV* show two sides of the log cabin coin: In the first, it's a place of family and independence, and in the second, it supports the oppressive cotton economy. *(Giving Thanks © 2017 The Barnes Foundation and* Cabin in the Cotton IV *courtesy of The Davis Museum at Wellesley College / Art Resource, NY)*

character and virtue. . . . Yet now we are warned that the country is endangered because the poor are having most of the children."[40] As valid as Quillen's argument is, such denigration of the poor, we know, is nothing new, or, sadly, old.

Later, in 1957, psychologist Donald G. Paterson blamed America's pervasive "occupational maladjustment" in part on "the 'log cabin to the White House' tradition." This ubiquitous misconception "leads youth and adults alike to strive for the highest occupational levels regardless of whether or not they possess the necessary aptitudes, abilities, and interests."[41] Log cabin myths had perverted Americans' concept of success, leading to notions that it was always easy, that it was always attainable, and that every American was entitled to it, all of which bore disappointment when reality and lore collided, as they so often do. *Womp-womp.*

HARD NOTCH

Rich Log, Poor Log

"We lived in a little log cabin right in the
woods, and were too far from civilization to
bother about anything."

—Colorado vacationer
George S. Elstun, 1901.[1]

I
N 1919, as the fog of war lifted, wealthy financier Louis Kaufman
asked the Chicago architects Marshall and Fox to design him a
country retreat in Marquette, Michigan. It took four hundred
laborers four years to build it, and another three for interior decorat-
ing, and in the end the $5 million home boasted ten bedroom suites,
twenty-six fireplaces, a chef's kitchen, a game room, and twenty-four-
foot vault ceilings—it was some of the best 26,000 square feet money
could buy, all encased in the finest pine logs imported from Oregon.
Kaufman called the home Granot Loma, a meaningless mishmash of
his five children's names. But as nonsensical as the estate's honorific
is, the finished product speaks to the log cabin's decadent mutation
since 1880 or so. Once the most abominable of housing, log cabins had
become a novel escape. Anyone who was anyone had a home-away-

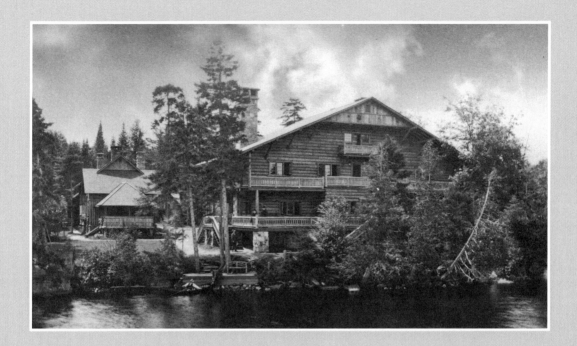

IMAGE HN.1 Rich folk adopted the log cabin around 1880, rendering it unrecognizable and turning it into an icon of excess. Above, Sagamore, the Vanderbilts' "rustic" country home. (*The Adirondack Museum*)

from-home, and the most fashionable of them tramped off to distended emulations of log cabins past.

Rich Americans had been quietly absconding to the woods for decades, but never had they elected to do so in log cabins. Thomas Jefferson enjoyed escaping to Poplar Forest, his octagonal brick mansion in Virginia's woods, and Johann David Schoepf noted in 1783, "Along the road indeed one sees for the most part sorry cabins, for the better houses of the well-to-do land-owners are all set a little off from the road."[2] It wasn't until the mid-nineteenth century that the log cabin, then on the cultural upswing, became a recreational end. *Backwoodsman* writer James Kirke Paulding encountered convalescents at a West Virginia health spa in 1835: "The visiters [sic] live in cabins built of square logs, whitewashed, and disposed in a range just on the skirts of a little lawn, so that they have all the air of a rural village;"[3] exclusive

Thomas
Cole's 1841 sketch of
Elisha Johnson's castle-
like "cabin," Hornby
Lodge. *(Detroit Institute
of Arts, USA Founders
Society Purchase,
William H. Murphy
Fund / Bridgeman
Images)*

log cabin-based men's hunting clubs arose in upstate New York around
the 1830s and 1840s;[4] and Rochester-based businessman Elisha Johnson
was so enamored with the 1840s log cabin campaign that he financed
a log home called Hornby Lodge. But naturally, this was no ordinary
cabin. William Peck noted later, "Far from being a mere cabin, it was
more like a castle, for it was four stories high and it contained eighteen
rooms."[5] Yet homes like Johnson's were still rare, and for the most part
the upper class weekend homes were just as modern as their town-
houses or estates. And so it remained until the 1870s and 1880s, when
industrialism-inspired nostalgia lit the way into the woods, turning
log cabins into a haute destination for Americans with money to burn.

Ground zero for this upper crust trend to the outdoors was, appro-
priately enough, that land of fabled gentry, Connecticut, where Yale-
educated Reverend William H. H. Murray turned memories from his
Adirondack Mountain adventures into a lecture series and then, in
1869, a manifesto called *Adventures in the Wilderness; Or Camp-Life
in the Adirondacks*, which urged urbanites to find respite in the forest.
"In the wilderness they would find that perfect relaxation which all

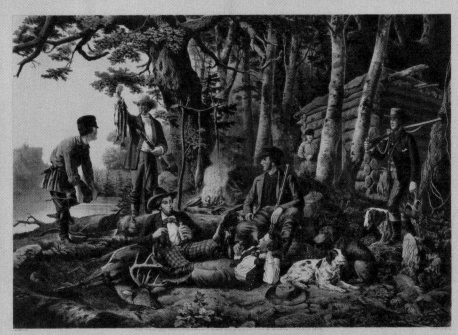

CAMPING OUT.

jaded minds require," he wrote, "In its vast solitude is a total absence of sights and sounds and duties."[6]

Though addressed to all Americans, Murray's book was particularly popular among the society set. Suddenly fleeing into the woods was chic, and the Gilded Age elite were clamoring to see the Adirondacks for themselves. Luckily for them, railroad fat cat Thomas Clark Durant anticipated the shift years earlier and filed paperwork for a line running from Saratoga Springs to North Creek, New York, in 1864. Hearing of his plans, the *New York Times* predicted that the Adirondacks "will become a suburb of New York" and "the furnaces of our capitalists will line its valleys and create new fortunes to swell the aggregate of our wealth, while the hunting-lodges of our citizens

IMAGE HN.3 The 1855 image *Camping Out* depicts a more rustic trend that preceded the wealthy manses soon to come. *(Smithsonian American Art Museum, Washington, DC / Art Resource, NY)*

will adorn its more remote mountain-sides and the wooded islands of its delightful lakes."[7]

That was an understatement: About two hundred hotels and other lodgings went up over the next few years, hosting the *crème de la crème* of East Coast elite. But the truly wealthy weren't about to slum it with common folk. They wanted their own homes. And they got them.

Textile tycoon Frank Stott broke ground on Bluff Point, a massive compound on Raquette Lake, in 1877, the same year architect William West Durant, railroader Thomas's son, built Camp Pine Knot, a compound of cottages and cabins that one writer described as "camping out . . . combined with the comforts and luxuries of city life."[8] A few years later they were joined by *New York Herald Tribune* publisher Whitelaw Reid's Camp Wild Air, another massive compound that included an eight-room guest house. And so began a race of architectural one-upmanship in which the elite strove to build the most expansive, expensive mansions possible, all so they could brag about who had the bigger log. J. P. Morgan moved into Camp Uncas and its 4,000 square foot lodge in 1895; President Benjamin Harrison, grandson of William, first slept in the eight-room Berkeley Lodge in 1896; Brooklyn warehouse magnate Timothy Woodruff and his wife Cora spent their weekends at their massive Kamp Kill Kare compound starting one year later, in 1897, just as Alfred Vanderbilt was plotting Sagamore, his 30,000-square-foot "log cabin" down the road.

And it wasn't just the rich WASPs who ventured into the once-verboten woods. Jewish families shunned at racist enclaves—people like the banking barons, the Lehmans, and the smelting giants, the Guggenheims—built their own cabin-shaped sanctuaries, sites where they were free to have a Shabbat dinner in peace, just like the settlers of yore, only this time with luxuries like toilets, hot water, iceboxes, telegraphs, gas generators, bowling alleys, and staff quarters. But in all cases, Jewish, gentile and everyone in between, these spacious camps had something rarely found in the original log cab-

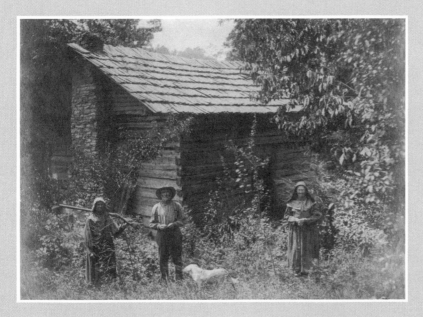

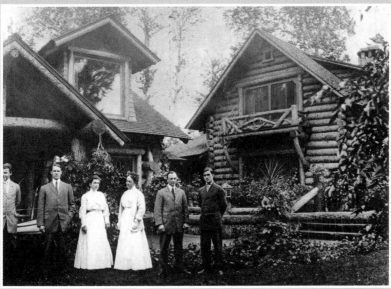

IMAGES HN.4–HN.5 The Fausts of Tennessee and the Woodruffs of Brooklyn outside their very different log cabins in 1909 and 1910, respectively. *(Library of Congress and The Adirondack Museum)*

ins: privacy. This cabin life was as far removed from the original as it was from the city.

For bothered, bewildered urbanites of this era, isolated cabins were oases from ever-hectic cities, spaces where they could forget their woes and satisfy a nostalgia for a simpler existence. Getting back to nature was (and remains) a way to get in touch with one's more organic self. Chilson D. Aldrich, author of the 1928 "how-to" *The Real Log Cabin*, noted, "Our forebears utilized logs because they had no other choice. We utilize logs because they are our first choice. *Pioneering has become an art instead of a duty*."[9] Emphasis there is mine, but there's no need for special italics with journalist George H. Dacy's 1930 article, "The Lure of the Log Cabin:" "Those of us who love to get close to Mother Nature feel that we are most nearly achieving our ideal when we live and sleep in a log cabin."[10] Millions of Americans on the other side of the tracks, however, would disagree.

While upwardly mobile Americans enjoyed the log cabin as a haven, poor Americans, the same people being fed rags-to-riches myths, still relied on more scaled and scant cabins as cheap, reliable housing. For many, cabins were just the same as in colonial days: crude and harsh. "We just had this one-room cabin they made from logs, with the cracks filled with moss and clay," Loretta Lynn wrote in *Coal Miner's Daughter*, the singer's memoir about growing up poor in Butcher Hollow, Kentucky. "The wind used to whistle in so bad, Mommy would paper the walls with pages from her Sears and Roebuck catalog and movie magazines."[11] Among the faces staring down were Clark Gable and Adolf Hitler. So, you know, it wasn't no Camp Pine Knot.

Yet places like Pine Knot were still referred to as "log cabins." A 1908 *Brooklyn Eagle* piece on the Woodruff's equally gigantic Kamp Kill Kare declared, "The pride of this log cabin in the wilderness is the inexhaustible water supply."[12] This is like the woman who admitted Harrison's home was a mansion, but still called it a cabin, and it reveals

a lot about our attachment to the *idea* of the log cabin. We do cognitive somersaults to accommodate a hardwood obsession, stretching the term "log cabin," not to mention our imaginations, to make room for houses that are more like hangars than homes, all in the name of log cabin lore. And, speaking of linguistics, "cabin fever" entered our lexicon around this time, too, in 1918. Coincidence, or lingual symptom of log cabin adoration run amok?

In any event, the log cabin as a concept and a structure now existed on two completely divergent economic planes, equal in philosophy but not in practice. For some it was a beatific resort. To others it was the last chance at survival, a refuge of a different sort. The first social trend to trickle from society's bottom rung to the top and back down again, the once-temporary cabin, erstwhile stigma of poverty, was now aspirational. People paid huge amounts of money for the thing early Americans like Lucy Smith tried desperately to leave behind. People strove to go from one log cabin, the dreary hovel, to another, the luxuriant castle. The "democratic" log cabin was now a glaring example of Gilded Age-era inequality, exposing the cracks in the American Dream the structure supposedly represented. Despite the nation's lofty ideals, only a scant percent of the population would ever settle into an Adirondack Camp.

This isn't to say upward mobility isn't possible: Enormously wealthy today, Loretta Lynn owns a vacation ranch where guests can stay in log cabins like the ones she knew way back when, minus the Hitler wallpaper. But, let's be real, most of us aren't Loretta. Nor do most people have the sheer genius and selflessness of Abraham Lincoln. Even Taft admitted at the Sinking Spring event: "Few men have come into public prominence who came absolutely from the soil as did Abraham Lincoln."[13] And if you need contemporary numbers to make this clear, a 2012 Economic Mobility Project report found that 43 percent of Americans born in the bottom economic quintile never rise above that rank, and that a majority, 70 percent, never make it to middle class. What's

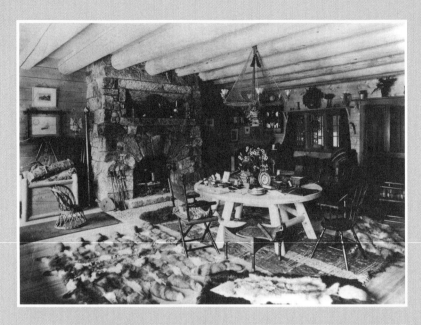

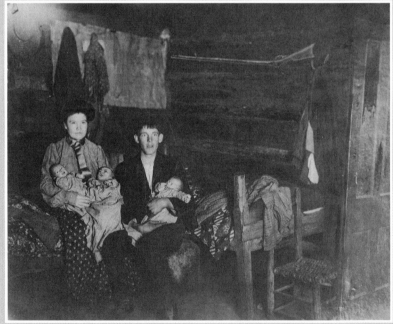

IMAGES R.6–R.7
Above, Sagamore's interior, 1899; below, an Arkansas couple and their triplets provide a more average view of log cabin life for the 99 percent. *(The Adirondak Museum and Library of Congress)*

more, only 4 percent of Americans in the bottom quintile make it all the way to the top quintile, "confirming that the 'rags-to-riches' story is more often found in Hollywood than in reality."[14] For most of us, places like Kaufman's Granot Loma are just a dream, especially considering its as-of-this-writing price tag: $19.5 million. That's a bargain compared to the $40 million for which it was originally listed in 2015, but still $19.5 million more than the average immigrant settler's cabin, which was free.

·8·

GOING NUCLEAR

SIDE FROM A brief 1950 dalliance with NBC, Walt Disney's first foray into the choppy waters of early television came in 1954, when the flailing network ABC agreed to broadcast his eponymous anthology series, *Walt Disney's Disneyland*.[1] The idea was that the show would generate enough capital to finish Disney's then-under construction amusement park while boosting ABC's prestige in the process. It would be a win-win. *If* it worked, that is, and it was pretty touch-and-go at the start.

The series's first offerings—well-trodden tales like *Alice in Wonderland* and forgettable "the-making-of" specials on Donald Duck were modest ratings successes, but were pretty humdrum in terms of moving merchandise, the real engine of Disney's economic plan. Uncle Walt's experiment seemed doomed. But then, on December 15, 1954, came the series' eighth installment, *Davy Crockett: Indian Fighter*, an imaginative retelling of the log cabin-living hero's time taking down "Injuns" in Tennessee, starring Fess Parker. As familiar a tale as Alice's, Crockett's ratings left her in the dust. Seriously. Rising with each rerun, the special ultimately netted around 40

million viewers, all eager for more. And so began the beginning of the end of pop culture's log cabin appropriation.

With dollar signs in his eyes, the ever-enterprising Disney expanded the vaguely fictional, "based on a true story-ish," three-part series by adding two entirely fictional prequels, *Davy Crockett's Keelboat Race* and *Davy Crockett and the River Pirates*. He then spliced the first three into a movie-length feature, making even more money off of what was essentially a very long rerun. It really was genius. And the impresario wasn't done yet: Disney further propelled the series' popularity by sending leading man Fess Parker on a tour through 42 US cities, Europe, *and* Japan. Everywhere he went, Parker was surrounded by hundreds, sometimes thousands of fans, all singing the song's inescapable opening theme, in English: "Davy, Davy Crockett, king of the wild frontier."

But the geese that laid the golden eggs were licensing deals—well over a hundred of them—for shelf after shelf of Crockett-themed wares, including but by no means limited to cap pistols, sheets, guitars, underwear, lunch boxes, bath towels, picture books, ties, socks, jeans, telephones, and obviously there were Davy Crockett Log Cabin Kits and the ubiquitous coonskin caps. Little did anyone know that Crockett's iconic cap was, like Harrison's log cabin, just a journalist's invention, one created in 1826 to make the then-freshman congressman look like a hick.[2] But it probably wouldn't have mattered. People were too busy fighting over Crockett-branded crap to mind the facts. Journalist Barbara Bundschu reported in 1955, "Department stores report that nothing—just nothing—in memory has hit their children's clothing and toy departments with such a fat wallop as Walt Disney's resurrection of 'the king of the wild frontier.' "[3] The Boston

IMAGE 8.1 The log cabin got a big boost from Walt Disney's Davy Crockett franchise. *(Everett Collection, Inc. / Alamy Stock Photo)*

IMAGE 8.2 A 1946 poem celebrating the cabin and the mountain men within. *(Spartanburg County Public Library)*

Museum of Fine Arts even staged an exhibit of a rare 1828 portrait of Crockett, bridging pop and high cultures with universal love for all things Davy.

But, remember the lesson from earlier about haters? Well, this Davy craze wasn't without its detractors: Crockett Truthers, if you will. John Fischer at *Harper's Magazine* decried the Disneyfied rendition for sanitizing Crockett's womanizing, booze-drinking ways. "[Kids] have been bedazzled into worshipping a Crockett that never was—a myth as phony as the Russian legend about Kind Papa Stalin. . . . He never was king of anything, except maybe The Tennessee Tall Tales and Bourbon Samplers' Association."[4] Ya burnt, Davy Crockett! And Fischer was hardly alone in taking the piss. Virginia journalist Ray Tucker wrote that Crockett was not "the backwoods nobleman glorified by Walt Disney [but] a mediocre member of Congress, an illiterate magistrate, [and] a shiftless farmer."[5] Historian Vernon Louis Parrington described Crockett as, among the aspersions above, an ecological terror: "His history serves to explain why the rich hunting grounds of the Indians were swept so bare of game so quickly by white invaders,"[6] while the *New York Post*'s Murray Kempton ran a similar argument under the headline "The Real Davy," writing that Crockett was a lazy louse "who would bear any hardship to escape a routine day's work."[7] Crockett's legions of fanboys were particularly furious at this latter jab and began picketing Kempton's office with signs reading, "Who you gonna expose next—Santa Clause?," while fretful mothers moaned, "Won't they leave kids any idols?"[8] Even

conservative William F. Buckley Jr. got in on the fun, sneering that year, "The assault on Davy is one part a traditional debunking campaign and one part resentment by liberal publicists of Davy's neuroses-free approach to life."[9] In the meantime, Disney was laughing all the way to the bank: Crockett fever generated $100 million in sales in just six months—that's

about a billion dollars in today's money—and that number ballooned to $300 million within another year.[10] Now completely financed, Disneyland, including its pioneer-*ish* Frontierland, opened in July 1955.

Reflecting on his overnight stardom, twenty-seven-year-old Crockett portrayer Parker chalked the "hullaballoo" up to "hero-hunger," a distinctly "twentieth century children's ailment": "It's like a vitamin deficiency, only it affects the development of character rather than body. In our vast effort to improve the food our kids eat, has anybody thought about the heroes they need to nourish their imaginations?"[11]

But there was something darker behind this long-dead pioneer's sudden popularity, something more existential than just run-of-the-mill hero worship.

BOOM!

The Great War wasn't supposed to have a sequel, but World War II was far more devastating and abominable than its predecessor: 60 million dead, including 500,000 American soldiers and at least 11 million people, six million of them Jewish, in a new and terrifying thing called a "concentration camp." The magnitude was so great that the

IMAGE 8.3 Disney's Frontierland, circa 1956. *(Disney by Mark Hickson)*

IMAGE 8.4 World War II's atomic end changed the world, but the log cabin remained the same. *(US Department of Energy)*

mass murder even had a name, "The Holocaust." And, as if that weren't mind-boggling enough, the atrocious war's atom-smashing, dread-generating end demolished any illusion of going back to normal. But that didn't mean people didn't try.

Just as we saw after the Great War, normalcy, continuity, and traditionalism were the name of the game in post-WWII, post-nuclear America. The nation was clawing its way back to the way things were: women like Rosie the Riveter were sent back to the kitchen; African-Americans allotted new opportunities in wartime were sequestered to their separate and allegedly equal place; anything out of the ordinary, anything "un-American" was looked at askew, viewed as shadowy in the cloying, Day-Glo light of the nuclear family and their prescriptive, Wonder Bread norms. The log cabin and Crockett's place therein were part of this formula, a continuation of the trend seen so many

times before. Turning back to the log cabin and its folk heroes gave the nation a sense of stability and, again, direction. Television was but a new medium transmitting a perennial American message—the log cabin is a national nucleus—and it was spreading it with the efficiency of an epidemic: Only 7 percent of American households had a TV set in 1950, a number that ballooned to 58 percent in 1955, imprinting idealized images of Crockett and his "heroic" fight against "savages" upon millions of nubile American imaginations. Crockett was well-known before the war, but he was no super popular hero, and he definitely wasn't illustrious enough to warrant bedsheets bearing his visage. He wasn't even the only cabin-dwelling hero romping around mid-century America: DC Comics started publishing the

adventures of pre-Revolutionary warrior Tomahawk in 1947, just after the war's end, and that some company introduced the similarly rustic Trigger Twins in 1951. So, no, Disney's Crockett wasn't the only cabin-dwelling hero around post-war America. He just happened to be in the right place at the right time, standing defiantly for American rights and honor, just like a flag on Iwo Jima. But Disney's Crockett wouldn't be alone for long.

Television schedules were soon stacked with Crockett imitators. Some were even produced by Disney himself, like 1957's *The Saga of Andy Burnett*, about a pioneer who lived among log cabins in the Rockies, and *The Swamp Fox*, the 1959 mini-series starring Leslie Nielsen as Revolutionary War soldier Francis Marion. Neither had

IMAGE 8.5 Cult hero Tomahawk defending log cabin dwellers in his titular DC Comics series. Perhaps he would be more famous if he had been on television. *(DC Comics)*

the cultural impact of the Crockett specials, though. Nor did they compare to what was happening over at Disney/ABC rival NBC: the 1959 western *Bonanza*, about a family living at the massive log-made Ponderosa Ranch. Part of a broader (and related) western craze, it ran for fourteen seasons and unleashed a merchandizing, um, bonanza that rivaled even Crockett's and which included comic books, View-Masters, an amusement park that closed in 2004, *and* a restaurant chain that still, as of this writing, has eighty-eight locations across the land.

And the Peacock network scored a coup in 1960, when they cast Fess "Crockett" Parker, fresh off his Disney contract, as another famous frontiersman, Daniel Boone. *That* series ran for six years and, yes, it too generated a line of trademarked accoutrements: synthetically rustic products shelved next to Roy Rogers log cabin sets and Lincoln Logs, an old-timey toy that was more popular ever, thanks to new owner PlaySkool's endless stream of commercials aimed at little Billy and Sally vegetating to Boone, *Bonanza*, and the like, their minds ripe for the picking.

But these trinkets, television programs, and other trifles are less about myth than marketing. Disney and company were more interested in entertainment than ethos, dollars than ideology. Though directly related to the past log cabin myth-making in that they relied on it, these trends existed mostly to make bank. They were turning a mud-

IMAGE 8.6 Baby boomers went whole hog emulating cabin heroes like Davy Crockett. *(SuperStock / Alamy Stock Photo)*

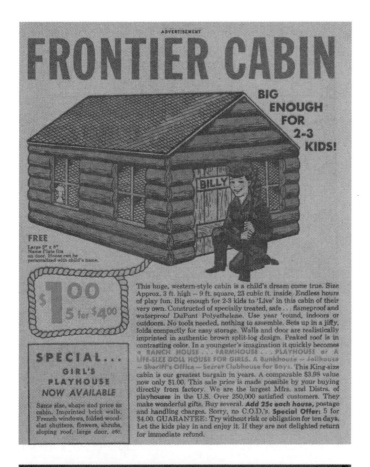

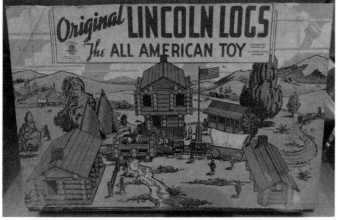

IMAGE 8.7 These "frontier cabins" were in fact just polyethylene plastic. There goes your allowance . . . *(Author's collection)*

IMAGE 8.8 Old school Lincoln Logs remained a go-to for American kiddies in shiny post-nuclear America. *(B Christopher / Alamy Stock Photo)*

dled history into Americana, little bits of camp that acted like a shellac, making the log cabin lore glossier, more colorful, and, most important, more consumable. This brand of myth-making was a candy-colored version of American heritage; surreal little confections. And they were ingested so enthusiastically because jarred Americans needed saccharine familiarity in trying times. History was thus hijacked and appropriated; it was burnished, branded, and bundled, becoming a plastic shadow of its former self. There's no hint of slave cabins or displaced Indians here; just white heroes like Boone, Crockett, and the Cartwrights of Ponderosa.

I.R.L.

In the rare moments that Americans weren't basking in television's glowing embrace or buying the shiny things seen thereon, they were absorbing log cabin lore in other ways. Even before Crockett hit the airwaves, Americans were buying up prefabricated log cabins, a ready-made version of the pioneer home. First introduced in 1938, they hit a stride in the 1940s. Navy veteran Morgan C. Elmer told *Kiplinger's Personal Finance* in 1948 that he couldn't make them fast enough. "Doctors, lawyers and businessmen want a place of quiet, away from things,"[12] read the report.

Elsewhere, tourists were traveling to the latest "Log Cabin Resorts" in Michigan, Washington, Iowa, and Wisconsin, stopping at log cabin-shaped gas stations along the way and buying Cokes from log cabin-shaped diners, too. Cruising along freshly paved routes, they could pop into South Carolina's Andrew Jackson State Park to use the log cabin-shaped toilet built there in 1953 (Americans really know how to honor a guy, huh?), and, if it was post-1966, these mid-century tourists could hit up Fort Worth's new "living western museum," the Log Cabin Village.[13]

LOCATED AT WEST END OF THE PRINCIPAL BUSINESS STREET.

62165 LOG CABIN SERVICE STATION.
 NATIONAL TOURISTS PROCLAIM IT THE MOST ARTISTIC IN THE U.S.A.
 LINDQUIST OIL CO. FERGUS FALLS, MINN.

LINCOLN LOG COLONY, E. J. McEnaney, Box 469, Fort George Road, Lake George, N. Y.

Or maybe these mid-century motorists were closer to Pennsylvania's James Buchanan log cabin, a tidy structure allegedly standing on the farm where the fifteenth president was born in 1791. There's no proof future president Buchanan was born in this cabin—he certainly wasn't brought up in it; his merchant father could afford a fine

IMAGES 8.9–8.10 The log cabin was now central to all-American recreation. (*Minnesota Historical Society*)

a brick home—and the structure was pretty much ignored for years, even *after* Buchanan's 1856 election. In the years since, the cabin had been a house, a Latin school, a barbershop, an antique shop, and a Girl Scouts headquarters, all with only a passing thought to its ties to the president. But then, in 1953, post-war, the air thick with dire sentimentality, the cabin was dusted off and deemed a national treasure. A barbershop no more, it was a symbol of America's greatness and opportunity. Poof! Just like that. Myths are magic.

James Polk received a similar but more dubious honor a few years later, in 1957. Not only was the lionized Polk replica based on two competing but somehow both "accurate" accounts of Polk's birth cabin, it was set up in Polk's birth state of North Carolina, a state that didn't even vote for Polk when he ran for president in 1844.[14] Voters

IMAGE 8.12 Marilyn Monroe and Robert Mitchum outside a cabin in *River of No Return*, one of many western and frontier-set flicks out of midcentury Hollywood. *(AF archive / Alamy Stock Photo)*

were still sore he had moved to rival Tennessee, but obviously they got over it. Another log cabin miracle . . .

Dead politicos weren't the only ones reaping the log cabin's benefits, though, as the structure again found itself firmly in the political spotlight. The 1952 presidential election saw not one but two Democratic candidates, Bob Kerr and Adlai Stevenson, reference log cabins. Kerr's entire platform was built on his log cabin birth. He even distributed campaign buttons emblazoned with the likeness of the log cabin. But Adlai Stevenson went a different route, trying to rise above the rote log cabin trope. "I wasn't born in a log cabin," he said, when a

IMAGE 8.13 Bob Kerr's 1952 campaign button played up his log cabin birth. *(Author's photo)*

reporter turned a simple hole in his shoe into a talking point. "I didn't work my way through school, nor did I rise from rags to riches, and there's no use trying to pretend I did." And author Kevin McCann's campaign biography of eventual winner Dwight D. Eisenhower's also alluded to America's rough-and-tumble olden days. From *The Man from Abilene*, about Ike's early years in Texas: "The lusty pioneer energies that built [his town] had moved farther West, but they left behind a robust, independent settlement whose rugged population knew the value of hard work and took for granted the virtues of sturdy individualism."[15] The log cabin isn't present here, but the subtext is clear. And that same spirit was there again in 1956, when Democratic vice-presidential nominee, Tennessee-born Estes Kefauver, rocked a coonskin cap to counter allegations that he wasn't sufficiently patriotic. But even that wasn't enough to unseat well-liked Ike.

Elsewhere on the mid-century cultural landscape, we know Holden Caulfield preferred a red hunting cap to coonskin, but even the famously angsty teen couldn't resist the log cabin. His whole woe-is-me narrative hinges on finding bark-covered refuge from phonies: "I'd build me a little cabin somewhere . . . and live there for the rest of my life," Caulfield mused in J. D. Salinger's best-selling 1951 novel *The Catcher in the Rye*. "I'd build it right near the woods, but not right *in* them, because I'd want it to be sunny as hell all the time." The log cabin also made a cameo in Chuck Berry's 1958 hit "Johnny B. Goode," about a cabin-born guitar genius. And who could forget country crooner Porter Wagoner's 1960 cover of the 1939 track "An Old Log Cabin For Sale"? Well, probably a lot of people. The point is that the postwar zeitgeist was lousy with log cabin imagery and idolization. If there was a place where the log cabin could appear, even the smallest little cultural nook, it would, slathering a happy sheen on America's fermenting times. How else do you explain Dogpatch,

USA, the cabin-dominated amusement park based on the *Li'l Abner* comic strip that opened in May 1968, right after Martin Luther King's assassination and the resulting protests?

As American astronauts raced to space, rocketing into the future—and in fact *because* Americans were racing to space—its earthbound denizens were clinging to the log cabin like a talisman, shielding themselves from the glaring threat of nuclear annihilation and social upheaval.

"Our complex lives, in contrast to the simple existence of our log cabin forebears, are being systematically exposed as matter of governmental record," C. A. Weslager wrote in 1969, as things seemed to be coming apart at the seams. "We are beginning to have a greater appreciation of [the log cabin lifestyle's] separation from the written questionnaire, the telephone survey . . . the punch cards, and the mag-

IMAGE 8.14 The man Holden Caulfield wishes he could be. *(Library of Congress)*

Old Courthouse and Cabin of Dallas's Pioneer Settler, John Neely Bryan, Dallas, Texas

DA-12

IMAGE 8.15 This replica of the humble 1843 cabin of Dallas founder John Neely Bryan was erected in 1936 in Founder's Plaza, next to city hall, as a way of highlighting the oil-rich town's remarkable growth. *(Dallas Historical Society)*

netic tape."[16] Replace punch cards and surveys with iPhones and Facebook, and that could be a tweet.

RADICAL, MAN

By the late '60s, the log cabin had become a fundamental component of the nuclear family/establishment complex that demanded so much youthful rebellion. Sick and tired of repressive norms and reactionary "values" dictated from above, a new generation of American kids—and many of their feminist mothers, proud brothers and sisters of color, and newly liberated LGBT siblings too—revolted against the patriarchal, heteronormative bourgeoisie. This anger was seen on the streets, in suburbs, and, yes, in the woods, where the most committed of counterculturists set up verdant log cabin communities to seed egalitarian utopias.[17]

The Oregon-based Bray Family collective turned log cabins into a

symbol of cultural revolt in 1968. "Their hair and dress, their pioneer spirit . . . evoke the nation's frontier beginnings," read a 1969 *LIFE* magazine cover story. "[But] the youthful pioneers, unlike the earlier Americans who went into the wilderness to seek their fortunes, are refugees from affluence."[18] These are the forefathers of Trustafarians. It was also in these years, in 1971, that Stephen Gaskin started his long-running Tennessee commune, The Farm, with one log cabin. But whether in Oregon or Tennessee, these cabins represented a revolutionary departure from the norm, a break from institutions, just as it was for so many settlers. These idealistic hippies saw the log cabin as an incubator for utopia, as a groovier replacement for a corrupted society.

But, wait—something else was happening in 1971. As Gaskin was setting up shop in Tennessee, Walt Disney was opening Disney World, down in Florida, including Fort Wilderness Cabins, a faux rustic retreat for middle class people hoping to escape their upwardly mobile lives but without all the trouble. "[It] promises to be the ultimate experience for hordes of Americans who take to the woods each year," complete with a log cabin-shaped general store stocked with T-bone steaks.[19] And it was only a quick, futuristic monorail ride away from the main park! Despite all their differences,

IMAGE 8.16 The *LIFE* magazine cover story on late-'60s hippies. (*LIFE magazine/Getty Images*)

yuppies and hippies could apparently agree on something: The log cabin was far out.

That's what generations of myth-making and conditioning will do. The log cabin was a lodestar to which *all* Americans were drawn, even if for completely disparate reasons. Powerful people who kept institutions in place loved it as a temporary release from pressures or as a marketing gimmick, a way to make bank; those who wanted to upend institutions saw the log cabin as the seed for an entirely new society. Rich or poor, conservative or counterculture, all had a deep-seated and certainly romanticized vision of what a log cabin represents: freedom and opportunity.

THE BIG 2-0-0.

The bicentennial and its pioneer-flavored patriotism inflamed America's log cabin obsession. Syrup and whiskey bottles were cast in its form, and log cabin-shaped floats were paraded about, too. And every city, town, and hamlet seemed to have an abandoned old cabin they wanted to save for eternity, a relic of our pure and just past. Sumner A. Mills, an Indiana man who, at 80, remembered neighbors living in log cabins, spent his last years restoring one such domicile to its former glory: "It will be suitable for small meetings and school classes to get an idea of pioneer days."[20] The log cabin was being passed from one generation to the next, like a family heirloom.

Speaking of generations, thousands of American students were subject to school-sponsored log cabin raisings—"The kids are really turned on with this project," said a totally with-it teacher[21]—though more than a few probably managed to stay home, "sick," watching the Wilders visit log cabin-dwelling neighbors on *Little House on the Prairie*, the 1974 to 1982 TV adaptation of Laura Ingalls Wilder's book series, the

first of which, *Little House in the Big Woods*, was first published in 1932, during the inter-war's frantic cycle of myth-perpetuating. "Turn, turn, turn . . ."

But even as patriotic bicentennial boosters danced around log cabins and donned tricornered hats, played fifes, and fired off fireworks, all happy and gay in public, behind closed doors they were reeling from a tide of political and cultural discontent. Disillusionment over Watergate and Vietnam still ran deep, inflation crippled bank accounts, unemployment stalled American dreams, Congress had a 24 percent approval rating,[22] and the threat of nuclear ruin invariably loomed. It was a worrisome and cynical time—and the stress was starting to show.

OH, THE HORRORS!

A funny thing happened after the bicentennial: The log cabin was inverted. Once so safe and secure, it was turned into the scene of heinous depravities in horror movies like Sam Raimi's *The Evil Dead*, the 1981 cult hit based on a 1978 short called *Within the Woods*. There's no cabin in the original short, but it's definitely there in the follow-up—and it ain't quaint: It's home to demonic forces that wreak havoc and shed massive amounts of blood. Talk about rude!

Raimi's movie, made as the nation suffered its sins (a whopping 77 percent of respondents told Gallup[23] they were disappointed with the country's direction in November 1979, and 78 percent said the same

in 1981, the year *Evil Dead* premiered),[24] flipped the switch. While "the man" continued to peddle the notion that the log cabin was the genesis for something intrinsically great and right, the United States, this celluloid depiction brought death and despair to the nation's youth. The American dream here was an American nightmare. And it was only just beginning.

Sean Cunningham started filming *Friday the 13th* in 1979, just after the release of *Within the Woods*, turning sleepy Camp Crystal Lake into a killing field as Mrs. Voorhees stalked and slashed through log cabins. Her son, Jason, would do the same the following year and in a stream of sequels, most of which took place in or around cabins. (Let's not talk about Jason taking Manhattan, okay?) And the otherwise faithful sanctuary would be host to unimaginable crimes in 1983's *Sleepaway Camp* and its many sequels, too.

Consciously or not, these films perverted the log cabin, turning the once-predictable safe haven into a commentary on the post-Nixon, post-Vietnam America, all awash in corn syrup and bare breasts. And even as Vietnam faded into the background, eclipsed by new real-life barbarities, the log cabin remained a palatable backdrop for cinematic scares, as in 2002's *Cabin Fever* and Drew Goddard's genre-busting 2012 movie *The Cabin in the Woods*, in which the iconic log cabin doubles as an altar for government-backed human sacrifice. Considering the structure's sacred status here in the States, that scenario seems almost plausible.

MORNING AGAIN IN AMERICA

But we know dogged conservatives wouldn't give up the log cabin without a fight. A group of gay Republicans came together in 1977 as the "Log Cabin Republicans," a name they hoped would invoke Lin-

coln, thus distracting their moralistic, homophobic peers from their sexuality. And then, more prominently, there was "Prouder, Stronger, Better," Ronald Reagan's aggressively sunny 1984 reelection campaign. Opening with a tableau of cheery shots of white Americans going to work, moving, getting married, the minute-long spot then cuts to a flag being raised above a log cabin, a group of vaguely-ethnic looking girls looking up in awe. A brighter future beckoned, said the narrator, and Reagan would light the way: "It's morning again in America, and under the leadership of President Reagan, our country is prouder and stronger and better."

Yes, it was morning in America, an America where greed was good, an America in which AIDS had killed more than 3,500 people in three years and showed no signs of slowing, and the Doomsday Clock had just ticked that much closer to nuclear obliteration, thanks in part to the president's commitment to an outlandish arms race with

the USSR. And yet, in the midst of all this commotion, there was the staid log cabin, being turned out for political gain. And commercial, too: Dolly Parton's Dollywood, complete with replica of the sparse cabin where the singer grew up, opened not long after, in 1986, bringing scores of tourists to Tennessee rental cabins, just a ways from "a new and *more authentic*" Daniel Boone replica that opened nearby (emphasis mine).[25] Log cabin enthusiasts in Michigan were simultaneously organizing that state's first "Log Cabin Day," an annual event that continues today. *Log Home Magazine* launched that year, too, and would be joined by *Log Home Living* in 1988 and *Backwoods Home* in 1989. And it comes as no surprise that sales of prefabricated cabin homes, one-room affairs and mansions alike, were through the roof, generating $416 *million* in sales in 1986, and another $440 million in 1987, the tail end of Reagan's second term.[26] This boom in off-the-rack log cabins doesn't necessarily have to do with Reagan's bellicose rhetoric (though that probably didn't help); this was just the twentieth-century American way: buying up factory-made facsimiles of the past, little bits of ready-made rusticity. And the trend only grows in years to come. The more things change, the more they stay the same. Or so we wish, hope, and pay.

HARD NOTCH

The Log Cabin and Deforestation

"The greater part of the animal and vege-
table matter [of America] which nature had
been accumulating for a great length of time,
is destroyed in a day or two."

—JOHN LORAIN, 1825[1]

M OST PEOPLE REMEMBER Ronald Reagan for yelling at Sovi-
ets and for giving the neo-con movement a friendly, rosy-
cheeked face. Less remembered are the 10 million acres of
untouched nature he set aside during his eight years in office. The pres-
ident wanted to ensure that future generations saw "how the land must
have looked to the first Pilgrims and pioneers."[2] But the Republican
also supported slashing environmental regulations and leasing, lend-
ing, and otherwise forfeiting public land to rapacious drilling and min-
ing companies. The Gipper's self-contradictory, give/take approach to
the environment is emblematic of our nation's long and uncommonly
troublesome relationship with the land, that perceived tension between
economic growth and ecological sustainability.

Forests in particular have been the source of so much pride and

opportunity for this country, yet Americans have taken just as much pride in cutting them all down, even at our own detriment. "The pioneer of the western forests seems to have taken a pleasure in devoting to destruction every noble tree within a furlong of his dwelling,"[3] Zachariah Allen said in 1832, "These [trees], if spared, might have furnished him refreshing shade." As expansive as our nation's imagination—sea to shining sea;

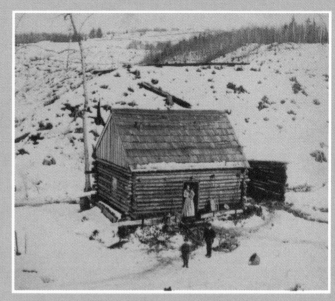

how bold!—there's no shortage of short-sightedness when it comes to the environment. Early Americans didn't worry about running out of resources. We had *so much*, so we just charged full steam ahead, blithely using axes, fire, and rope to destroy centuries-old forests as if they were our fiercest foes. And the log cabin was standing there every step of the way, first as a witness to ruination and then as a sentinel against it.

From the colony-cum-nation's earliest days we see strikes against trees described in macabre terms. Captain John Smith advised prospective colonists in 1625 to "spoil" the woods by hacking away trees' bark and letting them die a slow death: "the tree will sprout no more" and branches will "rot;"[4] the Marquis de Chastellux remarked on Americans' violent approach to trees in the early 1770s: "[The settler] boldly attacks those immense oaks, or pines . . . he strips them of their bark, or lays them open all around with his axe."[5] "Mortally wounded," the trees are left "a hideous skeleton."[6] And British traveler Isaac Weld was equally aghast at the young nation's "unconquerable aversion"[7] to trees. "They cut away all before them without

IMAGE HN.1 The log cabin stories we tell ourselves rarely mention that the structure we hold so dear was a bystander to terrible amounts of destruction, as seen in this 1872 photo taken in New Hampshire. *(Photography Collection, The New York Public Library)*

IMAGE HN.2 "The newly cleared lands in America have, almost invariably, a bleak, hopeless aspect," our old friend Basil Hall wrote in 1828 about the denuded land Americans called "improved." *(Library of Congress)*

mercy," he wrote in 1799.[8] And as beautiful as the country may be, most Americans had no interest in enjoying the view. Not back then, at least. As Weld wrote, "They stare with astonishment at a person who can feel any delight in passing through such a country."[9] The land was far too valuable, a sentiment captured in this 1775 remark from North Carolina and Daniel Boone-employer Judge Richard Henderson: "The country might invite a prince from his palace merely for the pleasure of contemplating its beauty . . . but only add the rapturous idea of property and what allurements can the world offer for the loss of so glorious a prospect?"[10]

Yes, Romanticism opened some eyes to the ecological depredation at hand, but for the most part Americans agreed with Andrew Jackson's 1830 assessment: "What good man would prefer a country covered with forests, and ranged by a few thousand savages to our extensive Republic, studded with cities?"[11] That's basically the same thing Reagan said more than a century later, in that famous misquote: "If you've seen one redwood, you've seen them all." The actual remark, delivered in 1966, when the former actor was a guber-

IMAGE HN.3 Log cabins litter a decimated Alaska forest in the early 1900s. *(Library of Congress)*

natorial candidate in California, isn't much better, but went like this: "I mean, if you've looked at a hundred thousand acres or so of trees—you know, a tree is a tree, how many more do you need to look at?" In other words, "Trees are trees, let's cut the whole thing down."

When Europeans arrived in 1600, there were an estimated 850 million acres of forest on the contiguous states. By 1850 there were 720 million;[12] 130 million had been wiped off the face of the map, converted into farmland, fuel, timber for building booming, ever-growing towns, and of course for split-rail fences to keep trespassers out, about 3.5 million miles of it by 1850.[13] And at the center of all this American carnage sat the log cabin. "Cut branches cover the paths, trunks, half charred by fire or mutilated by the axe, still stand along our way. [We] come to a wood in which all the trees seem suddenly to have perished. . . . Beyond this field, we see, not yet completed, the first steps of civiliza-

IMAGE HN.4 Logging crew and locomotive near Marshfield, Wisconsin, c. 1888. *(Wisconsin Historical Society WHi-24327)*

tion in the wilderness—the owner's cabin,"[14] wrote de Tocqueville in a general 1831 description of the passage from unkempt forest into one of America's many embryonic towns.

We can't blame the lil' ol' log cabin for all this ruin. Not directly, at least. The humblest of them required only about eighty logs, give or take, so the structure was more of an accomplice. The log cabin didn't cause ecological marauding; it simply enabled it. It simply sheltered the settlers who were busy "improving" the untouched land, salvaging it from woodland "savages" for cash in the bank. The log cabin was the seed for little individual empires, all dotting the land. And just as we can't impugn the log cabin for the havoc it wrought, we have to cut the settler some slack: even the most superstitious and greedy among them could "improve" only so much forest. No, there were larger forces at work. *Market* forces.

Just as George Croghan used cheap, convenient log cabins to build his fur empire in Pennsylvania and Ohio, and as plantation owners did to house slaves in the south, so too did Industrial Era corporations bank on log cabins as they laid waste to huge swaths of forest, chasing profits to all four corners of the continent. Between 1850 and 1860 alone, 40 million acres of forest were destroyed, much of it cleared for trains that themselves burned through 6.5 million cords of wood a year.[15]

Naturally, the lumber industry played an enormous role, in decimating America's woodlands, too. It had gobbled its way beyond the Northeast and into the South, the West, and Great Lake states like Michigan and Wisconsin, where millions of trees were taken down with corporate efficiency. About 40 million acres were cleared from 1850 to 1860 alone, and though the Civil War cut production to around 19.5 million acres between 1860 and 1870,[16] sawmills came back full-force the next decade, devouring 49.3 million acres between 1870 and 1879. And from all this debris rose a cultural hero. Or, rather, an anti-hero: the lumberjack. William H. H. Murray, the Boston pastor who inspired so many rich folk to flee to the woods, described them as "the curse and scourge of the wilderness."[17] Lumberjacks "were perceived to be stripping the country of a moral resource and an object of national pride," Michael Williams writes in his history of American forests. "But the products of lumbering were so necessary for everyday living that, paradoxically, the lumbermen . . . had to be tolerated . . . and frequently they were praised

IMAGE HN.5 Just as log cabins were cheap and reliable housing for settlers, those "tree destroyers," so too did the sylvan structure provide an economical housing for oil, mining, and lumber concerns cashing in on our natural resources. This image, taken in 1859, shows oil fields in Pennsylvania, denuding the landscape to its barest bones. *(Photography Collection, The New York Public Library)*

for acting in the public interest."[18] By the end of the century, a total of 330 million forested acres were gone.[19]

RED, WHITE, AND GREEN

But as lumberjacks like Paul Bunyan[20] were hacking their way through the woods and into pop hero status, a contrasting paragon gained strength, too: the eco-warrior. Horace Greeley, the newspaper publisher credited decades before with telling young men to "go west," where they would proceed to raze so many trees, was warning Texans

in 1871 to avoid "reckless extermination" of trees. He and his New England forefathers foolishly believed "there will be timber enough," but now the whole region "lived to deplore their error."[21] *The Nation* noted in 1873 that the public at large was starting to doubt the wisdom of giving business interests free reign over public lands.[22] One year later, famed conservationist John Muir serialized his *Studies in the Sierra*. What had once been a small movement was gaining strength, and spurring serious change.

We saw the first hints of this "save the planet" movement in the previous chapters, among people like Thomas Cole, ambivalent artists who rued the unencumbered expansion they synchronously championed. "Improvement . . . makes us fear that the bright and tender flowers of the imagination shall all be crushed beneath its iron tramp," Cole wrote in 1836, not long after exalting Daniel Boone.[23] But there were more full-throated objections against deforestation around, too. And I'm not just talking about transcendental writers like Henry

82733

IMAGE HN.8 Park rangers and their canine companion at a log cabin station in Stanislaus National Forest, 1909. *(Forest History Society, Durham, NC)*

David Thoreau, but among government officials, as well. President James Madison warned as early as 1818 that "injurious and excessive destruction of timber and firewood" would result in calamity;[24] Congressman George Perkins Marsh raised the specter of climate change in 1847: "It is certain that climate itself has in many instances been gradually changed and ameliorated or deteriorated by human action;"[25] the Interior Department in 1860, as the nation faced a timber famine, called out the "ruthlessness" and "indifference which [the American people] exhibit for valuable trees." The federal agency continued, "It is lamentable . . . to observe the utter disregard manifested by the American people [for nature]."[26] And by 1866 Wisconsin-based Allen Lapham penned a state-sponsored report prophesizing some-

LOOKOUT
STATION
At head of Eddys

thing akin to the Dust Bowl, though he got the locale wrong: "[A] day shall come when the winds and droughts shall reduce the plains of Wisconsin to the condition of Asia Minor. Trees alone can save us from such a fate."

And as this pro-Gaia chorus grew louder, rhetoric sparked the nation's first legislative moves toward eco-friendly action. Abraham Lincoln's Yosemite Grant Act conserved thousands of acres of California forest in 1864; President Grant gave Yellowstone final approval in 1872; and Benjamin Harrison in 1891 signed the Forest Reserve Act that gave presidents carte blanche in earmarking protected land and helped the next three commanders-in-chief save 47 million acres before the law was amended in 1907, one year before famed tree hugger Teddy Roosevelt declared conservation a "national duty," "We cannot, when the nation becomes fully civilized and very rich, con-

IMAGE HN.10 A 1936 aerial view of a planned community Greenhills, Ohio. There are no ghouls or goblins here, that's for sure. *(Library of Congress)*

tinue to be civilized and rich unless the nation shows more [environmental] foresight than we are showing at this moment as a nation."[27]

Meanwhile, in the midst of this legislative flurry there arose a bureaucratic apparatus tasked with protecting and "managing" the forest. (The government couldn't give up total control; some of this land had to be reserved for lumber and other purposes, *natch*.) The Division of Forestry emerged in 1881, begetting the Bureau of Forestry in 1901 and then the US Forest Service four years later; the National Park Service coalesced soon after, in 1916, rounding out a battalion of young rangers tasked with protecting our nation's prized possession, the forest. And where did these mighty rangers set up shop? In the log cabin. Yes, the epicenter of so much ecological annihilation was now a guardian against it. Now it stood among the trees, protecting them from people, not the other way around. The log cabin is versatile like that.

Slowly but surely the forest began to recover, thanks in part to widespread replanting efforts. The CCC cheerily replenished the land

their forefathers had just as cheerily ravaged, eventually adding about 2.5 million new trees to our national holdings. And private companies got involved too, though not always with the purest of intentions. Henry Ford bought a few hundred thousand forested acres in Iron Mountain, Michigan, both to gouge for timber but also to protect his bottom line. "Mr. Ford is simply looking ahead," E. G. Kingsford, general manager for Ford's sawmill, told reporter Ovid Butler in 1922. "He doesn't want his business to be in any way unsettled by sudden or periodic timber shortages."[28]

Around the same time, and around the same region, The Wisconsin Land and Lumber Company had a pretty ingenious two-tiered plan. One aspect involved planting saplings on a few hundred thousand acres they'd denuded, and the other converting some 20,000 acres into a faux rustic village, complete with log cabins for tourists looking to back to nature before it was too late.[29] Affordable and somewhat kitschy, these cabins proved to be immensely popular, inspiring dozens of imitators up and down Michigan's countryside: "These were often log cabin construction and they exemplified a[n] [Upper Peninsula] conviction that visitors wants to 'rough it' in a cabin."[30]

This blaring tension between ecological responsibility and economical self-preservation has continued ever since, and is encapsulated nicely in "National Forest Products Week," an event kicked off in 1960 as a way to both hype toilet paper *and* raise enviornmental awareness. It's a fist-bump to the lumber and timber industries but a finger wag against irresponsibility. What fun! But, in all seriousness, President Obama's remarks in 2016, the fifty-sixth such event, show just how closely linked the issues remain: "Forests generate billions of dollars in economic growth, sustaining local economies and enhancing communities across our country. We rely on them in so many aspects of our national life." He added, "We must continue working to protect the precious resources our forests hold so they can continue

enriching our world and supporting our way of life."[31] Managing the forest and forest-based industry is a balancing act, and it could tip the wrong way at a moment's notice.

Today we have more forest than at any other time since 1920—751 million acres and growing[32]—but we're not out of the woods yet. Even with replanting and conservation efforts, our newer forests aren't strong enough to stop the climate change of which we've been warned for well over a century. Not only are many of them too young, making them woefully incapable of keeping up with humans' carbon output, but altered climate is stunting their growth, which, according to a 2016 report, could be creating a "feedback loop with the potential to accelerate climate change beyond critical tipping points."[33] And, more worrisome, a 2017 survey showed that the distance between average Americans and the closest forest is widening, further alienating citizens from a national resource.[34]

We've seen climate change's impact on contemporary Americans: Families are fleeing receding coastlines in Louisiana and Alaska, just like farmers fled the Dustbowl, a disaster fed in part by irresponsible over-farming. Climate change isn't new; it's just worse. To reverse course, we'll need to remain vigilant against the wanton destruction that for too long defined the American identity and economy, a mission that's especially urgent as anti-regulatory, anti-science, anti-common-sense politicians tear at environmental gains. To ensure our future, we must remain proactive, attacking climate change with the same vigor and dynamism with which we once felled the forest, while also innovating ways to safeguard our land, water, and other resources. Luckily, Americans have lots of imagination. We just have to mine it.

· 9 ·

THE LOG CABIN,
READY TO WEAR

DETROIT *NEWS* DESIGN journalist Marge Colborn dedicated her final column of 1990 to newly divorced Donald and Ivana Trump. With the "greed decade" officially over, it was high time the Trumps disavowed ostentation and embraced a more natural look: "Soon the divorced Trumps will be divvying up their digs," she opened. "To help Donald and Ivana as well as the rest of us mere mortals redecorate for the '90s, here's a handy What's In and Out List."[1]

On the "out" side, banished to the realm of the unfashionable, were Chippendale chairs, Georgian end tables, and the whole "English country" look that helped set the sumptuous stage for *The War of the Roses*; the 1986 novel-turned 1990 movie *The Bonfire of the Vanities*; and similarly consumption-fixated tales in which excess and ornate materialism played supporting roles. Down comforters, skirted ottomans, and gilt were to be swapped out for more elemental, but preferably just as expensive, Navajo blankets, twig tables, and wood. Colborn goes on: "A need to escape from a stressful job at the end of

the day . . . will result in vacation-type interiors—pseudo-log cabins, a farmhouse ambience."[2] We know that Trump never took Colborn's advice to ditch glitz, but millions of other Americans did, paying top dollar for things that looked worn out. It was the log cabin obsession's last stop: our home and closets. Complete lifestyles were built upon high-priced "pioneer" wares and wears. Ralph Lauren referred to this mode as "Wilderness,"[3] but Colborn preferred "log cabin chic," a then-mainstreaming locution that belies the style's innate incongruity: a projection of rusticity with an uptown price tag.

Though it was a concept as old as Adirondack Camps, "log cabin chic"[4] was just percolating when Colborn penned that piece. A direct descendant of the earlier "country chic," as in the 1984 *Historic Preservation* headline, "Humble Log House . . . Now It's Country Chic,"[5] and a cousin of British-born "shabby chic," the more distinctly American and appropriately aspirational phrase "log cabin chic" was subsequently name-dropped in a 1986 *Chicago Tribune* piece, "Live like a Rockefeller," about The Point, a $600/night resort at William A. Rockefeller's former upstate compound: "It's log cabin chic at this posh great camp in the Adirondacks. . . . Elegant meals are served in the Great Hall, though breakfasts (fresh-baked croissants, breads, butter and jams) are delivered in a basket to your room."[6]

IMAGE 9.1 This 1920s couple could be contemporary hipsters. (*H. Armstrong Roberts / Retrofile / Getty Images*)

Elsewhere, Howard Fineman employed "log cabin chic" in his aforementioned 1987 critique of wealthy presidential candidates playing poor,[7] a rare detour from design but one that shows how rapidly the concept was catching on in Reagan's waning years, as a new decade—and *millennium!!*—dawned. But the expression was completely style-centric again come 1991, when marketing guru Faith Popcorn ballyhooed log cabin chic as a "vicarious escape through consumerism, catharsis through consumption."[8] Also calling it "nostalgia escape," Popcorn continues, "If you can transport yourself to the past, you don't have to face the future."[9] L. L. Bean, a company founded in 1912, the height of the Adirondack Camp, designated their look "log cabin chic" in 1992;[10] and Ken Charbonneau, a director of color marketing for Benjamin Moore paints, wryly defined the concept

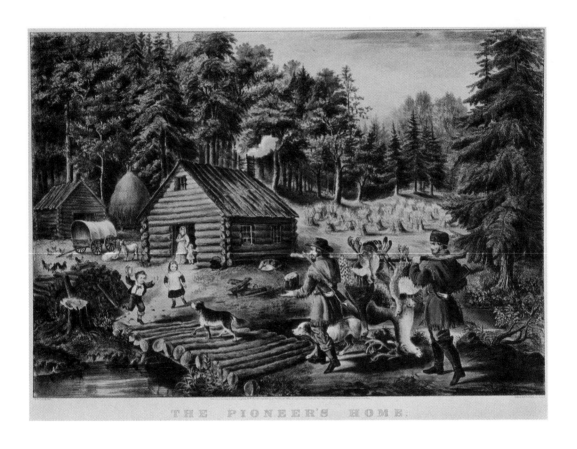

THE PIONEER'S HOME.

IMAGE 9.3 An image from a 1992 L. L. Bean catalogue. *NOT!* It's actually a Currier and Ives print, but a lot of people wanted to live this dream. *(Art Resource, NY)*

in in 1994 as an aesthetic for "grown-up yuppies [who] don't want to camp out in the Rockies." It was ornate in its sparseness: "If something is simple, the detail had better be exquisite."[11] But not even.

The high-end trend went mass market as fast as the dial-up and overseas labor could carry it. Before too long, American suburbs were awash in mail-ordered rustic duds. Log cabin fantasies were only a 1-800 number away as traditionally rustic catalogue companies like L. L. Bean and Eddie Bauer saw sales skyrocket. Over in the shoe department, Timberland's sales almost doubled in 1993 as the hip-hop set bought scores of the outdoor company's signature hiking boots, an unmistakably American backwoods accessory being repur-

posed for streetwear.[12] Even Kurt Cobain, the Holden Caulfield of his generation, rocked flannel like the most romanticized of cabin-dwelling lumberjacks. And Claire Danes's Angela Chase and Jared Leto's Jordan Catalano moped around their high school in various tones of plaid on ABC's short-lived but impactful 1994 to 1995 series *My So-Called Life*. With AOL all the rage, Americans of all walks wanted to look like they lived in the woods. In 1995, the same year Amazon, Match.com, and Craigslist launched on the exponentially widespread Internet, the *New York Times* wrote of Eddie Bauer, "The chain hopes to cash in on what it sees as a consumer trend toward the wear-

IMAGE 9.4 Writer Studs Terkel rocking buffalo plaid, sometime in the mid-1950s. *(Glasshouse Images / Alamy Stock Photo)*

ing of clothes for the corporate workplace that feature a more casual accent."[13] This was around the same time that office-oriented Banana Republic introduced their look of the moment: "cabin wear." The log cabin had made it to the corner office. Or the idea of it had, at least.

As journalist Judy Rose wrote early in the trend's upswing, in 1990, "[Designers] go through lots of trouble to create a past you never had."[16] Log cabin chic was the coonskin cap of the 1990s, only bigger—and more pervasive.

STILL GOT THE GROOVE

est assured, the log cabin hadn't lost its architectural luster amongst all this fashionable appropriation. The American Institute of Architects praised a newly constructed log cabin-esque Maryland home as "deeply American" and a "tour de force" in 1996. Mahogany-framed windows, Western red cedar siding, "crisp," "unadorned" cabinetry inside and imported boulders outside all contributed to an exemplar of a "raw yet manicured piece of architecture."[14] Other late-twentieth-century cabin afficionados meanwhile preferred a more traditional route: restoring old cabins. Or, rather, hiring someone to do it. "Business has just been great," said Kentucky-based restoration expert Bill Pace in 1995. "You used to see a lot of these [cabins] get burned down or bulldozed, but in the last two or three years I've seen an incredible interest in restoring old log cabins."[15] And prefabricated cabins like the ones seen after World War II homes were so popular that at least two American companies were expanding into Japan, offering overseas clients a slice of the States as American as apple pie.

IMAGE 9.5 This 1930s cabin was just as desirable in the 1990s. *(Wisconsin Historical Society, WHi-91200)*

PRODIGAL SONS

The log cabin trend cooled for a minute around 2000, when flamboyant metallic fabrics and glaring blond tips replaced understated flannel and feral locks. The so-called metrosexual gelled into form, reigning supreme for a few seasons. But you know how style goes: what's out is in soon again, and lo and behold, come 2010 or so, as the nation was digging itself out of the Great Recession, there was that familiar log cabin look, back on Americans' backs—specifically, American men's backs.

Tom Puzak laid it all out in October 2014 at GearJunkie.com, noting with zoological detail that the metrosexual was being "replaced by men more concerned with existing in the outdoors, or the pseudo-outdoors." He goes on, "His backpack carries a MacBook Air, but looks like it should carry a lumberjack's axe. He is the Lumbersexual."[17] This stylish species wants to look as if he's just come from his cabin in the woods, as if he's only dipping his toe into civilization proper before heading back to nature. While this is often cited as the first mainstream usage of the term, "lumbersexuality" had actually been around since 2010, as a subset of metrosexual. From Urban Dictionary: "A metro-sexual who has the need to hold on to some outdoor based ruggedness, thus opting to keep a finely trimmed beard."[18] It's concocted rusticity.

Lumbersexuality was suddenly name-dropped everywhere, just like "log cabin chic" before it. Newspapers like the *New York Times* and the *Guardian* analyzed lumbersexuals, wondering if all the buffalo plaid and beards spoke to a crisis in masculinity; first person accounts confessed to participating in the trend; fashion mags devoted lavish spreads to the provincial mode. As time went on, women jumped on board, too: Troy Patterson noted in 2016 that "the log cabin pattern" had been picked up by "logger ladies," evidence

that "buffalo plaid, once the uncomplicated icon of woodsy masculinity, is now a bit of a camp classic."[19] *The Atlantic*'s Willa Brown meanwhile highlighted the irony of Brooklyn hipsters adopting lumberjack airs. "The lumberjack seems like a startlingly apt symbol for hipsters to appropriate. On one level, it's just a neat metaphor for gentrification: Lumberjacks were, after all, an ad-hoc army of Caucasians, invading regions they imagined to be empty, sucking up the local resources, and leaving vast, bland spaces in their wake."[20] It's funny, but not in a "ha-ha" way.

On a larger, *meta* scale, however, there's really nothing to see here. "Lumbersexual" was/is just a new name for a long-established pattern. It's not "log cabin chic" *per se*, but it's a very close relative, spawned from the same yen for simpler times. Lumbersexuals and "logging ladies" are quenching that longing the only way they can, by buying it, just like early-twentieth century Americans who bought L. L. Bean's first offerings in 1912. This isn't meant to be a dis. Eighty percent of Americans live in urban areas; getting away from it all is infrequently an every-weekend routine. It's a rare, if ever, event. The sales rack is therefore the closest many can get to the rustic life, so we project the log cabin onto ourselves, just as historians project it into the past. (I confess, I've written the bulk

IMAGE 9.6 This hip-looking squad struck a mean pose in 1903. *(Library of Congress)*

of this book in an oversized cardigan fit for a cabin, feeling closer to the subject as a result.)

Even if the log cabin-inspired look is banished to the "out" side of things for a spell, replaced by something like "athleisure," it's only a matter of time before flannel, beards, and other rustic-*ish* emulations make a stylish return. Hell, maybe the coonskin cap will make a comeback. It would make a perfect helmet for a sky that we're constantly told could fall at any moment. But blue shards raining down or not, it's as one designer told Colborn in that 1990 article dedicated to the Trumps: "The log cabin look . . . has an enduring warmth that will ensure its popularity for some time."[21] The aesthetic needs no label, either designer or etymological. Log cabin chic, lumbersexuality, and all other design jargon are just sartorial emulations of the American spirit—and, like the country itself, people want a piece of it. We're fetishizing and idolizing the frontier pioneer's mores and methods, just like the people of 1900.

Some may read all the cabin-related consumerism as a cultural nadir: the end result of the marketing offensive started way back in 1840, the log cabin campaign. And in some ways it is. The log cabin's ugly underbelly is still whitewashed and tailored to fit our ideals, but commodification, consumption, and costuming doesn't necessarily deplete the log cabin of its symbolic power. In fact, that may be its great strength. Americans of every brand feel connected to the log cabin. We saw this with hippies and yuppies in the 1970s, as well as in the introduction to this book. The log cabin transcends race,

IMAGE 9.8 The log cabin, a timeless American fantasy. *(Library of Congress)*

gender, class, and genre. But no matter who's rocking the log-cabin look—black, white, Puerto Rican, or Asian immigrant, or native born, the aesthetic says it all: "America," pure and simple. And it's here that we find the log cabin's true value, something you can't put a price tag on: the potential to unite an increasingly anxious and uncertain nation.

CONCLUSION

IN THE FALL of 2016, three stories above the Bowery, the once rough-and-tumble Manhattan frontier that's since been "improved," and not far from where Lincoln's alleged birth cabin was stored around 1900, I sat with the artist Will Ryman to discuss his 2013 sculpture, *America*. An exact replica of the so-called Lincoln birth cabin that began this tale, the structure is varnished in gold resin and its interior is beveled with similarly gilded artifacts of America's economic evolution: arrowheads, corn, coal, cigarettes, and iPhones. Ryman compares this mosaic to hieroglyphics; it's a coded map of the nation's arc from meager colony to heavy-handed empire. It's an exploration of "the contradiction between America's motto of opportunity and the reality of success being built on people's backs."[1] There couldn't be a more fitting metaphor for the chasm between American ideals and reality than a solid gold cabin. Nor could there be a better visual for the structure's own story.

In some ways, the log cabin is the ultimate rags-to-riches story. It embodies the very myth it helps perpetuate. Once home to the "lesser kind," something to be

ashamed of and discarded ASAP, the cabin was redeemed via odes in romantic oils, and then manipulated by political masterminds and massaged by corporate marketers. The years ahead saw the cabin projected into the past and recast as the anchor from which a mighty empire grew. No one mentioned the slaves being imprisoned within that iconic silhouette, nor the darkness it brought to American Indians. The nastier bits were edited out in the name of a national fiction. And thus the log cabin was mutated into a glittering yet amorphous icon.

It's a prism that reflects and refracts the American story. From one angle, it's the key to a new future, the driver of incomparable, almost incomprehensible national expansion and wealth; from another, it's the imprisonment and displacement of millions, the people who were used and/or abused for that wealth; hold it this way and you see hideous ecological destruction; hold it another and there's the cabin, atop a mountain, at one with nature. But stand back a bit, taking it all in,

and you see the trajectory of the nation, the good and the bad. In the log cabin, we see the nation's determination, resilience, and grit, but also its avarice, ignorance, and materialism. The log cabin is the forebear of modern-day gentrification and a catalyst in the populist, anti-intellectual political movements that still hold sway today. It's the engine of change that made this country possible and the epicenter of widespread ecological destruction that threatens our very future. Beatific or grotesque, there would be no America without the log cabin.

Yes, there were lots of lies and chicanery involved in the log cabin's rise to cultural monolith, but every myth contains a morsel of truth. The cabin wrought terrible destruction but also made American expansion possible. The "log cabin to White House" meme spoke of rare rags-to-riches tales, all the better to keep people in their place, but let's not forget that the people in their log-cabin place were essential to this nation. Like hardworking Americans today, these squatters/settlers, these immigrants/pioneers, woke up and went to work. They loved, they laughed; they cried and cooked. They celebrated holidays, made memories, and, most important, they looked forward to the future. And they couldn't have done it without the sturdy, adaptable log cabin, as dismal as some of those structures may have been.

IMAGE C.2 A colorful plug for everyone's favorite, Warner's Log Cabin Remedies. *(Stephen Jackson)*

The Founding Fathers formed our government, sure, but the log cabin and the settlers roosted within forged our national character. American grit came from sleeping on earthen floors, our resiliency from

IMAGES C.3–C.4 A black family in Reconstruction-era Florida and a group at the Vanderbilt's "log cabin" mansion show the structure's divergent identities. *(Photography Collection, The New York Public Library and The Adirondack Museum)*

IMAGES C.5–C.6 Poor children studying in their log cabin in the early twentieth century, and a picture of an 1872 cabin built in Fergus Falls, Minnesota. *(Library of Congress and Photography Collection, The New York Public Library)*

IMAGE C.9 Log cabin
settlers like these
Kansas pioneers had
a larger impact on our
national character
than stodgy Founding
Fathers. *(Kansas
Historical Society)*

shivering within bark-covered walls, and our tenacity from the hardship endemic to our forefathers' frontier lives. Without the log cabin, both as a structure and as a symbol, the United States might not have united. Millions of immigrants and lower class Americans have relied on the log cabin over the years. It kept them alive and thriving. The log cabin was therefore integral to this great nation's survival and ultimate rise to superpower. In this way, frantic Frederick Jackson Turner was right: The log cabin turned Europeans into Americans, and it became part of our identity in the process. "The wilderness masters the colonist," he wrote in 1893, echoing de Crèvecoeur. "It finds him a European in dress, industries, tools, modes of travel, and thought. . . . It strips off the garments of civilization and arrays him in the hunting shirt and the moccasin. It puts him in the log cabin. . . . Here is a new product that is American."[2]

Writing in 1971, archeologist Stanley South described our nation's "obsession with the log cabin as a symbol of early American pioneer life"[3] as "log cabin syndrome." Historian Harold R. Shurtleff, mean-

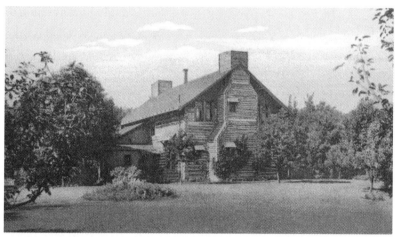

IMAGES C.7–C.8 Americans memorialize cabins in many ways. Up top, a re-creation of a pioneer village in Kentucky, and below Thomas Palmer's massive log cabin vacation home in Detroit, Michigan. *(University of Kentucky and Photography Collection, Miriam and Ira D. Wallach Division of Art, Prints, and Photographs, The New York Public Library, Astor, Lenox, and Tilden Foundations)*

while, called it "log-cabinitis" in 1939. But, like log cabin chic/lumber-sexual, these are different words for the same thing: a devotion to an idea that begs to be believed, one that lets us assume America is exceptional, that our nation is immanently, eminently better than the rest. It may be an exaggeration, but hyperbole, overstatements, and general baloney are essential to national cohesion. They provide the throughline for a national narrative.

Out there today are countless Americans engaging the log cabin, and not just in terms of clothing. The cash-strapped city of Detroit recently allocated $400,000 to restore long-dead senator Thomas Palmer's 1885 vacation cabin. Organized log cabin communities continue to thrive on both ends of the economic spectrum, high end and low: The Farm, Stephen Gaskin's 1971 commune, boasts about 200 residents; Beaver Brook in Barryville, New York, is more hipster than hippie; and pricey log cabin villages exist in Maryland, North Carolina, Wyoming, and Georgia, the latter of which is a 450-acre community put together by a company called New Creation Land Developers. Americans just love remaking the land. And, yes, there are still prefabricated cabins companies, including two named for American heroes, Honest Abe Log Homes, Inc. and Pioneer Log Systems, also Inc., without a hint of irony. And even the so-called "tiny house" movement is related to this type of log cabin retreat, in a way: It's a rejection of the western world's overconsumption, a rejection of an overly materialistic culture that feeds Marie Kondo's legion of decluttering devotees. But no tiny house, no matter how cute or free from debris, will ever match the allure of its architectonic forebear, the log cabin, the singular original.

As *Popular Science* wrote in their aforementioned 1934 DIY book, ". . . The log house is so firmly rooted in American history. It will be a long time before, in the mind of the average American, any other structure can replace it as a symbol of primitive comfort. The person who conceives the idea of building a summer or vacation home invari-

IMAGES C.10–C.11 These two images, both from the 1930s, speak to the log cabin's cross-cultural presence. *(Library of Congress and Wisconsin Historical Society, WHi-55685)*

ably thinks first of a log cabin."[4] No matter how rich or poor, left or right an American may be, chances are they have a fond memory of or feeling for the log cabin. In this light, our apparent cultural divides may not be that deep; we all have at least one thing in common: a love for hardwood. Out of many cabin loves, one country. *E Pluribus Unum* and all that jazz.

Today, as we debate the future of the nation, how we want to handle domestic affairs like immigration and how we present ourselves to the rest of the world, let's remember the good and the bad of the log cabin, log house, and even log-shaped oil rigs. Let's remember the freedom the structure can represent, but also the bondage, too. Let's remember the cabin as eco-warrior and eco-destroyer. Let's remember how the log cabin brought people together in 1840, and how it divided them by class before and after. In other words, let's remember that the

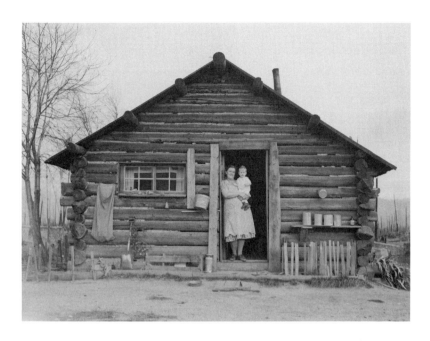

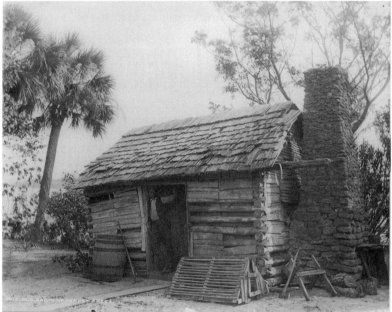

IMAGES C.13–C.14 But despite all the log cabin myths, let's not forget it was integral to the survival of disparate Americans. *(Library of Congress)*

United States, as exceptional as we like to think they are, aren't perfect. But that doesn't mean they can't be made into a more perfect union, one that rights our wrongs and charts a more egalitarian course into tomorrow.

With seventy percent of Americans saying the nation is losing its identity[5] and wondering what defines us, let's define ourselves by recommitting to the values on which our country was founded, values seen in the log cabin—accessibility, equality, and opportunity—while fighting the legacies of injustice seen therein, too. By recognizing classism's long history here, perhaps we can erase one of the uglier aspects of America, eradicating terms like "trailer trash" from our vocabulary. By remembering the millions and millions of immigrants who hunkered down in log cabins, perhaps we can approach today's immigration debate with empathy, acknowledging how—and why— our nation and its rhetoric still shine like beacons. By highlighting the nation's darker bits, the maltreatment of minorities and ecological waste that are a national shame and dreadfully age-old tradition, let's fight to right those wrongs, creating an America more aligned with its democratic myths than its divided, fractious reality.

Remembering the cabin as democratic incubator can enliven our national pride, while seeing its negatives can spur us to action. Seeing this overlooked structure for what it is—a complex blueprint of the American experience—perhaps we can turn the log cabin into a big tent again, like in 1840, using it as a universal symbol of solidarity. I know it may sound silly, but consider this: Out there today there are hundreds of historic log cabins, survivors from when log cabins were discarded. They're defying the odds—kind of like America. One cabin in particular stands out: the Mary Locher cabin in Maryland. Also referred to as the Alfred Poffenberger cabin, after the tenant who rented it from Mrs. Locher, pieces of the cabin date back to 1780, with additions added over the next few decades. The fact that it's still intact is impressive enough, but consider this: The Locher/Poffen-

berger cabin survived the Battle of Antietam, the most ferocious, bloodiest battle of the Civil War that ended with nearly 21,000 dead or wounded. When the dust settled and the dead were buried—many right there on the battlefield—the cabin remained. And so too did America, emerging from the war scathed, yes, but stronger for its wounds, looking forward to what Lincoln earlier described as a "new birth of freedom."[6]

The nation didn't always get it right—see: Jim Crow laws—nor do we have it all together today—see: echoing economic and racial inequality—but all-in-all the USA was moving in the right direction, together. And like that battle-scarred cabin, the nation has stood the test of time. Even in the face of adversity and aspersions, tragedy and triumph and Trumps, the nation has persevered. But, unlike that cabin, we can change. We can improve upon ourselves. No matter how fearsome, foreboding, or divisive the present or future may seem, we can and will overcome inequality and injustice. And, yes, I know this is a little schmaltzy, but this is the end, our goodbye. I wanted to leave on a high note, not on some bummer. So, finally, just remember this: What was once one man's trash has become a national treasure. Don't take anything for granted, because you never know what lies around the next turn of history. But whatever it is, the log cabin is sure to be there, waiting to embrace its biggest fans: Americans.

ACKNOWLEDGMENTS

Log cabins can stand alone, but authors can't, and this one would like to offer much gratitude to my editor Dan Crissman, as well as Michael Tizzano, Noa Wheeler, and the production team at The Countryman Press. A big thank you to my agent, the great Jessica Papin, for taking a chance on an unknown kid! Much love to Kerry Wagner, Marco Salcedo, Susan Squire, Kris Dahl, Stephanie Frerich, Jeffries Blackerby, David Hirshey, and Richard Zacks for all your advice and encouragement. Julian Fleisher, thank you for being my photographer *and* driver during our road trip to the nation's oldest cabins. To Maya Willner and Uri Romano, Joie and David Jacoby, Mimi Jung, and Justin Conner, thank you for your friendship and support over these *many* years! To Annie and Adam Shulman, I would be in a ditch if it weren't for you two; I have endless adoration and admiration for you two. To my boyfriend, Michael Lepore, I couldn't have done this without you. You're the best and I love you. Thank you for your patience. I also have to give a shoutout to my late mother, Marsha, wherever she may be. I miss that lady like mad. Thank you to the many archivists and librarians who helped me track down sources over these past three years. And, finally, last but definitely not least, to the reader: Thank you for trekking through the centuries with me. This was a labor of love and I'm extremely grateful for your time. Now, go make me proud at trivia night!

NOTES

INTRODUCTION

1 "Letter from From Benjamin Franklin to Benjamin Franklin Bache," 25 September, 1780.

2 Dr. Daniel Drake, Discourse on the History, Character, and Prospects of the West (Cincinnati: Truman and Smith, 1834), 5.

CHAPTER 1: HARD TRUTHS

1 "Log Cabin a Shrine. Glory Given Lincoln," *Oshkosh Daily Northwestern*, February 12, 1909.

2 "The Lincoln Farm Celebration," *The Columbian*, February 11, 1909.

3 Barry Schwartz, *Abraham Lincoln and the Forge of National Memory*, (Chicago: Chicago University Press, 2003), 279.

4 Ibid.

5 "Lincoln Memorial Ceremony," *The Cincinnati Enquirer*, February 7, 1909.

6 "Is the Lincoln Birthplace Cabin Authentic?" *The Abraham Lincoln Quarterly*, Vol. 5, No. 3 (September 1948), 153.

7 Gloria Peterson, *An Administrative History of Abraham Lincoln Birthplace National Historic Site, Hodgenville, Kentucky*, September 20, 1968, (Washington DC: National Park Service, Division of History). (https://www.nps.gov/parkhistory/online_books/abli/adhi/adhi3.htm) [Chap, II].

8 Quoted in Louis Warren, *The Traditional Birthplace Cabin*, unpublished manuscript, 1948, Files, Division of History, via Peterson, *Administrative History*, Chap. II.

9 Roy Hays, "Is the Lincoln Birthplace Cabin Authentic?" The Abraham Lincoln Quarterly, Vol. 5, No. 3 (September 1948).

10 Richard West Sellars, "Lincoln's Logs," *The New York Times*, February 12, 2013.

11 Peterson, *Administrative History*.

12 "Affidavit of John C. Creal, May 28, 1906," in Hays, "Lincoln Birthplace," 159.

13 " Submission of Evidence, Williams and Handley, Attorneys for the Lincoln Farm Association," quoted in Peterson, "Administrative History," Chap III.

14 Hays, "Authentic?" 162.

15 "Letter from Robert Todd Lincoln to Otto Wiecker," August, 25, 1919, Lincoln Financial Foundation Collection, Allen County Public Library, Fort Wayne, Indiana. [http://contentdm.acpl.lib.in.us/cdm/compoundobject/collection/p16089 coll38/id/4713/rec/1].

16 Hunter S. Thompson, "Those Daring Young Men in their Flying Machines . . . Ain't What they Used to Be!" *Pageant*, September, 1969.

17 "Nation's Head Attends Lincoln Farm Exercises," *The Courier-Journal* (Louisville, Kentucky) November 10, 1911.

18 Thayer's two Lincoln tomes were entitled *The Pioneer Boy, and How He Became President* and *From Pioneer Home to the White House*, published in 1867 and 1882, respectively. It wasn't until later that the gravity of Lincoln's legacy drew the aspirational locution into its orbit.

19 John G. Palfrey, *History of New England*, (Boston: Little Brown and Company, 1865), 62.

20 Douglas W. MacCleery, "American Forests: A History of Resiliency and Recovery" (Durham, North Carolina: The Forest History Society, 2011), 1.

21 Charles F. Carroll, "Forest Society of New England," in *America's Wooden Age: Aspects of its Early Technology*, ed. Brooke Hindle (Tarrytown: Sleepy Hollow Press, 1985), 20–21.

22 Carroll, "Forest Society," 17.

23 You're going to see a lot of crazy colonial spelling, so let's just put in a preemptive [sic], shall we?

24 Sir Thomas Dale, in *Journals of the House of Burgesses of Virginia, 1619–1658/59*, ed. H. R. McIlwaine (Richmond, VA: Virginia State Library, 1915) 30.

25 *A Breife Declaration of the Plantation of Virginia duringe the first Twelve Yeares*, (London: The Virginia Company, 1623), in *Journals of the House of Burgesses*, 28.

26 Edward Johnson, in *Johnson's Wonder-working providence, 1628–1651* ed. J. Franklin Jameson Ph.D (New York: Charles Scribner's Sons, 1910), 113.

27 John F. Watson, *Annals of Philadelphia, and Pennsylvania*, (Philadelphia: E.L. Carey & A. Hart, 1830), 159.

28 Fiske Kimball, *Domestic Architecture of the American Colonies and of the Early Republic* (New York: Charles Scribner's Son, 1922), 4.

29 Carroll, "Forest Society," 20.

30 Fred Kniffen and Henry Glassie, "Building in Wood in the Eastern United States: A Time-Place Perspective," in *Geographical Review*, Vol. 56, No. 1 (Jan., 1966), 58.

31 "Letter of Thomas Paschall, 1683," in *Narratives of Early Pennsylvania, West New Jersey and Delaware 1630–1707*, Vol. 13, ed. Albert Cook Myers, (New York: Barnes and Noble, 1940), 250.

32 C. A. Weslager, *The Log Cabin in America: From Pioneer Days to the Present* (New Brunswick, New Jersey: Rutgers University Press, 1969), 165.

33 Jasper Danckaerts, *Journal of Jasper Danckaerts*, eds. Bartlett Burleigh James B.D, Ph.D and J. Franklin Jameson, Ph.D, LL.D (New York: Charles Scrbiner's Sons, 1913), 98.

34 Harold R. Shurtleff, *The Log Cabin Myth: A Study of the Early Dwellings of the English Colonists in North America*, (Cambridge, Massachusetts: Harvard University Press, 1938), 166.

35 Danckaerts, *Journal*, 96.

36 Pehr Kalm, *Travels Into North America Vol. II*, Trans. John Reinhold Forster (London: Eyres, 1770), 69.

37 Pehr Kalm, *Travels Into North America Vol. I*, Trans. John Reinhold Forster (London: Eyres, 1770), 227.

38 Kalm, *Travels, Vol. II*, 45.

39 To other scholars, don't be fooled but Shurtleff's claim that Kalm referenced Englishmen living in "wretched" "vertical" planked homes; those were in fact French soldiers.

40 Shurtleff, *Log Cabin Myth*, 161–162.

41 *New Hampshire Provincial Papers, III* (1692-1722), 88, in Shurtleff, 82.

42 Hugh Morrison, *Early American Architecture: From the First Colonial Settlements to the National Period*, (New York: Dover Publications, Inc. 1987) 13.

43 Weslager, *Log Cabin*, 125.

44 Carroll, "Forest Society," 18.

45 There is evidence of English people living in log structures in Cape Porpoise, Maine, around 1662, and at least one in Springfield, Massachusetts, in 1678, though these were considered defensive necessities, rather than an acceptable domestic alternative. (Shurtleff, 80–81)

46 William Byrd, *Histories of the dividing line betwixt Virginia and North Carolina*, (Raleigh: The North Carolina Historical Commission, 1929) 94, n27.

CHAPTER 2: IMMIGRATION NATION:
THE LOG CABIN AS FREEDOM

1 Weslager, *Log Cabin*, 213.

2 Shurtleff, *Log Cabin Myth*, 175.

3 Fun fact: Though Dulany popularized the phrase "no taxation without repre-sentation," he supported the British during the war and was stripped of most of his earthly possessions as punishment.

4 Daniel Dulany, quoted in Richard Henry Spencer, "Hon. Daniel Dulany, 1685–1753, *Maryland Historical Magazine*, Vol. XIII (Baltimore: Maryland Historical Society, 1918), 24.

5 Governor Eden to Lord Dartmouth, Annapolis, 29 January 1773, in *Collections of the Massachusetts Historical Society*, Vol. X, (Boston: Massachusetts Historical Society, 1871), 694.

6 Nancy Isenberg, *White Trash: The 400-Year Old History of Class in America* (New York: Viking, 2016), 95.

7 James Logan, in Charles A. Hanna, *The Scotch-Irish: or, The Scot in North Britain, North Ireland, and North America, Vol. II*, (New York and London: G.P. Putnam's Son, 1902), 63.

8 John Winthrop, "A Model of Christian Charity," 1630.

9 Robert Parke, "Letter to Mary and Thomas Valentine, October, 10 1725," in Hanna, *The Scotch-Irish . . . Vol. II*, 65.

10 Robert Witherspoon, "Witherspoon Geneology", in Hanna, *The Scotch-Irish*, 26.

11 Weslager, *Log Cabin*, 233.

12 F. A. Michaux, Travels to the West of the Alleghany mountains, (London: D.N. Shury, 1805) 137.

13 Morrison, *Early American* Architecture, 13.

14 Shurtleff, *Log Cabin Myth*, 33–34.

15 John Bartram, *Observations on the inhabitants, climate, soil, rivers, productions, animals, and other matters worthy of notice made by Mr. John Bartram, in his travels from Pensilvania [sic] to Onondago, Oswego and the Lake Ontario, in Canada [microform] : to which is annex'd a curious account of the cataracts at Niagara by Mr. Peter Kalm, a Swedish gentleman who travelled there* (London: J. Whiston & B. White, 1751), 35.

16 Joshua Hempstead, Diary of Joshua Hempstead of New London, Connecticut, covering a period of forty-seven years, from September 1711, to November, 1758 (New London, CT: The New London County Historical Society, 1901), 524.

17 Shurtleff, *Log Cabin Myth*, 25.

18 With the exception of the Yorkshire-born "Hiddleston," these men all have typical Scots-Irish surnames.

19 Richard Peters, "The Report of Richard Peters, July 2, 1750,"in Minutes of the Provincial Council of Pennsylvania, (Harrisburg: Theo Fenn & Co, 1851), 442.

20 Peters, "Report," 449.

21 Weslager, *Log Cabin*,54.

22 Danckaerts, *Journal*, 98.

23 Weslager, *Log Cabin*, 248.

24 Weslager, *Log Cabin*, 238.

25 J. Hector St. John de Crèvecoeur , *Letters from an American Farmer* (New York: Fox, Duffield & Company, 1904), 114–115.

26 John Bradbury, *Travels in the interior of America, in the years 1809, 1810, and 1811* (London: Sherwood, Neely, and Jones, 1817) 293.

27 Weslager, *Log Cabin*, 239.

27 Diary of David McClure, Doctor of Divinity 1748–1820, (New York: The Knickerbocker Press, 1899), 14.

28 Joseph Doddridge, *Notes on the Settlement and Indian wars, of the Western Parts of Virginia & Pennsylvania* (Wellsburgh,VA: The Gazette, 1824), 111.

29 de Crèvecoeur, *Letters*, *49–50*.

30 While the Scots-Irish were *technically* colonists, on account of being English subjects, few felt personally invested in the colonial mechanics or the Kingdom.

31 James A. Henretta, Eric Hinderaker, Rebecca Edwards, Robert O. Self, *America: A Concise History* (Boston and New York: Bedford/St. Martins, 2012), 96.

32 Henretta, Hinderaker, Edwards, Self, *America*, 106.

33 Philip Fithian Journal, in John Franklin Meginness, *Otzinachson: A History of the West Branch Valley of the Susquehanna*, *Vol. I* (Williamsport, PA: Gazette and Bulletin Printing House, 1889), 441.

34 Timothy Dwight, *Travels in New-England and New-York: in four volumes*, *Vol. IV* (New Haven: Timothy Dwight, 1822), 84.

35 William Faux, *Memorable Days in America* (London: W. Simpkin and R. Marshall, 1823), 274.

36 Ibid.

37 John Mason Peck, *A new guide for emigrants to the West, 2d Edition* (Boston: Gould, Kendall & Lincoln, 1837), 99.

38 Basil Hall, *Travels in North America in the years 1827 and 1828, Vol. I* (Philadelphia: Carey, Lea & Carey, 1829), 69.

39 Isenberg, *White Trash*, 76.

40 Michael Williams, *Americans and Their Forests: A Historical Geography* (Cambridge: Cambridge University Press, 1992), 58.

41 Orsamus Turner, *Pioneer History of the Holland Purchase of Western New York*, (Buffalo: Jewett Thomas & Co., 1849), 322.

43 Resolutions of the General Assembly of Indiana, in relation to the bill "to establish a permanent prospective pre-emption system in favor of settlers on the public lands who shall inhabit and cultivate the same, and raise a log-cabin thereon," February 5, 1841.

CHAPTER 3: FOUNDING FATHERS THROWING SHADE

1 Alexander Hamilton, *The Federalist Papers: No. 35, 1788*. http://avalon.law.yale.edu/18th_century/fed35.asp.

2 Alexander Hamilton, "The Constitutional Convention of 1787," in *The Works of Alexander Hamilton*, Vol. 1, ed. Henry Cabot Lodge (New York and London: G.P. Putnam's Sons /The Knickerbocker Press, 1904), 401.

3 Gottfried Achenwall, *Some Observations on North America from Oral Information by Dr. Franklin*, 1766, The Franklin Papers, 346 (The American Philosophical Society and Yale University) at http://franklinpapers.org/franklin/framedVolumes.jsp?vol=13&page=346a.

4 Franklin, Benjamin, "Letter to Grandson, Benjamin 'Passy' Franklin Bache," September 25, 1780, reprinted in *The Compleated Autobiography of Benjamin Franklin, Volume 2: 1757–1790*, ed. Mark Skousen (Washington DC: Regnery Publishing, Inc, 2007), 218.

5 Dr. Benjamin Rush, "An Account of the Progress of Population, Agriculture, Manners, and Government in Pennsylvania," in *The Edinburgh magazine, or Literary miscellany*, Vol. 6, July 1787, 99.

6 Ibid, 99–100.

7 The good doctor clearly forgot that Continental Army soldiers hunkered down in log cabins at Valley Forge, and that his fellow wartime doctors used log cabins as war front hospitals: New Jersey doctor James Tilton turned log cabins into wards in Moorestown, NJ, in 1778.

8 Ibid, 100.

9 Reverend Charles Woodmason, in *The Carolina Backcountry on the Eve of the Revolution: The Journal and Other Writings of Charles Woodmason, Anglican Itinerant*, ed. Richard J. Hooker (Chapel Hill: The University of North Carolina Press, 1953), 6.

10 Dwight, *Travels, Vol. IV*, 84.

11 Ibid.

12 Thomas Jefferson, "Letter to Peter Carr, August 10, 1787," https://www.loc.gov/resource/mtj1.007_0959_0965/.

13 Thomas Jefferson, *Notes on the State of Virginia: with an appendix* (Boston: H. Sprague, 1802), 210.

14 Though Jefferson pushed an agrarian policy, his architectural habits tended toward the classical, as seen in his stately manor, Monticello. You'll notice that this happens a lot: "populist" public servants serving themselves first.

15 Thomas Jefferson, *Notes on the State of Virginia* (Richmond, Virginia: JW Randolph, 1853), 157.

16 Franklin's usage of "cabin" here confirms the solidification of "log cabin" somewhere between 1750 and 1770.

17 Achenwall, *Some Observations*, 346.

18 Ibid.

19 Dr. Benjamin Rush, "An Account of the Progress of Population, Agriculture, Manners, and Government in Pennsylvania," in *The Edinburgh magazine, or Literary miscellany*, Vol. 6, July 1787, 100.

20 Ibid.

21 Dwight, *Travels*, *Vol. II*, 459.

22 John Filson, *The discovery, settlement, and present state of Kentucke*, (Wilmington, DE: James Adams, 1784), 29.

23 Richard Bushman, *The Refinement of America* (New York: Vintage Books, 1993), 427.

24 Thaddeus Mason Harris, *The journal of a tour into the territory northwest of the Alleghany Mountain*, (Boston: Manning and Loring, 1805), 58.

25 Alexander Wilson, *The poetical works of Alexander Wilson: also his miscellaneous prose* (Belfast: John Henderson, 1844), 445.

26 Thanks, Psych 101!

27 Seymour Martin Lipset, *The First New Nation: The United States in Historical and Comparative Perspective* (New York: Anchor Books, 1967), 103.

28 Ibid.

29 Dr. Benjamin Rush, *An Account of the Manners of the German Inhabitants of Pennsylvania* (Lancaster: Pennsylvania-German Society, 1910), 56.

30 Dwight, *Travels*, *Vol. IV*, 84.

31 Israel Acrelius, *A history of New Sweden: or, The settlements on the River Delaware*, with introduction by William M. Reynolds, (Philadelphia: The Historical Society of Pennsylvania, 1874), 310.

32 Kalm, *Travels*, *Vol. II*, 70.

33 Dwight, *Travels*, *Vol. IV*, 73.

34 Bushman, *Refinement*, 425.

HARD NOTCH: THE LOG CABIN AS COLONIZATION

1 Scott Malcomson, *One Drop of Blood: The American Misadventure of Race*, (New York: Farrar, Straus and Giroux, 2000), 53.

2 John Barnwell, "Journal of John Barnwell," in *The Virginia Magazine of History and Biography*, Vol. 5 (Ludwell: Virginia Historical Society, 1898), 395.

3 Weslager, *Log Cabin*, 61.

4 Conrad Weiser, "Letter from Johann Conrad Weiser to Gov. Hamilton, 1754," in *The Life of (John) Conrad Weiser, the German Pioneer, Patriot, and Patron of Two Races*, ed C.Z. Weiser, (Reading, PA: Daniel Miller, 1876), 181.

5 David Jones, *A Journal of Two Visits Made to Some Nations of Indians on the West Side of the Ohio River, in the Years 1772 and 1773.* (Burlington, New Jersey: Isaac Collins, 1774), 69.

6 George Washington, "Seventh Address to Congress," December 8, 1795.

7 George Washington, "Third Annual Address to Congress," October 25, 1791.

8 This was hardly the end, as more removals followed the Second and Third Seminole Wars in Florida, the final conflict of which ended in 1858.

9 John G. Burnett, "Birthday Story of Private John G. Burnett, Captain Abraham McClellan's Company, 2nd Regiment, 2nd Brigade, Mounted Infantry, Cherokee Indian Removal, 1838–39," Floyd Glenn Lounsbury papers, American Philosophical Society.

10 In Gary E. Moulton, ed, *The Papers of Chief John Ross*, Vol. 1 (Norman: University of Oklahoma Press, 1985), 459–460.

CHAPTER 4: THE CABIN AS MUSE

1 Thomas Cole, diary entry, July 17, 1841, in Louis Legrand Noble, *The Course of Empire, Voyage of Life, and Other Pictures*, (New York: Cornish, Lamport & Co., 1853), 294–295.

2 To that point: There were only about five historical societies in 1800, and by 1860 there were over one hundred. [James D. Wallace, *Cooper and His Audience*, (New York: Columbia University Press, 1986), 176.]

3 Ironically, the textile industry that blossomed around around 1793, one of our nation's greatest economic successes, owes its start to Brit Samuel Slater, who memorized tightly guarded British production methods before illegally emigrating to the States in 1789.

4 Rodney P. Carlisle, *Handbook to Life in America, Volume I*, (New York: Infobase Publishing, 2009), 196.

5 1790 United States Census

6 1800 United States Census

7 J.F.D. Smyth, A Tour of the United States of America (London: 1784), 327.

8 "Thomas Dillon to James McHenry, May 22, 1796," in The Virginia Magazine of History and Biography, Vol. XII, No. 1 (Richmond, Virginia: Virginia Historical Society, 1904), 260.

9 Wayne Franklin, *James Fenimore Cooper: The Early Years*, (New Haven and London: Yale University Press, 2007), 336.

10 Jack Larkin, *The Reshaping of Everyday Life, 1790–1840* (New York: Perennial Library/Harper & Row, 1989), 205.

11 Alexis de Tocqueville, "Two Weeks in the Wilderness," in *Democray in America and Two Essays*, Trans Gerald E. Bevan, (New York: Penguin Books, 2003), 875.

12 Alexis de Tocqueville, "Democracy in America," in *Democray in America and Two Essays*, Trans Gerald E. Bevan, (New York: Penguin Books, 2003), 354.

13 Ibid.

14 Alexis de Tocqueville, "Excursion to Lake Oneida," in *Democray in America and Two Essays*, Trans Gerald E. Bevan, New York: Penguin Books, 2003), 930.

15 *The Life of Albert Gallatin*, Henry Adams, ed (Philadelphia: JP Lippincott & Co, 1879), 560.

16 George Troup, House of Representatives, February 15, 1815, in *Abridgment of the Debates of Congress, from 1789 to 1856, Volume V, May 24, 1813–March 3, 1817* (New York: D. Appleton & Company, 1857), 426.

17 Washington Irving, *A History of New-York* (Glasgow: John Wylie & Co, 1821), 109–110.

18 James Kirke Paulding, *The Backwoodsman: A Poem* (Philadelphia: M. Thomas, 1818), 69.

19 James Fenimore Cooper, *The Pioneers*, (New York: Viking Penguin, 1988), 208.

20 Unsigned review of *The Pioneers, Port Folio, Vol. 15* (Philadelphia: Harrison Hall, 1823), 230.

21 Franklin, *James Fenimore Cooper*, 338.

22 de Crèvecoeur, *Letters*, 60.

23 Dwight, *Travels, Vol. II*, 439.

24 Henry Clay, US Senate, June 20, 1832, in *Register of Debates in Congress*, Vol. 8 (Washington: Gales & Seaton, 1832); 86, column 1102.

25 Zachariah Allen, *The Practical Tourist, Vol. 1* (Providence: A.S. Beckwith, 1832), n.264.

26 Dwight, *Travels, Vol. II*, 459.

27 Charles Fenno Hoffman, *A Winter in the Far West*, (London: R. Bentley, 1835), 263.

28 Alexis de Tocqueville, *Democracy in America and Two Essays*, Trans. Gerald Bevan, (New York: Penguin Books, 2003), 544.

29 de Tocqueville, "Two Weeks," 881.

30 William Foster Otis, An Oration Delivered Before The 'Young Men of Boston' on the Fouth of July, 1831 (Boston: Carter, Hendee and Babcock, 1831), 33.

31 Dr. Daniel Drake, *Discourse on the History, Character, and Prospects of the West* (Cincinnati: Truman and Smith, 1834), 10.

32 Drake, *Discourse*, 8.

33 Dr. Daniel Drake, *Discourse*, 10.

34 Turner, *Pioneer History*, 563.

35 Doddridge, *Notes*, 110.

36 Drake, *Discourse*, 9–10.

37 Cole, On American Scenery," in *American Monthly Magazine*, Vol. 1, Issue 1 January, 1836 (Boston, E. Broaders and New York, George Dearborn), 3.

38 Ralph Waldo Emerson, *Nature*, (Boston: James Munroe and Co., 1836), 14.

39 Horace Greeley, *The autobiography of Horace Greeley: or, Recollections of a busy life* (New York: E.B. Treat, 1872), 60.

40 Williams, *Forests*, 12.

41 Ibid.

42 de Crèvecoeur, *Letters*, 60–61.

43 Henry Tudor, *Narrative of North America* (London: J. Duncan, 1834), 217.

44 Allen, *Practical Tourist*, 264.

45 James Fenimore Cooper, *Wyandotté, Or, The Hutted Knoll: A Tale*, (New York: Stringer and Townsend, 1856), 37.

46 Dr. Benjamin Rush, *Manners*, 57.

47 Benjamin Franklin, "Political Economy," in *The Life and Writings of Benjamin Franklin, Volume 2* (Philadelphia: McCarty & Davis, 1834), 429.

48 Benjamin Franklin, "Observations Concerning the Increase of Mankind, Peopling of Countries, etc, 1751;" https://founders.archives.gov/documents/Franklin/01-04-02-0080.

49 Williams, *Forests*, 13.

50 Alexis de Tocqueville, "Two Weeks in the Wilderness," in *Democracy in America and Two Essays on America*, Gerald Bevan, trans. (London: Penguin Books), 879.

51 John Muir, "The American Forests," in *The Atlantic Monthly*, Vol. 80, No. 478, 157.

52 Thomas Cole Diary, July 8, 1837, transcribed by The Adirondack Museum.

53 James Fenimore Cooper, *Satanstoe; or, The Littlepage Manuscript, Volume 1* (New York, Stringer and Townsend, 1852), 167.

54 Cooper, *The Pioneers*, 39–40.

55 "Agricultural Excursion in the Genesee Valley," in The New Genesee Farmer and Gardener's Journal, Vol. 2 (Rochester, N.Y., Bateham & Crosman 1841), 148.

56 Sen. Silas Wright, US Senate, June 9, 1841, in *Niles' National Register*, Vol. 10, No. 17, June 26, 1841, 264.

57 Kalm, *Travels Vol. I*, 60–61.

58 Peck, *New Guide*, 124.

59 de Tocqueville, "Two Weeks in the Wilderness," 881.

CHAPTER 5: THE LOG CABIN, POPULIST ICON

1 William Garrott Brown, *Andrew Jackson*, (New York: Houghton, Mifflin and Company, 1900), 121.

2 John Eaton, *The life of Andrew Jackson* (Philadelphia: M. Carey and Son, 1817), 10.

3 Ibid.

4 Eaton, *Andrew Jackson*, 1817 edition, vii.

5 Jill Lepore, "Man of the People," in *The Story of America: Essays on Origins* (Princeton and Oxford: Princeton University Press, 2012), 149–150.

6 John Henry Eaton, *The life of Andrew Jackson*, (Philadelphia: S. F. Bradford, 1824), 432.

7 Eaton, *Andrew Jackson*, 1824 edition, 19.

8 "Wyoming," *The letters of Wyoming, to the people of the United States, on the presidential election* (Philadelphia, S. Simpson & J. Conrad, 1824), 46.

9 "Wyoming," *Letters*, 48.

10 "An Association of Individuals," Truth's advocate and monthly anti-Jackson expositor (Cincinnati: Lodge, L'Hommedieu, and Hammond, 1828), 400.

11 Thomas Jefferson to Daniel Webster, in, "Old Hickory," *Harper's New Monthly Magazine*, July 1884, 279.

12 Isenberg, *White Trash*, 127.

13 "Last Hurrah," in William Safire, *Safire's Political Dictionary* (New York: Oxford University Press, 2008), 380.

14 Isaac Hill, " An address delivered before the Republicans of Portsmouth and vicinity, July 4, 1828," (Concord: Horatio Hill and Co, 1828), 8.

15 Ibid.

16 "Wyoming," 47.

17 Robert Walsh, "Biographical Sketch of Andrew Jackson," in *The American Monthly Magazine*, Vol. 1 (February 1824), 131.

18 *The Illinois Gazette*, January 15, 1825, via Ward, 51.

19 "Address of the Herkimer Convention," Jacksonian Republican, October 4, 1828, via Ward, 52.

20 Jacksonians of New York, "Address of the Republican General Committee

of Young Men of the City and County of New-York, Friendly to the Election of Gen. Andrew Jackson to the Presidency" (New York: Alexander Ming Jr, 1828), 38.

21 Margaret Bayard Smith, *The First Forty years of Washington Society, Portrayed by the Family Letters of Mrs. Samuel Harrison Smith*, ed. Gaillard Hunt (New York: Charles Scribner's Sons, 1906), 295.

22 George D. Prentice, *Biography of Henry Clay*, (New York: John Jay Phelps, 1831), 122.

23 David Crockett, *The life of Martin Van Buren, heir-apparent to the "government," and the appointed successor of General Andrew Jackson* (Philadelphia: R. Wright, 1835), 26–27.

24 Willie Mangum, December 24, 1832, US Senate, Register Debates in Congress, Vol. 9, Column 22 (Washington: Gale and Seaton, 1838), 22.

25 Robert G. Gunderson, *The Log-cabin Campaign*," (Westport, CT: Greenwood Press, 1957), 11.

26 Charles T. Congdon, *Reminiscences of a Journalist* (Boston: J.R. Osgood and Company, 1880), 60.

27 William Henry Harrison, speech at Ft. Meigs, Perrysburg, Ohio June 11, 1840, in Robert V. Friedenberg, *Notable Speeches in Contemporary President Campaigns*, (Westport, CT: Praeger, 2002), 22.

28 Biddle quoted in James A. Green, *William Henry Harrison: His Life* (Richmond, VA: Garrett and Massie, 1941), 294–295.

29 William H. Seward, *Autobiography of William H. Seward, from 1801 to 1834 : with a memoir of his life, and selections from his letters from 1831 to 1846* (New York: D. Appleton and Co., 1877), 448.

30 John de Ziska, *The Baltimore Republican*, December 11, 1839.

31 John Bach McMaster, 576. *A History of the People of the United States: From the Revolution to the Civil War, Vol. 5* (New York: D. Appleton & Co., 1883), 576.

32 *Baltimore Chronicle*, quoted in *The Pittsburgh Gazette*, December 16, 1839, 1.

33 Ibid.

34 *Delaware State Journal*, via Bushman, *Refinement*, 427.

35 *New York Daily Whig*, quoted in *Washington National Intelligencer*, January 14, 1840.

36 *Chronicle*, reprinted in *The Pittsburgh Gazette*, December 17, 1839, pg 2.

37 Richard Smith Elliott, *Notes Taken in Sixty Years*, (St. Louis, MO: R.P. Studley & Co., 1883), 121.

38 Michael Schudson, *Discovering the News: A Social History of American Newspapers*, (New York: Basic Books, 1978), 22–23.

39 Kenneth R. Stevens, *William Henry Harrison: A Bibliography* (Westport, CT and London: Greenwood Press, 1998), 60–74.

40 Ibid.

41 Horace Greeley, in Robert C. Williams, *Horace Greeley: Champion of American Freedom* (New York: New York University Press, 2006), 49.

42 Greeley in Williams, 53.

43 2004's *Future Soundtrack for America.*

44 "A Veteran of 1840," in *Weekly Graphic*, July 27, 1888.

45 Lecky Harper in Anthony Banning Norton's *The Great Revolution of 1840*, (Mount Vernon and Dallas: A.B. Norton & Co, 1888), 374.

46 Eds., *Washington Whig and Republican Gazette*, July 29, 1840.

47 Norton, *Great Revolution*, 52.

48 Norton, *Great Revolution*, 52.

49 Norton, *Great Revolution*, 49.

50 John Bach McMaster, *A History of the People of the United States: From the Revolution to the Civil War* (New York: D. Appleton & Co., 1883), 564.

51 Norton, *Great Revolution*, 124.

52 "E G Booz Old Cabin Whiskey 1863–1870," *Historical American Glass*, http://historical-american-glass.com/american-whiskey-bottles.html.

53 McMaster, *History*, 575.

54 Weslager, *Log Cabin*, 270.

55 General William Henry Harrison in Columbus, Ohio, June 5, 1840, via *The New-Yorker*, June 20, 1840, 220.

56 Alexander Duncan, "Speech of Mr. Duncan of Ohio on the General Appropriation Bill for 1840," delivered in the House of Representatives, April 10, 1840, (Washington: The Globe, 1840), 9.

57 "Log Cabins," in *Extra Globe*, September 9, 1840.

58 "Federal-Abolition-Whig trap," New Orleans, 1840, from the Library of Congress.

59 Letter dated March 7, 1840, reprinted in *Burlington Weekly Free Press*, April 10, 1840.

60 "Anna Tuthill Symmes Harrison," by Nancy Beck Young, in, Gould, Lewis L., ed. *American First Ladies: Their Lives and Legacies* (New York: Taylor & Francis, 2001), 59.

61 Eds, *Washington Whig and Republican Gazette*, July 29, 1840.

62 Thomas Allen, "Notes on the State of the Rural Arts in the Valley of Mississippi," in *The Horticulturalist*, September, 1846, 110–113, (111).

63 Orsamus Turner, *Pioneer History*, 465.

64 Lewis F. Allen, *Rural architecture. Being a complete description of farm houses, cottages, and out buildings*, (New York: A.O. Moore, 1852), XII.

65 William Dean Howells, *Lives and Speeches of Abraham Lincoln and Hannibal Hamlin* (Columbus, Ohio: Follett, Foster & Co, 1860), 21.

66 Howells, 23.

67 J.Q. Howard, *The life of Abraham Lincoln : with extracts from his speeches* (Cincinnati: Anderson, Gates and Wright, 1860), 6.

68 *New York Daily Tribune*, May 21, 1860, in Thomas A. Horrocks, *Lincoln's Campaign Biographies*, (Carbondale: Southern Illinois University Press, 2014), 29.

69 Ibid, 32.

70 "Republican Poetry," in *The Daily Milwaukee News*, July 3, 1860.

71 Henretta, Hinderaker, Edwards, Self, *American*, 230.

72 Howard Fineman, "And Now, 'Log Cabin Chic,'" *Newsweek*, November 30, 1987, 27.

73 Bill Clinton, "Remarks at the Democratic National Convention, September 5, 2012," Charlotte, North Carolina, from CBS News. http://www.cbsnews.com /news/transcript-bill-clintons-remarks-at-the-dnc/.

CHAPTER 6: AN AMERICAN MYTH, VOL. 1

1 Fun Fact: This property was once owned by President Harrison, who inherited it and then sold it. Tyler bought the farm after that, but before he inherited the White House from Harrison.

2 "Celebration at Jamestown," *The Daily Dispatch*, May 15, 1857, 1.

3 Tyler's presidential legacy included the annexation of Texas and the Preemption Act of 1841, a homesteading law that gave ownership to settlers who "improved land," most often by clearing space for a log cabin.

4 Though in vogue for years, this impulse wouldn't have a term until 1845, when journalist John O'Sullivan coined the phrase.

5 Lyon G. Tyler, *Letters and Times of the Tylers, Vol. 1* (Richmond, Virginia: Whittett & Shepperson, 1884), 2.

6 Gov. Henry A. Wise, "Celebration at Jamestown," in *Southern Literary Messenger*, Vol. 24, No. 6 ed. JR. Thompson (Richmond, VA: MacFarlane, Fergusson, & Co, January–June 1857), 462.

7 The Swedes and Finns, America's first log cabin constructors, as well as the Germans and Scots-Irish who came after them, must have been spinning in their graves at all this English-worshipping spin. Even after the War of 1812 reset our American identities, historians were still Anglocentric, overlooking or ignoring the Swedes, Finns, Germans and Scots-Irish who truly spread the log cabin across

America. Poor, disenfranchised immigrants being edited out of history? What a shocker. And we'll see more of it soon enough.

8 Reverend Alexander Young, *Chronicles of the Pilgrim fathers of the colony of Plymouth, from 1602–1625*, (Boston: Charles C. Little and James Brown, 1841), 179, n.3.

9 George Bethune, "Art in the United States," in *The Home Book of the Picturesque*, (New York: G.P. Putnam, 1852), 171.

10 Henry Bronson, *The history of Waterbury, Connecticut* (Waterbury: Bronson Brothers, 1858), 80.

11 C.M. Endicott, "The Old Planter's House," Historical Collections of the Essex Institute (Salem: H. Whipple, 1859), 40.

12 John Gorham Palfrey, *History of New England* (Boston: Little, Brown and Company, 1858), 62.

13 Shurtleff, 194.

14 Erastus Worthington, *History of Dedham*, (Boston: Dutton and Wentworth, 1827), 13.

15 Tyler, *Letters*, 1–2.

16 Keeping with the theme of mistruths and apocrypha, though this quote is often attributed to Twain, he co-wrote 1873's *The Gilded Age* with Charles Dudley Warner, and many historians believe it is the less famous of the two who coined these iconic words.

17 Greeley, *Autobiography*, 23.

18 Benson J. Lossing, *Centennial History of the United States : from the discovery of the American continent to the end of the first century of the republic* (Hartford: Thomas Belknap, 1875), 112, n. 2.

19 Edward Atwater, *History of the Colony of New Haven to Its Absorption Into Connecticut* (New Haven: Edward Atwater, 1881), 71.

20 Noah Porter, "The New England Meeting House," in *The New Englander*, May 1883, 303.

21 Porter, "Meeting House," 306.

22 Reverend William Barrows, "Significant Beginnings Out West," in *The Magazine of American History*, December 1884, 503.

23 Phillip Alexander Bruce, *Economic History of Virginia in the Seventeenth Century*, (New York: MacMillan, 1896), 147.

24 John Gorham Palfrey, *A compendious history of the first century of New England, Vol. 1* (Boston: H.C. Shepard, 1872), 296.

25 William B. Weeden, *Economic and Social History of New England, 1620–1789* (Boston and New York: Houghton, Mifflin, and Company, 1890), 212–213.

26 The nation's unwavering pioneering spirit was also being extolled in Mark

Twain's *Adventures of Tom Sawyer* and *Huckleberry Finn*, which were published in 1876 and 1884, respectively. And Willa Cather explored similar themes in *O Pioneers!*, *Song of the Lark*, and *My Ántonia*, her "prairie trilogy."

27 This idea was spurred in large part by foreign observations, the earliest of which was Alexis de Tocqueville's 1840 proclamation that "the position of the Americans is therefore quite exceptional, and it may be believed that no democratic people will ever be placed in a similar one."

28 Reverend William Barrows, "Rifle and Cabin," *The Magazine of American History*, July 1880, reprinted in *The National Magazine*, Vol. VII, 1888, 292.

29 George C. Swallow, *Geological report of the country along the line of the southwestern branch of the Pacific Railroad, State of Missouri*, (St. Louis: George Knapp & Co., 1859), 36.

30 Ralph Henry Gabriel, Ed., *The Yale Pageant of America, Volume 1* (New York: Yale University Press, 1925), 204.

31 Isaack de Rasieres to Samuel Blommaert 1627, Library of Congress, http://hdl .loc.gov/loc.gdc/gckb.025.

32 Ibid.

33 Shurtleff, *Log Cabin Myth*, frontpiece.

34 Frank Herman Perkins, *Handbook of Old Burial Hill, Plymouth, Massachusetts: Its History, Its Famous Dead, and Its Quaint Epitaphs* (Plymouth, Mass; A.S. Burbank, Pilgrim Bookstore, 1896), 73.

35 Bureau of the Census, *Report on Population of the United States at the Eleventh Census: 1890, Part 1*, xxxiv.

36 Frederick Jackson Turner, *The Frontier in American History*, (New York: Henry Holt and Company, 1920), 165.

37 Turner, *Frontier*, 263.

HARD NOTCH: THE LOG CABIN AND THAT "PECULIAR INSTITUTION"

1 Interview with Annie Young Henson, September 27, 1937, Baltimore, Maryland, in *Slave Narratives: A Folk History of Slavery in the United States From Interviews with Former Slaves: Volume I, Maryland Narratives, Works Progress Administration* (Washington DC: Library of Congress, 1941), https://www.loc .gov/collections/slave-narratives-from-the-federal-writers-project-1936-to-1938 /about-this-collection/.

2 Interview with Mary Ella Grandberry, June 9, 1937 in *Slave Narratives: A Folk History of Slavery in the United States From Interviews with Former Slaves: Volume I*, Alabama Narratives, Works Progress Administration (Wash-

ington DC: Library of Congress, 1941), https://www.loc.gov/collections
/slave-narratives-from-the-federal-writers-project-1936-to-1938/about-this
-collection/.

3 Frederick Law Olmsted, *A Journey in the Seaboard Slave States: With Remarks
on Their Economy*, (New York: Dix & Edwards; London: Sampson Low, Son & Co,
1856), 88.

4 Johann David Schoepf, *Travels in the Confederation [1783–1784]*, trans. and ed.
Alfred J. Morrison, (Philadelphia: William J. Campbell, 1911), 100.

5 Interview with Marriah Hines, Norfolk, Virginia, March 27,1937, *Slave
Narratives: A Folk History of Slavery in the United States From Interviews with
Former Slaves: Volume 17, Virginia*, Works Progress Administration (Wash-
ington DC: Library of Congress, 1941), https://www.loc.gov/collections
/slave-narratives-from-the-federal-writers-project-1936-to-1938/about-this
-collection/.

6 Booker T. Washington, *Up from Slavery: An Autobiography*, (New York: Dou-
bleday, Page & Co, 1907), 1.

7 Washington, *Up from Slavery*, 3.

CHAPTER 7: AN AMERICAN MYTH, VOL. 2:
THIS TIME IT'S PER$ONAL

1 Frederick Jackson Turner, "Contributions of the West to American Democ-
racy," in *Atlantic Monthly*, January, 1903.

2 Lyon G. Tyler, *The Cradle of the Republic: Jamestown and James River*, (Rich-
mond, VA: Hermitage Press, 1906), 184.

3 Bruce Craven, "The Significance of the Mecklenburg Declaration of Indepen-
dence," in *The North Carolina Booklet*, October, 1908, Vol. VIII, No. 2 (Raleigh:
North Carolina Society of the Daughters of the Revolution) 56.

4 Erasmus Wilson, "The Quiet Observer," *Pittsburgh Post-Gazette*, February 18,
1915, 4.

5 Warder William Stevens, *Centennial history of Washington County, Indiana*,
(Indianapolis: BF Bowen & Company, Inc., 1916), 155.

6 Ibid, 156.

7 "Pioneers Meet in the Log Cabin" *The San Bernardino County Sun*, May 3,
1903, 7.

8 "Old People's Reunion," in *The Bradford Star*, September 11, 1902, page 3, col-
umn 5.

9 Oliver Kemp, *Wilderness Homes: A Book of Log Cabins* (New York: The Outing
Publishing Company, 1908), vii.

10 "Open Philosopher's Hall," in *The Washington Post*, December 3, 1910

11 "To Put Log Cabins in City Parks," *The New York Times*, May 3, 1913.

12 "Attractive 'Log' Bungalow Built of Concrete," in *Popular Mechanics Magazine: Written So You Can Understand It* (Chicago: Popular Mechanics Company, 1919), 729.

13 As with Lincoln's so-called birth cabin, this Roosevelt-related edifice was trotted around for patriotic gawkers, making subsequent appearances at the 1905 Lewis and Clark Exposition in Portland, the 1906 North Dakota State Fair and then at Bismarck's capital grounds, where it sat for almost fifty years before being reinstalled at the Theodore Roosevelt National Memorial in 1959, back on the land from whence it came.

14 I'd be remiss not to note that Grant biographer Hamlin Garland claimed in 1898, at the height of log cabin myth-making, that the future president had been born not in a frame structure, as was the truth, but in a "cabin home." (Hamlin Garland, *Ulysses S. Grant; his life and character*, (New York: Doubleday & McClure, 1898), 1.

15 "Daniel Boone Memorial Dedicated Yesterday," *The Wilmington Morning Star*, May 1, 1910, 9.

16 "Sherman Tells How Lincoln Was Great," *Salt Lake City Tribune*, February 13, 1909.

17 "Real Log Cabims." *The Indianapolis Sunday Star*, July 9, 1922.

18 " For Americanism of Lincoln Mr Wilson Makes Vigorous Plea," *The Charlotte News*, September 4, 1916.

19 Ibid.

20 President Woodrow Wilson, "Address in Favour of the League of Nations," September 25, 1919, Pueblo, Colorado.

21 Mary Newton Stanard, *Colonial Virginia*, *Its People and Customs*, (Philadelphia and London: J.B. Lippincott company, 1917), 54.

22 CE Kemper, "The Settlement of the Valley," *The Virginia Magazine of History and Biography*, April, 1922 (Richmond, Virginia: Old Dominion Press), 180.

23 Truslow Adams, *The Founding of New England*, (Boston: Atlantic Monthly Press, 1921), 99.

24 *Popular Science* Eds., *How to Build Cabins, Lodges and Bungalows* (New York: Popular Science Publishing, 1934), 5.

25 *Ibid*.

26 "Lincoln Shrine Sells Foreign Made Souvenirs," *Chicago Daily Tribune*, May 24, 1936.

27 "Ohioans to Honor Couple," in *The Cincinnati Enquirer*, May 12, 1935.

28 Franklin D. Roosevelt, "Address at Marietta, Ohio," July 8, 1938.

29 Elbert K. Fretwell, "Foreword," in Conrad Meinecke, *Your Cabin in the Woods*

A Compilation of Cabin Plans and Philosophy for Discovering Life in the Great Out Doors. (Buffalo: Foster & Stewart, 1945), vii.

30 Rodney P. Carlisle, *Encyclopedia of Play in Today's Society, Volume 1*, (Los Angeles: SAGE Publications, Inc, 2009), 363.

31 "Local." in *The Herald*, Shelbyville, MO, August 9, 1899.

32 Wilson, "The Quiet Observer," 4.

33 Marie M. Meloney, "Foreword," in *The Log-cabin Lady: An Anonymous Autobiography* (Boston: Little, Brown and Company, 1922), vi.

34 "Goes from Log Cabin to Mansion," in *The Charlotte News*, November 10, 1922.

35 "How Three Poor Boys Paved Careers From Rags to Riches," in *The Cleveland Star*, October 27, 1922.

36 A.O. Beamer, *Midwest Museums Quarterly* (Detroit: Midwest Museums Conference, April, 1943), 13.

37 The cabin was moved, piece by piece, to Shady Brook, about twenty-five miles away, in 1982, and then, in 2002, it was moved yet again, this time on a flatbed, to its present location, at the Lake County Historical Society, thirty miles northeast.

38 Joseph P. Ferrie, "History Lessons: The End Of American Exceptionalism? Mobility In The United States Since 1850," *Journal of Economic Perspectives*, Summer 2005, 199–215.

39 "Horatio Alger in Hall of Fame," in *Edwardsville Intelligencer*, September 18, 1936, 2.

40 "Plain Talk," Richard Quillen, in *Plainfield Courier-News*, February 5, 1940, 6.

41 Donald G. Paterson, "The Conservation of Human Talent," *American Psychologist*, March 1957, 135 (134–144).

HARD NOTCH: RICH LOG, POOR LOG

1 "Buttonhole Interviews," in *The Weekly Gazette*, October 3, 1901.

2 Schoepf, *Travels*, 9.

3 James Kirke Paulding, *Letters from the South By A Northern Man, Vol. 1* (New York: Harper & Brothers,1835), 155.

4 Craig A. Gilborn, *Adirondack Camps: Homes Away from Home, 1850–1950*, (The Adirondack Museum/Syracuse University Press, 2000), 12–13.

5 William Peck, "Elisha Johnson," in *Publications of The Rochester Historical Society*, Vol. 6 (Rochester: *The Rochester Historical Society* 1927), 294.

6 William H. H. Murray, *Adventures in the wilderness, or, Camp-life in the Adirondacks*, (Boston: Fields, Osgood & Co., 1869), 21–22.

7 "Adirondack.," *The New York Times*, August 9, 1864, 4, column 4.

8 Gilborn, *Adirondack Camps*, 125.

9 Chilson Aldrich, *The Real Log Cabin* (New York: The Macmillan Company, 1928), 28.

10 George H. Dacy, "The Lure of the Log Cabin," in *American Home* (American Home Publishing Company, August, 1930), 495.

11 Loretta Lynn, *Loretta Lynn: Coal Miner's Daughter*, (New York: First Vintage Books, 2010), 5.

12 "The Politicians' Rendevous at Kamp Kill Kare," *The Brooklyn Daily Eagle*, September 6, 1908, 3.

13 "Lincoln Memorial is Dedicated by President Taft," in *The Scranton Truth*, November 9, 1911.

14 "Pursuing the American Dream: Economic Mobility Across Generations" (Pew Trust's Economic Mobility Project, July 2012), 2.

CHAPTER 8: GOING NUCLEAR

1 Randy Roberts, James S. Olson, *A Line in the Sand: The Alamo in Blood and Memory*, (New York: The Free Press, 2001), 246.

2 Andro Linklater, *Owning the Earth: The Transforming History of Land Ownership* (New York: Bloomsbury USA, 2013), 231.

3 Barbara Bundschu, "Multi-Million Dollar Hornet's Nest Buzzes Around Davy Crockett," *Daily Independent Journal*, May 27, 1955, 4.

4 John Fisher, "Personal and Otherwise: The Embarrassing Truth About Davy Crockett, the Alamon, Yoknapatawpha County, and Other Dear Myths," *Harper's Magazine*, July 1955, 16–18.

5 Ray Tucker, "National Whirligig," *The Bee*, August 10, 1955, Section A, 6.

6 Murray Kempton, "The Real Davy," *New York Post*, June 21, 1955.

7 "Davy Crockett—'A Huge Western Joke,'" in *The Decatur Herald*, July 17, 1955.

8 Charles Mercer, "Davy Crockett Myth Probed," *The Ithaca Journal*, July 6, 1955, 16.

9 "50s-Kids: Crazy for Crockett and Coonskin Caps," *Chicago Tribune*, July 22, 1985.

10 Roberts, Olson, *A Line in the Sand*, 245.

11 Fess Parker, "Our Kids Are Hero-Hungry," in *The Baltimore Chronicle, This Week: The Sunday Magazine*, October 9, 1955, 9.

12 "Packaged log cabins for the weary," in *Kiplinger Magazine*, April 1948, 21.

13 Preservation' Theme of Historical Survey Meeting in Fort Worth," *Hood County News-Tablet*, December 8, 1966.

14 Weslager, *Log Cabin,* 282–283.

15 Kevin McCann, *Man from Abilene* (New York: Doubleday, 1952), 14–15.

16 Weslager, *Log Cabin,* 313.

17 This radicalism seemed new at the time, but it wasn't: dozens of similar communes preceded it, including French socialist Icarian communities that arose in the south around after 1848, and the racist leftist Kaweah Colony in Sequoia National Park in the 1890s.

18 "The Commune Comes to America," *Life Magazine,* July 18, 1969.

19 "Fort Wilderness," Sanders LaMont, *Florida Today,* September 26, 1971.

20 "Old-Time Formula Used in Restoration of Log Cabin," *The Indianapolis Star,* February 26, 1976.

21 "Students Build Log Cabin Village," *Hazleton Standard-Speaker,* May 24, 1976.

22 Gallup Poll, "Congress and the Public," January 23–26, 1976, http://www.gallup.com/poll/1600/congress-public.aspx.

23 Gallup Poll, "Satisfaction with the United States," November 2–5, 1979, http://www.gallup.com/poll/1669/general-mood-country.aspx.

24 Ibid.

25 "Dolly Parton Theme Park Opens May 3," *Indiana Gazette, Family Leisure,* April 12, 1986.

26 "Riverfront Lots Up For Sale for $2 Million Each," in *The Washington Post,* October 22, 1988.

HARD NOTCH: THE LOG CABIN AND DEFORESTATION

1 John Lorain, *Nature and Reason Harmonized in the Practice of Husbandry,* (Philadelphia: H.C. Carey & I. Lea, 1825), 336.

2 Ronald Reagan, "Remarks on Signing Four Bills Designating Wilderness Areas," June 19, 1984.

3 Allen, *The Practical Tourist,* 245.

4 Captain John Smith, *Advertisements for the unexperienced planters of New England or anywhere. or, The pathway to erect a plantation,* (Boston: W. Veazie, 1865), 47.

5 Marque François Jean Chastellux, *Travels in North America, in the years 1780, 1781, and 1782, Volume I,* (London: Printed for G.G.J. and J. Robinson, 1787), 45.

6 Ibid, 46.

7 Isaac Weld, *Travels through the states of North America, and the Provinces of Upper and Lower Canada, Volume I* (London: John Stockdale, 1799), 39.

8 Ibid, 32 and 39.

9 de Tocqueville, "Two Weeks," 876.

10 "Richard Henderson and John Luttrell to the Proprietors of Transylvania," July 18, 1775, printed in *Louisville News-Letter*, May 9, 1840.

11 Andrew Jackson, "Transcript of President Andrew Jackson's Message to Congress 'On Indian Removal,'" Washington DC (December 6, 1830).

12 Michael Williams, *Deforesting the Earth: From Prehistory to Global Crisis, An Abridgment*, (Chicago and London: The University of Chicago Press, 2006), 77.

13 Ibid. 71.

14 de Tocqueville, "Two Weeks," 885.

15 Kern, via Williams, 347.

16 Williams, *Deforesting*, 286.

17 Murray, *Adventures*, 16.

18 Williams, *Forests*, 20.

19 MacCleery, "American Forests," 1.

20 Bunyan, a late-nineteen lumber camp folk character, was officially introduced to the American public by the Red River Lumber Company, in a 1916 promotional pamphlet.

21 Horace Greeley, *Mr. Greeley's letters from Texas and the Lower Mississippi*, (New York: Tribune Office, 1871), 20.

22 J.B. Hodgskin, "The Truth About Land Grants" in *The Nation*, December 1870, 417–418, via Nye, *Second Creation*, 180.

23 Thomas Cole, "On American Scenery," in *American Monthly Magazine*, Vol. 1, Issue 1 January, 1836 (Boston: E. Broaders and New York, George Dearborn), 3 (1–12).

24 President James Madison, "Address to the Agricultural Society of Albemarle, 12 May 1818," https://founders.archives.gov/documents/Madison/04-01-02-0244.

25 Frenchie de Chastellux made similar remarks decades earlier, fretting in his 1787 work, "The melioration of the climate, even from the partial and comparatively inconsiderable destruction of the woods in many parts of the continent, is so rapid as to be strikingly perceptible even in the course of a few years," *Travels Vol. II*, 52.

26 Joseph C.G. Kennedy, "Preservation of Forest Trees," in *Agriculture of the United States in 1860* (Washington: Government Printing Office), 22.

27 Theodore Roosevelt, "Conservation as National Duty," Washington D.C. May 13, 1908

28 "Henry Ford's Forest," Ovid Butler, in *American Forestry*, Vol. 28, no. 348 (December 1922), 726.

29 "Blaney ParK Represents Novel Reforestation Plan," in *The Escanaba Daily Press*, June 15, 1930.

30 ". . . And Depended on Transportation," in *The Escanaba Daily Press*, July 1, 1976.

31 Barack Obama, "Presidential Proclamation, National Forest Products Week, 2016," Washington D.C., October 14, 2016.

32 MacCleery, "American Forests," 1.

33 Noah D Charney et al, "Observed forest sensitivity to climate implies large changes in 21st century North American forest growth," *Ecology Letters*, (2016), 1127 (1119–1128).

34 Sheng Yang and Giorgos Mountrakis, "Forest dynamics in the US indicate disproportionate attrition in western forests, rural areas and public lands," in *PLoS One*, February 22, 2017, http://journals.plos.org/plosone/article?id=10.1371/journal.pone.0171383.

CHAPTER 9: LOG CABIN, READY TO WEAR

1 Marge Colborn, "The Ins and Outs of Furnishing," in *The Detroit News*, December 29, 1990.

2 Ibid.

3 Marge Colborn, "Avocado is peachy and old is new again for the '90s," in *The Detroit News*, December 29, 1990.

4 The origin of this concept may be found in old vacation and real estate listings, circa 1965, when ads sometimes read "log cabin, chic . . .," as in an ad from the September 11, 1965, edition of the *Chicago Tribune* that read "Log cabin, chic hide-away . . ."

5 "Historic Preservation," in *The Magazine of the National Trust for Historic Preservation*, April 1984.

6 "Live like a Rockefeller," in *Chicago Tribune*, (Chicago, Illinois) December 21, 1986

7 Fineman, ". . . Log Cabin Chic," 27

8 Candice Russell, "Faith Popcorn Has Seen the Future," *South Florida Sun-Sentinel*, November 17, 1991.

9 Faith Popcorn, *The Popcorn Report: Faith Popcorn on the Future of Your Company, Your World* (New York: HarperBusiness, 1992), 37.

10 "Sweaters warms to new status in menswear; Cosby gets credit," in *The Akron Beacon Journal*, November 15, 1992.

11 Judy Stark, "Take a glimpse ahead at which style trends are heading for homes," in *The Arizona Republic*, September 3, 1994.

12 Michel Marriot, "Out of the Woods," in *The New York Times*, November 7, 1993.

13 *The New York Times*, January 17, 1995.

14 Judy Rose, "Designer Highlights a Rough-Hewn Heritage," in *Detroit Free Press*, October 25, 1990.

15 Edward Gunts, "Log-Cabin Chic," *The Baltimore Sun*, May 16, 1996.

16 Mark Shallcross, "Cabin Fever," *The Courier-Journal*, September 20, 1995.

18 Tom Puzak, "The Rise of the Lumbersexual," at GearJunkie.com. October 30, 2014, https://gearjunkie.com/the-rise-of-the-lumbersexual.

19 "Lumbersexual," in Urban Dictionary, http://www.urbandictionary.com/define.php?term=Lumbersexual.

20 Troy Patterson, "Buffalo in the City," in *The New York Times Magazine*, January 27, 2016.

21 Willa Brown, "Lumbersexuality and Its Discontents," *The Atlantic*, December 10, 2014, https://www.theatlantic.com/national/archive/2014/12/lumbersexuality-and-its-discontents/383563/.

22 Colborn, "Avocado," *Detroit Free Press*, December 29, 1990.

CONCLUSION

1 Interview with Will Ryman, New York, NY, September 24, 2016.

2 Turner, *The Frontier*, 305–306.

3 Stanley South, "The Log Cabin Syndrome," in *The Conference on Historic Site Archaeology Papers 1970*, Vol. 5, 1971, 103 (103–113).

4 *Popular Science* Eds., *How to Build Cabins*, 11.

5 The Associated Press-NORC Center for Public Affairs Research, "Divided Americans fret country losing identity," February 16–20, 2017.

6 Abraham Lincoln, *Gettysburg Address*, November 19, 1863.

INDEX

Note: Page numbers in italics represent images in the text.

A

Abbottstown, PA, 47

acculturation, 50–53

Achenwall, Gottfried, 67–68

Acrelius, Israel, 74

Across the Continent: Westward the Course of Empire Takes its Way (Palmer), *17*

Adams, James Wolcott, 132

Adams, John Quincy, 116–18

Adams, Truslow, 193

Adirondacks, 213–14

Adventures in the Wilderness (Murray), 212–13

advertisements, 163–66

Alaska, 60, 198–99, 245

alcohol, 153

Aldrich, Chilson D., 215

Alger, Horatio, 203, 206–7

Allen, Lewis, 140

Allen, Thomas, 139

Allen, Zachariah, 96, 107, 244

Allston, Washington, 148–49

America (Ryman), 265–66, *266*

Americana, 226–28

American Art-Union, 102

American exceptionalism, 157, 172, 186, 273

American expansion, 89, 95–96, 108, 148–49, 158, 160, 249, 266–67

American identity, 10, 88, 108, 270, 276

American Progress (Gast), 160–63, *160*

American values, 138–39, 276

Anglocentric worldview, 146–47

anti-immigrant sentiment, 45–46

anti-intellectualism, 118, 267

"Arguing the Point, Settling the Presidency" (Tait), *140*

Atwater, Edward E., 153

B

backwoodsmen, 95–96

"The Backwoodsman" (Paulding), 93

Baltimore Chronicle (newspaper), 125–26

Barrows, William, 155

Bartholomew, George, 41

Battle of Chancellorsville, *154*

Battle of Tippecanoe, 122

Beaver Creek, NC, 188

Bethabara, NC, *44*

Bethune, George, 147–48

bicentennial, 236–38

Biddle, Nicholas, 122

Bierstadt, Albert, 75

Manufacturing by LSC Communications, Crawfordsville
Book design by Judy Abbate
Production manager: Devon Zahn

The Countryman Press
www.countrymanpress.com

A division of W. W. Norton & Company, Inc.
500 Fifth Avenue, New York, NY 10110
www.wwnorton.com

978-1-68268-080-3

10 9 8 7 6 5 4 3 2 1